JAPANESE ANTIQUE FURNITURE

Rosy Clarke

Japanese Antique

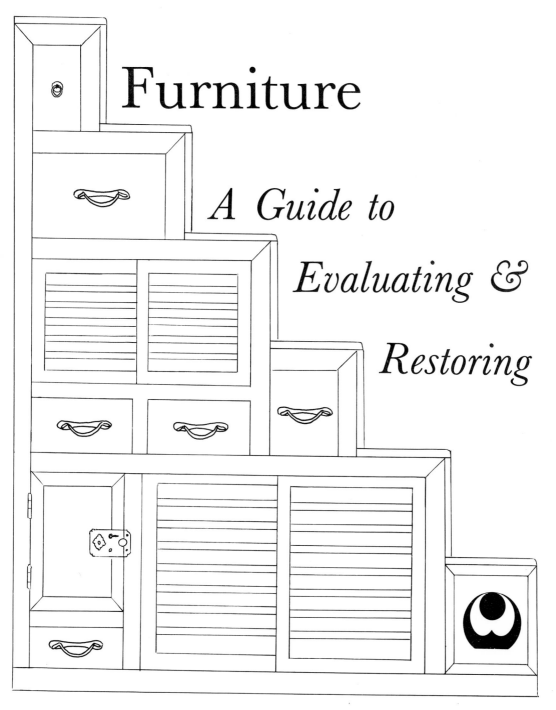

Furniture

A Guide to

Evaluating &

Restoring

New York • WEATHERHILL • *Tokyo*

Photographs on pp. 8–53, pp. 90–91, and pp. 125–26 by Katsuo Meikyo.

First edition, 1983
Second printing with revisions, 1984

Published by John Weatherhill, Inc., of New York and Tokyo, with editorial offices at 7-6-13 Roppongi, Minato-ku, Tokyo 106, Japan. Protected by copyright under terms of the International Copyright Union; all rights reserved. Printed and first published in Japan.

Library of Congress Cataloging in Publication Data: Clarke, Rosy. / Japanese antique furniture. / Bibliography: p. / Includes index. / 1. Furniture — Japan — Valuation. 2. Furniture — Japan — Repairing. I. Title. / NK2671.C54 1983 749.2952 / 82–21916 / ISBN 0–8348–0178–7

For my father

Contents

A map and chronology appear on page xii

Preface

Surprisingly little is definitely known about Japanese furniture since so much of the information on this subject has been passed down by word of mouth, through legend, or in the few texts available only in Japanese. While the discovery of available examples of antique Japanese furniture can be enjoyable and exciting, research on any given piece is often a challenge in modern-day Japan, where the traditional craft of making wooden furniture has continued with but a handful of established craftsmen.

To uncover some of the history of Japanese furniture—more appropriately "cabinetry," since the Japanese developed primarily storage cabinets as their furniture—I conducted hours of interviews with dealers and collectors of Japanese antique furniture. In the absence of a substantial Japanese museum of furniture craft, the shops and flea markets became my "furniture museums," since it is there that a wide range of furniture can be seen, compared, and judged.

Fortunately, today there are many surviving examples of furniture of the eighteenth through early twentieth centuries. Comparison of many types of tansu (chests), hibachi, and other furniture during the years I have lived in Japan has given me a greater understanding and appreciation of furniture styles, their areas of origin, and their use in Japanese life. In addition, old Japanese paintings and prints depicting interior scenes, old books containing architectural photos and drawings, and a number of history and folkcraft publications all have helped shed light on furniture development in Japan.

Because there are so many variables to consider when evaluating antique Japanese furniture, a systematic, conclusive approach is impossible. At best, the primary distinguishing features—style, wood type, metalwork, and finish—must form the basis of a comparative and evaluative study. Adding to the complexity is the fact that antique dealers and collectors themselves often have differing opinions as to a particular item's area of origin, its age, or even what it is to be called. And so, the best teacher becomes the experience derived from examining hundreds of pieces, comparing their features, and pressing those who have information to share it.

Since this book is general and introductory, designed for those just beginning their exploration of tansu and other furniture, apologies are extended for any oversights or omissions, and for the lack of greater detail in places.

While I introduce a range of Japanese furniture, special emphasis is put on tansu since they are the most popular furniture items among Westerners. The range of tansu styles is extensive, given all the regional variations that developed,

but this book focuses on representational styles bearing features that are easily distinguished and recognized, thereby providing a framework for approaching other varieties of tansu and furniture.

In the guide to evaluating and selecting antique furniture, I've attempted to organize my findings to help those seriously interested in purchasing a tansu. And for those interested in trying their hand at restoring tansu or other Japanese furniture, I present an easy-to-follow restoration procedure that was developed over years of restoring Japanese furniture. The procedure uses supplies and tools available in both Japan and the United States.

The factors that affect the value of antique furniture are many and varied. Accordingly, I have tried to present basic guidelines, clarify misinformation, and direct the reader to the proper considerations important to make before purchasing tansu or any other furniture. Owning a tansu, a hibachi, or any piece of Japanese furniture can provide a lifetime of enjoyment and use, combined with the satisfaction that the value of antique Japanese furniture is always increasing. And, with a deeper understanding of the piece you own—especially the piece you restore yourself—the reward is your participation in a rich part of Japanese history and culture.

Acknowledgments

Many people shared in the creation of this book, foremost among them my husband, A. B. Clarke, Jr., who evolved the restoration procedure for tansu during his many years of studying and examining tansu, taking them apart, rebuilding them, and restoring them to their original integrity. With keen sensitivity to the elements of tansu craft, A. B. became an enthusiast of antique Japanese furniture, with a high regard for the men who built it with their hands and from whose imagination Japanese furniture craft was shaped. For his months of help, advice, and confidence, my appreciation is utmost.

Special thanks is also due to Kazuko Yoshida for assistance in translation, and for providing much information on Japanese customs, tradition, and lifestyle, in addition to her patience and support while living with my family during the work on this book.

To Mr. Y. Hasebe, owner of Hasebe-ya Antiques and a well-respected authority on Japanese furniture, I owe gratitude for his cooperation and assistance in permitting me to have photographs taken of many pieces in his antique furniture collection. The staff of Hasebe-ya Antiques was also extremely helpful and congenial. Mr. Kenji Tsuchisawa, owner, and Mr. Yasuo Karino of Okura Oriental Art shared their time and ideas with me and provided a staircase chest for the cover photograph. To these two friends, I offer my deepest thanks.

And to the many dealers of antique Japanese furniture in Tokyo who offered historical information, personal perspectives, time, and answers, I am greatly appreciative. Especially I wish to thank two American dealers of Japanese antique furniture in Tokyo, Jim Luttrell and Denny Engelman. Jim and Denny were the first real sources of information on tansu when my husband and I began our exploration many years ago. They kindly shared with us information on history and their own informed opinions, and gave us important leads on locating restoration supplies and materials in Tokyo. From discussions with them, we were able to look at tansu in a special way and form a base of judgment upon which we were able to expand and refine in the years that followed.

To the many friends who offered important contributions and documentation for the book, I am also very thankful. While space limits naming everyone who participated, it is with extreme gratitude that I thank my editor, Pamela Pasti, whose professional advice, creative judgment, and encouragement were so significant and forthcoming during the months of work on this book.

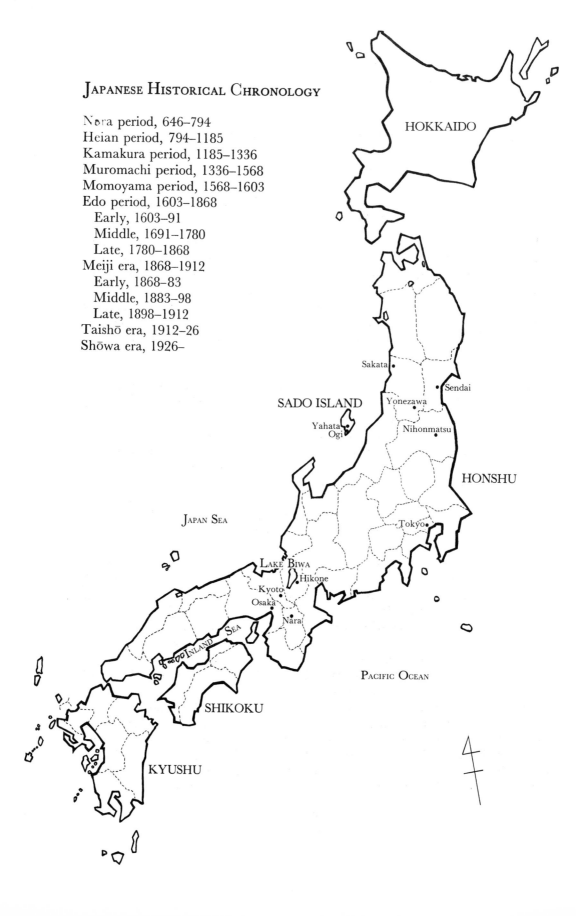

JAPANESE HISTORICAL CHRONOLOGY

Nara period, 646–794
Heian period, 794–1185
Kamakura period, 1185–1336
Muromachi period, 1336–1568
Momoyama period, 1568–1603
Edo period, 1603–1868
 Early, 1603–91
 Middle, 1691–1780
 Late, 1780–1868
Meiji era, 1868–1912
 Early, 1868–83
 Middle, 1883–98
 Late, 1898–1912
Taishō era, 1912–26
Shōwa era, 1926–

HOKKAIDO

Sakata

Sendai

SADO ISLAND
Yonezawa

Yahata
Ogi
Nihonmatsu

HONSHU

JAPAN SEA

Tokyo

LAKE BIWA
Hikone
Kyoto
Osaka
Nara

INLAND SEA

PACIFIC OCEAN

SHIKOKU

KYUSHU

JAPANESE ANTIQUE FURNITURE

Introduction: A People's Craft

Furniture Development in Japan

Although a few types of furniture were in existence as early as the eighth century in Japan, the production of tansu (Japanese wooden cabinetry) and other wooden furniture items did not emerge on a popular scale until the eighteenth century.

Economic and political circumstances and cultural dictates must have influenced the emergence of furniture, but since there are no complete records on this subject, the story of furniture development in Japan must be pieced together from what is known about Japanese history and lifestyle, and from the surviving pieces of furniture that can be dated to particular eras.

The earliest extant pieces of furniture, those preserved at the Shōsō-in (the imperial storehouse at Tōdai-ji temple) in Nara, show a strong Chinese influence. Chinese art, customs, and manners were quite fashionable during the Heian period (eighth to twelfth centuries), and the imperial furniture in the Shōsō-in—tea-utensil shelves, bookshelves, and writing desks—clearly reflect Chinese aesthetics as adopted by a world of nobility and leisure.

Around the middle of the tenth century, the Chinese influence on architectural styles began to give way to a Japanese aesthetic that eased the strict proportions of Chinese style, and in cabinetry for the aristocracy, a Japanese style started to take form. At about the same time, Zen Buddhism, with its adherence to natural and simple elements, was taking root in Japan, and by the twelfth century, trends in art and architecture began to shift to a more spontaneous and natural style reflecting indigenous taste and ideas. This natural style influenced the still small production of cabinetry, such that by the late fifteenth century storage containers and functional boxes were of a purely Japanese style.

Furniture in Japan, up to this point, consisted of the basic, crude storage boxes used by the middle class and itinerant peddlers, and the household furniture of the samurai—freestanding shelves, clothing trunks, and personal storage chests. Quite a gap existed between these two classes as well as their furniture. But by the seventeenth century, the repositioning of wealth from a samurai to a merchant base was occurring, and at the same time the predominantly agricultural economy was shifting to one relying more and more on a growing sea trade. A higher standard of living was clearly emerging. Former feudal restrictions prohibiting ownership of property and material

3

goods by artisans, merchants, and peasants were lifted, and slowly these people began to acquire more personal goods, including cabinetry to store their wares and possessions. By this time, a peasant of some means may have even owned a *nagamochi* (large storage trunk) or *mizuya-dansu* (kitchen chest).

During the prosperous Edo period (1603–1868), tansu production became widespread concurrent with the increasing material wealth of the lower classes. By the mid-eighteenth century, tansu were being made in the Kanto district (around Tokyo) and the Kinki area (Osaka, Kyoto, Nara), and in the rural areas of northeastern Japan (Sendai, Yonezawa), the northern Japan Sea coast (Hokuriku), and Sado Island. Distinctive tansu styles developed in each of these areas, and tansu production continued in these regions through the Meiji era (1868–1912). Other smaller types of Japanese furniture, pieces such as hibachi (braziers), vanities, tobacco and pipe boxes, money boxes, and sewing boxes, became popular and, like tansu, were produced abundantly from the mid-1700s through the end of the Meiji era.

The production of tansu and other containers flourished into the Taishō era (1912–26). In addition to the fact that Japan had plentiful wood resources, lumbering methods and planing techniques progressed during this time; furniture became mass-produced, and demand for custom-built tansu declined. The largest number of antique tansu, hibachi, and other wooden items found today are pieces that can be dated to the period of from about 1870 to 1920.

Furniture craft in Japan was not destined to develop like the sophisticated furniture art of Europe at the same time in history. It must be remembered that furniture as conceived from a Western point of view had no counterpart in a Japanese orientation. The Japanese lived on tatami mats in small houses; their artistic aesthetic emphasized simplicity; personal possessions simply weren't acquired on the scale they were in the West. And so "furniture" took the form of storage cabinets in Japan. The decorative, often non-functional, nature of Western furniture simply had no application in Japanese life. The Japanese needed furniture only for storing their most important possessions of frequent use—kimono, documents, writing objects, books, and tea utensils. Thus, the antique furniture of Japan consists of a large range of storage containers, from tiny sewing chests to enormous trunks on wheels.

A People's Craft

The roots of furniture production in Japan were function, and its flowering a people's craft. Mastery and skill are evident in the antique furniture of Japan, but conceived of need, it was more of a folkcraft than a fine art. Unlike highly developed Japanese art forms, such as *sumi-e* (ink painting) or kimono stencil dyeing, the craft of cabinetry developed in response to the demand for useful, everyday containers, trunks, or chests for, originally, totally functional purposes. And therein lies the beauty of Japanese furniture. As Sōetsu Yanagi, the founder of Japan's folkcraft movement, so aptly put it, "The particular kind of beauty found in crafts is that identified with use. It is beauty born of use. Apart from use, there is no beauty in crafts. The strong points of folkcraft are that they are never made for purposes other than use...to serve the people daily."

Yanagi considered furniture craft, or cabinetry, as *getemono,* meaning art of

the people. To him, utilitarian objects—pottery, textiles, baskets, furniture—formed fundamental art, that which combines utility with good design. Looking back to the eighteenth century, when tansu and other furniture items started to proliferate, Yanagi's view on cabinetry as *getemono* bears consideration since it was the lower classes—the merchants, artisans, and farmers—who were creating the greatest demands for furniture, for use in their homes, at their shops, and on their farms. As a result, a host of cabinetry styles developed, corresponding to diverse needs.

Furniture of all descriptions was being produced toward the end of the nineteenth century when Japan was changing from a feudal to a modern society. Clothing tansu, chests with drawers, were common in most homes for the storage of kimono. Wooden safes guarded valuables in homes and shops. Sewing chests, vanities, and cabinets for tea utensils and crockery were important items in the lives of Edo and Meiji women. The upper classes, families of the former samurai powers, special-ordered sword chests (*katana-dansu*) and writing desks. A man born into the aristocracy would have studied Noh (Japanese classical drama) and would have possessed a trunk for his costumes and a small chest of square drawers (*nōmen-dansu*) for storing his Noh masks.

Tansu craftsmen in the late Edo period and the Meiji era must have enjoyed the brisk demand for tansu, and it is certain they passed down the skills and knowledge of their craft to their sons. Customers included everyone from sea captains, whose ships began to be outfitted with small but elaborate wooden safes for storing the valuables and documents on board, to the village pharmacist, who would have needed a medicine chest with its numerous, tiny drawers. For the barber, a tall, thin chest (*dōgu-bako*) for combs, razors, and scissors was designed. For the ironsmith, or anyone working with hand tools, there was a small tool chest with narrow drawers called a *kanagu dōgu-bako*. Merchants would have had a *han-bako*, a small, one-drawer box for keeping name seals (*hanko*) and ink, or a *suzuri-bako*, a box with several drawers for storing an abacus, an inkstone (*suzuri*), sumi, and brushes for writing bills and receipts. Peddlers ordered cabinets to accommodate the wares they sold. The eyeglass salesman carried on his back a long, slender box with small drawers filled with glasses; and lamp oil was delivered to homes or shops in an *abura-gyōshō-bako* (oil peddler's box) carried on a pole across the shoulders of the delivery man.

Large and small, plain and intricate, functional cabinets proliferated. Wherever a need existed, a corresponding tansu was developed, leading to the vast array of styles, shapes, sizes, and tailoring found in antique Japanese cabinetry and still enjoyed today.

1 Identification

The term "tansu" is heard and used frequently in Japan, and some confusion understandably exists as to what actually constitutes a tansu. Tansu (pronounced -*dansu* in compounds) simply refers to Japanese cabinetry constructed of wood and used for storage. This cabinetry is most often associated with basic chests of drawers, but, in fact, it embraces a wide range of styles.

Some types of furniture are more common than others, and this chapter will provide a basic introduction to the general tansu types most frequently encountered and common varieties of smaller furniture. The primary distinguishing features of furniture include: style as it relates to function; wood type; functional and decorative metalwork; and finish. Judging age can pose problems since designs and construction methods for most types of furniture changed very little from the early nineteenth century through the Taishō era when production was at its peak. Further complicating accurate dating, artistry and improvisation began to play an important role as tansu became more popular and as tansu craftsmen became more skilled at their craft. However, learning to recognize certain typical tansu features can help you place the tansu in its area of origin as well as date its production to within a period of about fifty years. The Japanese system of dating by historical period or era (see chart on p. xii) is adopted here since that is the system used by the Japanese and most dealers. For more detailed explanations of construction, wood types, metalwork, and finishes, see Chapter 2.

CLOTHING CHESTS

Clothing chests, generally called *ishō-dansu* in Japanese, are used for the storage of kimono and personal garments. They are designed in a chest-of-drawers configuration of either single-chest or two-piece construction, containing most often four drawers and sometimes including a small door in the bottom right corner of the chest that covers two smaller, inside drawers. An exception to this configuration is the double-door clothing chest, whose distinctive features are described later in this chapter.

The large drawers of the clothing chest are built into a box frame. In the case of two-piece chests, the configuration is usually two drawers in the top box and two drawers, often accompanied by a small door compartment, in the

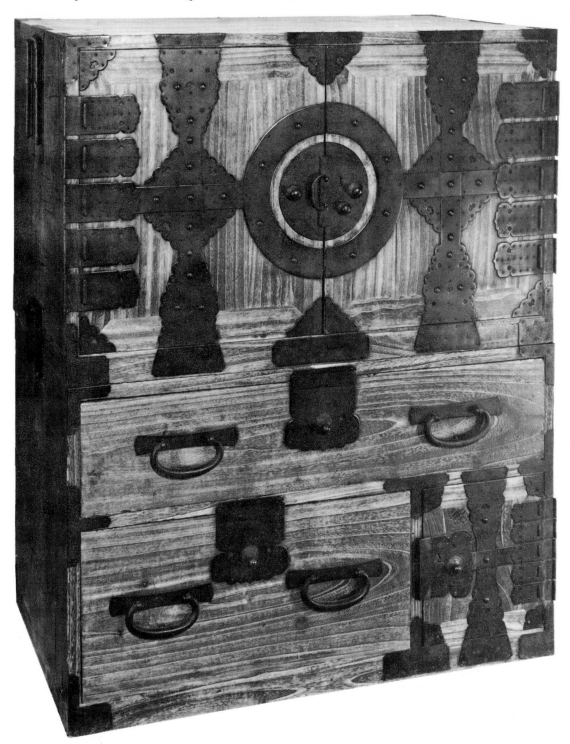

Fig. 1. Double-door clothing chest, two-piece, with cryptomeria box and pau-
lownia drawer and door fronts. Mid-Meiji era. H. 110 × w. 91 × d. 43 cm. Clarke
collection.

bottom box. Quite often, the two boxes, or cases, of a two-piece chest are not equal in height. Frequently the bottom box is greater in height than the top box since, when the two are stacked and viewed from a standing position, they appear to be equal in size if the bottom box is a little larger. Asymmetry of this sort is found more often than not in Japanese cabinetry.

In the case of one-piece clothing chests, a series of large drawers is built into a large, one-box frame, and this style, too, is often accompanied by a small door compartment in the bottom right corner of the box.

In general, metalwork is uniform among regional styles of clothing chests, with each of the large drawers bearing two iron handles and a central lock-plate covering the drawer lock, which is located at the middle, upper edge of the drawer. However, the design, degree of artistry, and elaboration in the metal-work depends on the area of origin of the tansu.

Double-door Clothing Chests
Ryōbiraki Ishō-dansu

One of the most popular and unusual of all Japanese chests is the double-door, or *ryōbiraki,* clothing chest (Fig. 1). It's not difficult to understand why these chests are in such demand: the hinged double doors on the top case of these two-piece stacking chests are adorned with striking metalwork that immediately presents a dynamic and symmetrical pattern.

CONSTRUCTION: Most double-door chests are of two-piece, stacking-style construction. (Although some one-piece cases with double doors were also produced, most often they were not clothing chests.) The top case features two hinged front doors, which open outward to reveal two large inside drawers. The bottom case is constructed of either two identical drawers or two drawers of differing sizes accompanied by a door compartment on a bottom corner of the tansu. The double doors are hinged at the edge of the chest where the front and side meet, so that each hinge forms a ninety-degree angle when the doors are in a closed position. Some chests bear *kannonbiraki* double doors, which are mounted flush against the face of the chest so that each hinge forms a 180-degree angle when the doors are in a closed position, but such chests are not clothing chests. Although not technically correct, the term *kannonbiraki* is often used to refer to double-door clothing chests.

WOOD TYPE: The most common wood is paulownia for the case, doors, and drawers. Variations include cryptomeria cases with paulownia drawers and doors, or cryptomeria cases with hardwood doors and drawers. For the rich, a number of solid hardwood chests were also produced, but the standard still remains paulownia.

METALWORK: Although doors without extensive metalwork were also made, most double-door chests have a ring of iron encircling the round lockplate, which is split in half across the two doors. Extending from the side of each half

of the circle is a plain horizontal band of iron intersected by a vertical strip which fans out slightly at both ends. Usually, five hinges are attached to each door. Drawers on the bottom case usually have simple locks with square sides and slightly curved bottoms. Drawer handles vary, occurring in the simple, rounded *warabite* style; the *gumbai* style, a curved design which rises slightly in the middle; the *mokkō* style; or the *kakute* style. *Hirute* handles are also sometimes found. Backplates of the drawer handles are usually flat strips that have been carved slightly. Corner metal on the drawers is usually fan-shaped. Notable on most double-door chests are large-headed iron nails used to fasten metalwork to the wood.

FINISH: Since the most common wood for these chests is paulownia, Tokyo chests are unfinished; a natural patina, ranging from blond to pale brown, is characteristic. Restored chests uniformly exhibit a medium brown color. Hardwood chests and chests from northern Honshu usually exhibit a medium brown lacquer finish on the case and the chest front.

DATING: Double-door chests were developed in the mid-Edo period, and production continued through the Taishō era. The basic style remained consistent throughout, but earlier chests were constructed of solid paulownia, with quite heavy metalwork. Thickness of the wood and of the iron fittings is often the key to age. Thick wood of the same type throughout and heavy ironwork usually indicate an older chest. Those produced from the middle of the Meiji era and into the Taishō era exhibit thinner pieces of wood, cases of cryptomeria instead of the former paulownia cases, and thinner metalwork.

REGION OF ORIGIN: These chests became popular all over Honshu. However, it is generally agreed that the chests were initially produced in the Kantō Plain area, which includes Tokyo. Slight regional variations do exist, but all chests show the standard double-door design with circular metalwork.

Nihonmatsu Clothing Chests
Nihonmatsu Ishō-dansu

Large and imposing when compared in size to other clothing chests, Nihonmatsu chests (Fig. 2) offer a high degree of utility due to their expansive dimensions and ample drawer space. Although understated and simple in design, the chests are quite impressive owing to the large, thick pieces of hardwood used for the drawer fronts. Attractively designed lockplates, usually bearing raised motifs worked in brass, copper, or iron, give a three-dimensional effect and contribute to the popularity of Nihonmatsu chests.

CONSTRUCTION: Identifiable by their large size—about h. 135 × w. 114 × d. 46 cm when stacked—these chests are of the two-piece chest-of-drawers style. Four drawers and a corner door compartment are standard.

WOOD TYPE: Cases are most often of cryptomeria and drawers are of zelkova.

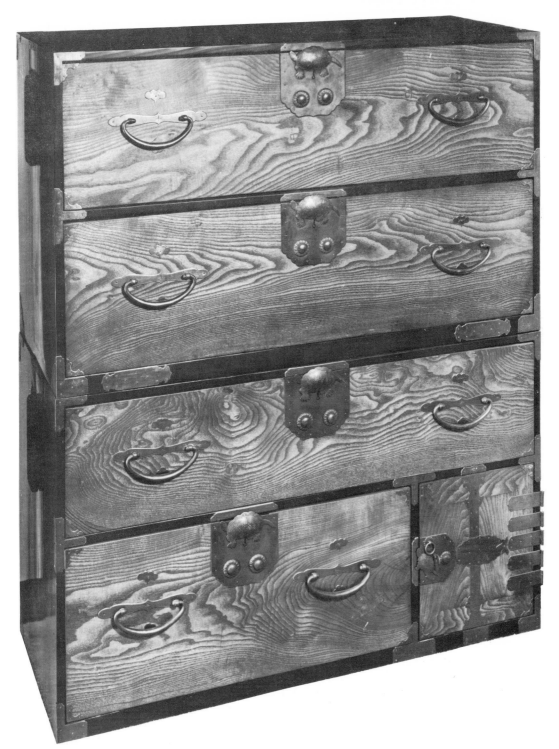

Fig. 2. Nihonmatsu clothing chest, two-piece, with cryptomeria box and zelkova drawer and door fronts. Note raised tortoise motif on lockplates. Late Meiji era. H. 136 × w. 114 × d. 44 cm. Clarke collection.

METALWORK: Metal decoration consists of small, simple corner pieces on the drawers and chest corners and lockplates that are either square with the bottom corners clipped at an angle, or round, often surrounded by a thin band of silvery *hakudō*. Lockplates bear a raised motif across the top of the lockplate, over the latching mechanism, which may be any of a number of typical motifs including a bamboo tree and bird, a tortoise, or bamboo leaves. Two parallel knobs, one for locking and one for latching, are apparent on the lockplates of each drawer. Drawer handles are quite heavy iron in the *warabite* style. Backplates of the drawer handles are simple iron strips cut out to form a modified, horizontal figure 8. *Atari* (small iron knobs) are present under the large handles, and on most chests a small decorative iron piece appears just above each handle. Iron carrying handles are standard.

FINISH: If the original finish is still intact, both case and drawers are usually dark, the result of aging of the lacquer finish. (When applied, finishes on drawer fronts were reddish brown.) However, many restored Nihonmatsu chests have drawer fronts that have been finished in a light or medium brown stain to expose the beautiful grain of the zelkova.

DATING: Nihonmatsu chests evolved in the middle of the Meiji era, with peak production occurring at the very end of Meiji, around 1910. Since design, metalwork, and wood type remained consistent throughout the history of Nihonmatsu chest production, it is sometimes difficult to date these pieces precisely. However, newer chests often show evidence of slight warping across the large zelkova drawer fronts. This is an indication that the wood was not given sufficient time to cure and age properly before construction, a result of rapid and mass-scale production at the end of Meiji to meet high demand.

REGION OF ORIGIN: Nihonmatsu area of Fukushima Prefecture in central northern Honshu.

Sado Island Clothing Chests
Ogi Ishō-dansu, Yahata Ishō-dansu

The clothing chests of Sado Island owe their distinctiveness to their abundant, intricate metalwork and handsome design. The two major types of Sado chests are those built in the town of Ogi (Fig. 3) and those produced in the town of Yahata (Fig. 4). While Yahata-style chests are decorated with elaborate metalwork that almost covers the entire front of the piece, Ogi chests are plainer, with fancy metalwork embellishing a smaller portion of the chest front.

CONSTRUCTION: Sado chests are built in both one-piece and two-piece styles and come in a wide range of sizes. Ogi chests are either of a four-drawer style with several smaller drawers and a door compartment or are built with five drawers and a door compartment. Yahata chests usually consist of four large, deep drawers plus the door compartment. In both styles, one or two small drawers near the door compartment may be evident.

WOOD TYPE: The case, drawer fronts, and interiors of early Ogi chests are most often composed of paulownia. Later pieces have cryptomeria boxes and drawer fronts of zelkova. Many Yahata chests are also constructed entirely of paulownia, but late-Meiji and early-Taishō pieces are predominantly cryptomeria throughout or cryptomeria boxes with hardwood drawer fronts.

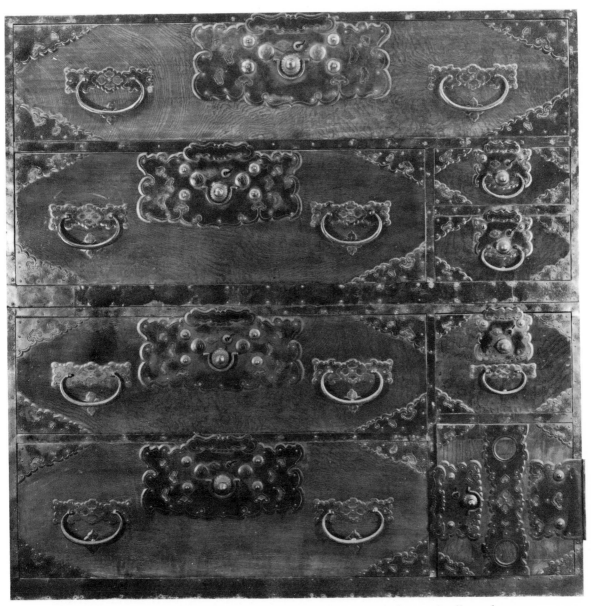

Fig. 3. Ogi clothing chest from Sado Island, with cryptomeria box and zelkova drawer and door fronts. Early Meiji era. H. 117 × w. 112 × d. 46 cm. Courtesy Hasebe-ya Antiques.

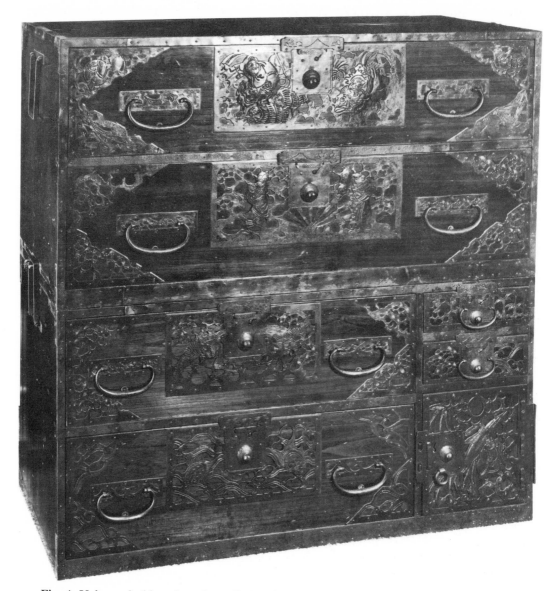

Fig. 4. Yahata clothing chest from Sado Island, two-piece, with cryptomeria box and paulownia drawer and door fronts. Mid-Meiji era. H. 114 × w. 117 × d. 43 cm. Courtesy Mr. and Mrs. Bruce Brenn.

METALWORK: Metalwork on Ogi chests looks as if it has been cut in a curly pattern, with edges rounded and swirling. Fancy lockplates of this design surround the drawer locks, and the corner metal is quite large and elongated, giving the appearance that the corner metalwork meets along the side edges of the drawer. Curved handles of the *warabite* style are backed by plates of the same swirling pattern, with a cut-out middle area that looks like four converging diamonds or petals. Four raised knobs are apparent on the lockplates, and

they are situated symmetrically in pairs on either side of the locking button.

Yahata-style chests appear to be covered on the front face almost entirely by intricately cut-out metalwork. Most typical are large, squared lockplates that have been cut out to form pictures, usually figures, birds, trees, and flowers, but sometimes alternating lockplates are decorated respectively with crane, tortoise, and/or bamboo motifs, or will show legendary characters. It is typical for the theme of each lockplate to vary. Corner iron pieces are large triangles, also cut out extensively, which meet at the center of the drawers' side edges. The theme of the corner metal of one drawer usually does not match that of the other drawers but, rather, has been designed to coordinate with the particular theme of the lockplate on that drawer. Of course, artistry, thickness of metal, and general feeling will be the same despite design variations on each drawer. Large, curved *warabite* handles are most frequently used, backed by rectangular handleplates in a cut-out design that matches the corner metal pieces. *Hirute* handles are also used. Yahata chests are unusual in that the entire front framework (the wood surface surrounding the drawer fronts and door) is practically always covered with nailed-on iron strips. Locks display a single, large locking knob. Since Yahata chests are so large, the two-piece varieties often have rectangular clamping handles (cf. Fig. 4) that hold the two pieces together, as well as two additional *warabite* handles on the sides for carrying.

FINISH: In paulownia chests produced in Ogi, the wood was most often left in its natural, unfinished state, forming a striking background for the fanciful metalwork. In Ogi chests built with cryptomeria cases and hardwood drawer fronts, the cases show a medium to dark brown non-glossy lacquer-based finish, while the hardwood on the drawers runs a range of reddish brown hues that usually do not obscure the zelkova grain. Yahata chests show dark lacquer-finished cases, with deep red or maroon lacquer-based finishes applied to the drawer and door faces.

DATING: Production of Ogi chests began in about 1850 and continued through the Taishō era. Yahata chests originated somewhat later, probably about 1890, and also continued to be constructed through the Taishō era.

REGION OF ORIGIN: Sado Island, located off the Japan Sea coast west of Niigata City and north of the Noto Peninsula.

Sendai Clothing Chests
Sendai Ishō-dansu

The attractive combination of fancily cut metalwork on hardwood stained in rich, deep wine hues is most likely responsible for the continued popularity of and demand for Sendai clothing chests (Figs. 5, 6). Perhaps, too, the uniquely Japanese motifs, which are elaborately carved in the decorative metalwork, make these tansu especially appealing to the foreign collector. Whatever the reason, Sendai chests are among the most expensive on the tansu market today and are coveted by tansu lovers and antique furniture dealers all over the world.

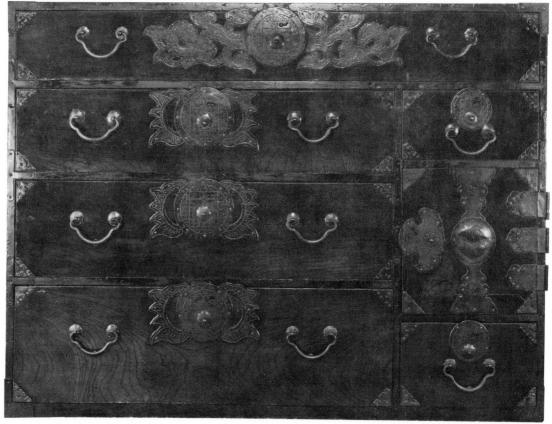

Fig. 5. Sendai clothing chest, with cryptomeria box and zelkova drawer and door fronts. Early Meiji era. H. 90 × w. 121 × d. 46 cm. Clarke collection.

CONSTRUCTION: Both single-chest and two-piece styles were produced in varying sizes, some, although rare, as wide as two meters. The two-piece stacking style contains a typical four-drawer configuration with a small corner door on the bottom case covering two smaller drawers. One-piece styles vary relative to the number of drawers and their arrangement, but most have a single wide top drawer as well as a small door compartment. Additionally, the one-piece chests often have two vertically stacked smaller drawers, identical in width to the door compartment, on the right-hand side of the chest; sometimes the compartment is located between these two small drawers rather than at the very bottom corner of the chest (the more usual arrangement). Another typical feature of some Sendai clothing chests is the addition of a vertical bar bearing a small lock mechanism at the top end, which covers several drawer fronts (cf. Fig. 6). This style, called *bō-dansu* (*bō* meaning bar), is typical of Sendai clothing chests, although these vertical bars are occasionally found on chests produced in other areas.

WOOD TYPE: In chests most frequently found today, boxes are made of cryptomeria while drawer fronts are of such hardwoods as zelkova or chestnut.

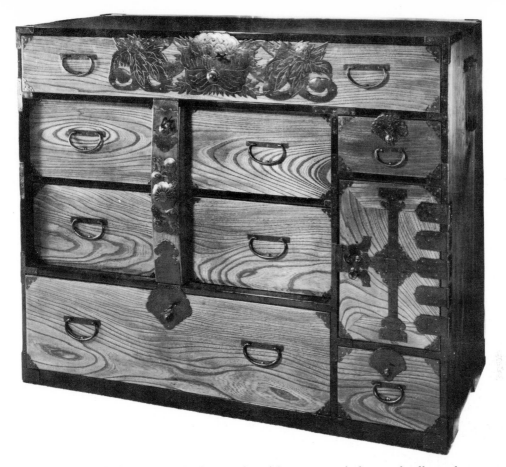

Fig. 6. Sendai clothing chest, *bō-dansu* style, with cryptomeria box and zelkova drawer and door fronts. Meiji era. H. 93 × w. 117 × d. 43 cm. Courtesy Mr. and Mrs. Paul G. Donald.

Pre-Meiji Sendai chests were often constructed of paulownia but are rarely found now. Those owned by the very wealthy may have been constructed entirely of hardwood, but the standard remains a cryptomeria box with hardwood drawer and door faces.

METALWORK: Standard Sendai metalwork is distinctive owing to the fancy appearance of the cut-out, raised pieces with over-engraving. Typical lockplates bear a cut-out flower or crane design, while fancier lockplates may range from carved dragons and temple dogs to characters from *The Tale of Genji* and decorative family crests. Whatever the motif of the lockplate, the design usually flares outward toward the drawer ends in a horizontal pattern. Simple, curved handles of the *warabite* style, with plain handleplates, or scalloped handles called *mokkō*, with round iron disks, are most commonly found. Single-action locks are evident in pre-Taishō chests, whereas double-action locks were used in Taishō pieces.

FINISH: Boxes appear with dark finishes. Drawers range from deep rust to rich burgundy, the result of lacquer-based finishes.

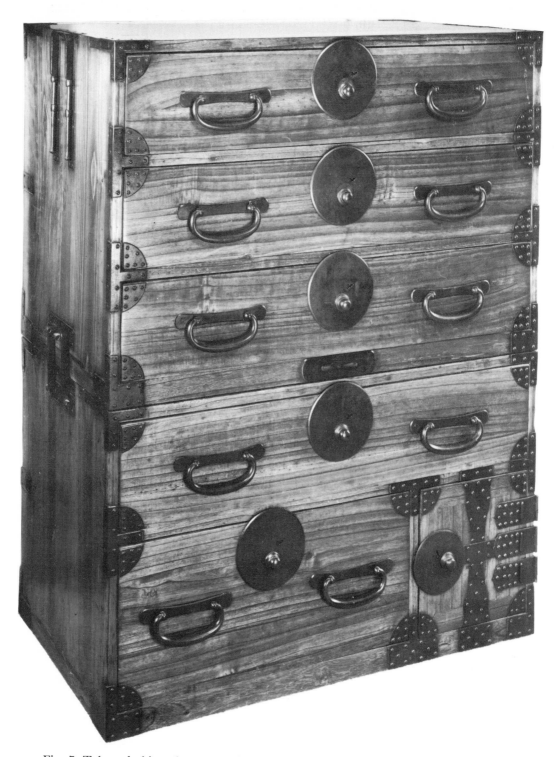

Fig. 7. Tokyo clothing chest, two-piece, with cypress box and paulownia drawer and door fronts. Late Meiji era. H. 113 × w. 91 × d. 43 cm. Clarke collection.

DATING: Sendai chests were produced in large quantity, and many typical ones still exist today. In terms of dating, Sendai chests underwent several identifiable stages of development: pre-Meiji chests are simpler in design and constructed often of paulownia or a combination of paulownia and cryptomeria. These chests are not commonly found today. During the Meiji era, zelkova drawer fronts began to replace the paulownia drawers of pre-Meiji times; metalwork became more elaborately carved, and the crane became a dominant motif for lockplates. Following mass production of *bō-dansu* chests in the late Edo period, the *bō-dansu* style lost popularity and finally was discontinued sometime in the middle of the Meiji era. In late Meiji, individually locking drawers and extensively engraved lockplates emerged. By the Taishō era, double-action locks had replaced the single-action locks on drawers, and the small door compartment had become less common. Metalwork continued to be embellished in the style of late Meiji.

REGION OF ORIGIN: Sendai area of central northeastern Honshu near the Pacific coast.

Tokyo Clothing Chests
Tōkyō Ishō-dansu

One of the most common and functional of chests produced in Japan is the simple Tokyo clothing chest (Fig. 7). Somewhat plain and austere, this chest is not as popular today as the fancy Sado Island or elegant Sendai chests, but it was, nonetheless, quite popular in its day owing to its convenient design and simple, uncluttered appearance. Its lack of high ornamentation kept production costs down originally, another reason why this chest was once so popular and produced in such volume. Today, that same principle operates, and the Tokyo clothing chest is an affordable, not to mention sturdy and practical, piece of furniture. Even though the Tokyo chest tends to be the least expensive of clothing chests, it is most often constructed of thick paulownia, a prized wood, and bears quite heavy, impressive handles.

CONSTRUCTION: Typical construction is the two-piece stacking style with four drawers and a bottom door compartment. Both boxes are usually equal in size, except in the case of five-drawer chests, which contain three large drawers in the top box and two drawers and/or a door compartment in the bottom box. Five-drawer Tokyo chests were produced in abundance, but it is the four-drawer style which was, and still is, the most prevalent.

WOOD TYPE: All paulownia for most late-Edo to mid-Meiji pieces. Cryptomeria or cypress boxes with paulownia drawer fronts appear more commonly on pieces constructed toward the end of the Meiji era or during the Taishō era.

METALWORK: Simple corner fittings and metal with large nailheads are evident. Lockplates are also simply designed and appear in either of two styles. Earlier chests often bear angular lockplates having straight sides and top and a slightly

round, cut design across the bottom of the plate. Later chests have large, round, undecorated lockplates. Handles are most often of a heavy *warabite* style, with plain handleplates showing perhaps a slight bit of carving. Some Meiji-era chests may have heavy *mokkō* handles, an influence from chests built further north in Sendai. *Atari* (small iron knobs) are found just under the handles. Decorative metalwork on the door is kept to a minimum and features a small lockplate that matches those on the drawers. Simply designed strips of iron intersect at the middle of the door. Side carrying handles of iron are standard.

FINISH: Since paulownia is usually left unfinished, Tokyo chests of this wood develop a light brown coloring, the result of years of exposure and use. On some Tokyo chests, a black lacquer-based finish was applied, which usually appears worn and spotty since this type of finish wears away unevenly on paulownia and is affected by climatic changes.

DATING: Tokyo chests emerged during the late Edo period and continued to be built through the Taishō era. Heavy metalwork was used throughout the years of production, but earlier chests may show angular locks while later pieces consistently show round lockplates with no decoration. Small, round lockplates indicate chests built in the Taishō era.

REGION OF ORIGIN: Tokyo area of central Honshu.

Yonezawa Clothing Chests
Yonezawa Ishō-dansu

Yonezawa-style chests (Figs. 8, 9) combine the best of understated Japanese design with a sense of tradition. Additionally, for many years they have offered good value when compared to the higher-priced Sendai chest or to the popular, fashionable staircase chest or double-door clothing chest.

CONSTRUCTION: Both one- and two-piece styles were produced from the middle of the Meiji era, but two-piece styles are most commonly found. Both types display a four-drawer configuration complemented by a small corner door that conceals two small inner drawers. Some Yonezawa chests have five drawers, although four is more usual.

WOOD TYPE: Most commonly, the case is constructed of cryptomeria, and the drawer faces and door, of a hardwood, either zelkova or chestnut.

METALWORK: The metalwork is elegantly simple. The round lockplates are often rimmed with a thin band of silvery *hakudō*, a nickel alloy (cf. Fig. 9). With or without the thin "silver" rim, lockplates are always round and engraved, and often cut-out. The most popular motifs seem to be the cherry blossom crest and the butterfly. A cut-out butterfly on a round plate ringed with *hakudō* was an especially popular motif (cf. Fig. 9). Drawer handles are primarily of the scalloped *mokkō* design, with handleplates cut out in a pine

tree motif. Drawer corner metal is always used, and the usual pattern is a small triangular piece cut out in the interior and raised in a small bubble at its midpoint. Iron carrying handles are standard.

Finish: Boxes appear darkly finished and sometimes rather dull unless they have been restored and polished. Drawers range from orange and reddish brown to medium brown, finished with a lacquer process, and the hardwood grain always shows through.

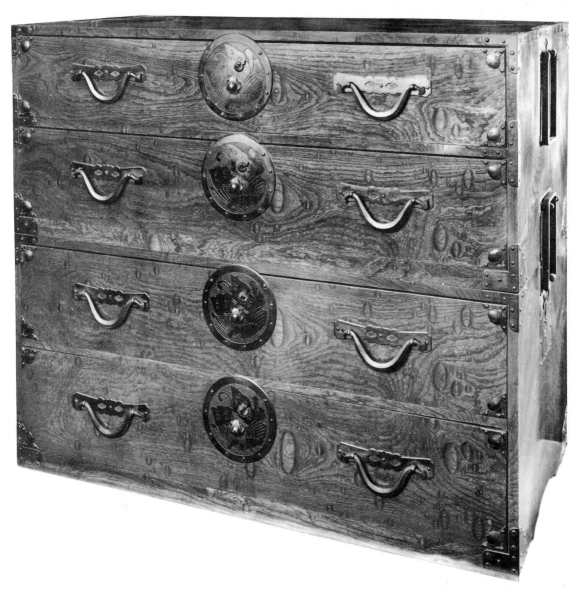

Fig. 8. Yonezawa clothing chest, two-piece, with cryptomeria box and burled zelkova drawer fronts. Meiji era. H. 94 × w. 119 × d. 48 cm. Courtesy Hasebe-ya Antiques.

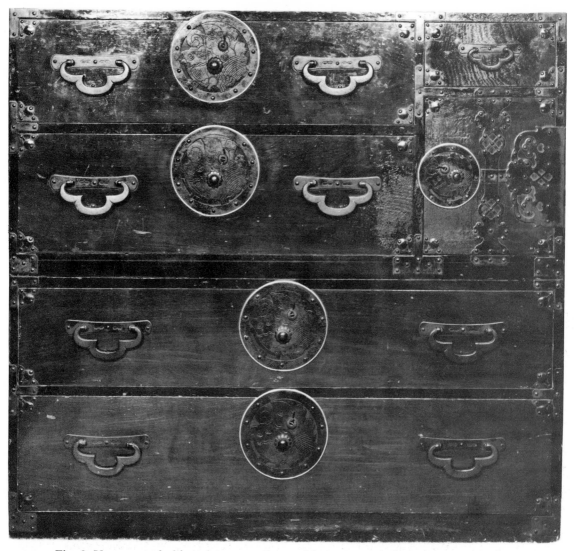

Fig. 9. Yonezawa clothing chest, two-piece, with cryptomeria box and zelkova drawer and door fronts. Mid-Meiji era. H. 86 × w. 109 × d. 46 cm. Courtesy Hasebe-ya Antiques.

DATING: Development of Yonezawa chests began around 1890, with production reaching a peak around 1900. Construction and style remained consistent during this time, although later two-piece Yonezawa chests often have the door compartment built into the top piece rather than the typical bottom placement (cf. Fig. 9). Because Yonezawa chest production started late, many reasonably priced chests are available today.

REGION OF ORIGIN: Yonezawa area of the inland region of central northwestern Honshu. (Note: Furniture dealers often name Shōnai, a plain lying northwest of Yonezawa, as the production region of these chests.)

OTHER CHESTS

Kitchen Chests
Mizuya-dansu

Only recently have the large, kitchen storage chests called *mizuya-dansu* (Fig. 10) caught the fancy of antique furniture collectors. Along with this surge in interest, prices for these chests have also risen. Five years ago, the average

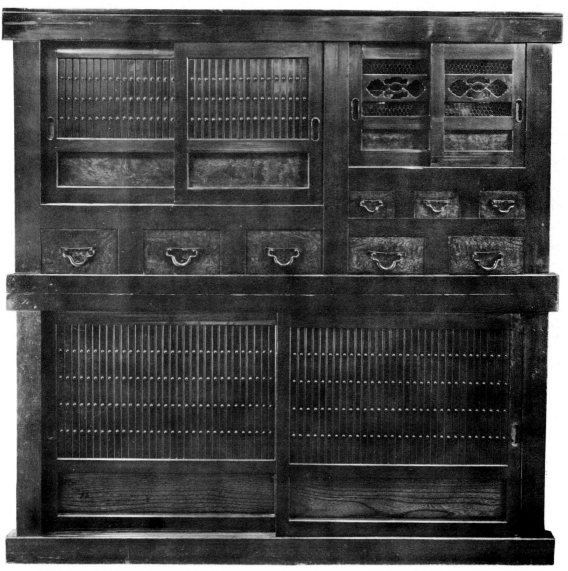

Fig. 10. Kitchen chest, two-piece, with cryptomeria box and zelkova drawer and door fronts. Late Edo period. H. 180 × w. 180 × d. 68.5 cm. Courtesy Hasebe-ya Antiques.

kitchen chest would have sold for about a third of the price these pieces command today. The most appealing aspect of the kitchen chest for most people is its spacious and versatile storage area. Conveniently placed inner shelves, sliding doors, and deep drawers make this chest perfect for storing dishes, crockery, or other tableware. Imaginative owners have been known to convert these ample chests into linen chests, freestanding libraries, and even stereo cabinets.

CONSTRUCTION: Typical construction is a two-piece chest-on-chest arrangement with sliding doors and drawers in the top chest and a large cabinet with sliding doors in the bottom chest. One-piece styles were also made, but the two-piece chests must have been more popular since they are in greater abundance today. Kitchen chests are easily identifiable by sections of wire mesh, resembling chicken wire, built into a small hinged door and, sometimes, the sliding doors of the top chest. The wire mesh allowed ventilation where tea, food, and utensils were stored, and also kept out mice and large insects.

The sliding-door compartment and the hinged door, which is often bordered by several tiny drawers, occupy the upper part of the top cabinet. Below these sliding doors and hinged door are a series of horizontally spaced drawers of equal size. For the bottom cabinet, the most usual design is two large sliding doors that conceal a series of shelves and compartments. The sliding doors on both the top and bottom cabinets serve as identifying features of the kitchen chest: each door consists of a wooden frame holding thin vertical slats. Overall design is simple and functional since these cabinets were used daily in Japanese kitchens.

WOOD TYPE: Generally, kitchen chests have either cryptomeria or cypress boxes with zelkova faces for drawers and doors. Older, rural pieces having pine boxes and cryptomeria faces for drawers and doors can also be found.

METALWORK: These chests traditionally bear no metalwork other than drawer handles, which are most often of the *warabite* style, and iron studs used to secure the vertical slats to the sliding-door frame. The studs are placed symmetrically, with three or four appearing on each slat.

FINISH: Dark brown finishes are found on most kitchen chests of the late Meiji and early Taishō eras. Older pieces from the Edo period are not finished but through the years have developed a natural brown patina as the result of exposure and use.

DATING: These chests were produced from the middle of the Edo period through the early Taishō era. Later pieces exhibit more sophisticated woodworking than earlier, simpler pieces. For example, in later chests the sliding doors and/or hinged door containing wire mesh often display a horizontal slat of wood with a carved cut-out design of, usually, a flower or bird. Squat, rounded handles are often found on chests made after 1900.

REGION OF ORIGIN: In southern Honshu, the area around Hikone, near Lake Biwa, is a notable production center of kitchen chests, although production also occurred near Kyoto and Osaka. In northern Honshu, Iwate Pre-

fecture was noted for its large production of kitchen chests during the late Edo period and all of the Meiji era.

Medicine Chests
Kusuri-dansu

The Japanese medicine chest, or *kusuri-dansu* (Fig. 11), with its numerous, tiny drawers has become one of the most popular collectibles among small Japanese cabinetry. The chests were used as long ago as the tenth century by doctors and medicine peddlers, and in pharmacy shops, to store the many herbs, roots, tree barks, flower petals, tea leaves, powders, minerals, and even dried insects considered of medicinal value. It is reported that in the seventh century, Empress Suiko of Japan summoned a Korean medicine man to bring a supply of herbs to Japan, thereby beginning the development of Japanese herbal medicine. Likewise, the idea of the medicine chest was an import from Korea along with much of the knowledge concerning medical cures and procedures.

By the early sixteenth century, medicine chests were being produced and used on a wide scale in Japan. In addition to the stationary chests used in pharmacies and by doctors, portable models were used by traveling medicine peddlers in rural areas. Even as late as the 1950s, medicine was still being peddled door-to-door in the countryside, particularly in the Toyama region of northwestern Honshu.

CONSTRUCTION: Medicine chests vary in size, from small ones measuring about h. 31 × w. 46 cm to large ones of approximately h. 91 × w. 122 cm. Drawer configuration varies. Simple chests have numerous rows of tiny, identical square drawers, with perhaps one wide drawer or two adjacent narrow drawers at the bottom of the chest. More elaborate chests have a number of tiny square drawers in rows at the top of the chest, followed by several rows of slightly larger drawers, ending with two or three wide drawers across the bottom of the chest. Peddlers' chests were often constructed as two tall boxes connected with hinges along one vertical edge, so that the boxes opened like doors to reveal the small square drawers inside.

Often you will see paper labels, bearing Japanese writing, glued onto the drawer fronts or just over them on the frame of the medicine chest to indicate the contents of each drawer. Sometimes the names of the medicines have been carved into the wood of the drawers or painted in black directly onto the drawer faces.

WOOD TYPE: The most common wood type is paulownia, although some chests were built of cryptomeria. Paulownia, being lightweight, was popular for the portable models, which peddlers carried on their backs.

METALWORK: Very little metal is found other than drawer pulls and protective corner metal on the box. The drawers do not have locks, but a simple lock and lockplate may be evident on large drawers at the bottom of the chest. These large drawers always bear standard drawer handles, the most common

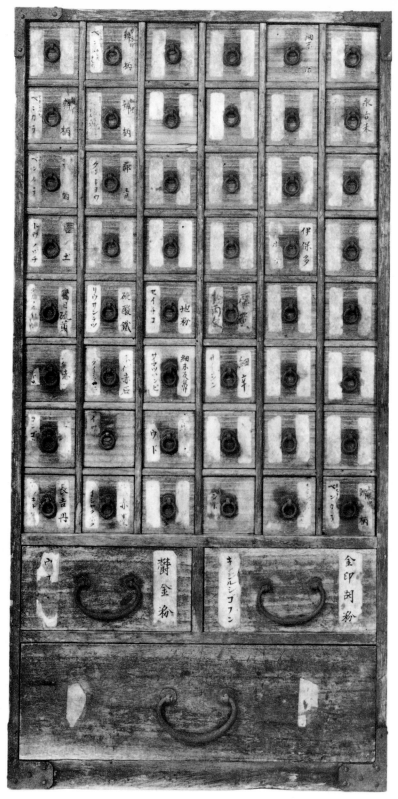

Fig. 11. Medicine chest, all paulownia. Mid-Edo period. H. 102 × w.
53 × d. 46 cm. Courtesy Hasebe-ya Antiques.

styles being *warabite* and *hirute*. The tiny drawers bear ring pulls of iron or copper. It is rare today to find a medicine chest with all its original drawer pulls, since the number of pulls for one chest and the potential for even one to become broken or lost over the years were great. If you plan to purchase one of these chests, examine it carefully to determine what, if any, of the hardware has been replaced.

FINISH: Medicine chests usually appear well-worn, and often dilapidated, from years of use. Since they were purely functional pieces, usually no stain or finish was applied so that the paulownia aged naturally, developing a warm, brown patina. In the case of peddlers' chests, the condition of the wood is often poor, with scratches and dents reflecting heavy wear and exposure. Even, smooth surfaces and a finished appearance are indicative of restored pieces.

DATING: Medicine chests were produced on a large scale early in the Edo period; they comprise some of the oldest of Japanese cabinetry. Although production declined greatly by the end of the Meiji era, it is still possible, even today, to find these chests in use in pharmacies in older sections of Tokyo.

AREA OF PRODUCTION: Because of their long history in Japanese life, these chests were produced locally in villages all over Japan by the beginning of the Edo period and continuing through the Meiji era.

Merchant Chests
Chō-dansu, Chōba-dansu

Multi-drawered and bearing heavy ironwork, the conveniently sized merchant chest (Fig. 12), *chō-dansu* or *chōba-dansu* in Japanese, is a favorite for homes and offices even today. The two Japanese names for this chest are used interchangeably to mean a tansu which belonged to a shop merchant, was kept in his shop in full view of the public, and was a receptable for his account books, ink and writing paraphernalia, and other papers and documents relating to his trade.

The merchant chest, because it was seen in the shop and represented the shop owner's prosperity, was constructed of good materials with heavy ironwork. Accordingly, these chests are quite appealing and are usually good investments.

CONSTRUCTION: The merchant chest is most often a single unit, although some two-piece versions were also produced. Normally it is quite sturdy in construction, containing numerous drawers of various sizes and one or two sliding door compartments of varying size and placement. Some merchant chests have a hinged double-door compartment rather than sliding doors (Fig. 13). In a typical chest, a single, wide drawer stretches across the top, beneath which a sliding door compartment and then a set of drawers are located. Along the right side of the chest runs a vertical series of three to five small drawers, some with and some without locks. If the tansu is of the variety containing two sliding door compartments, the second set of sliding doors is located at the bottom, usually extending across the full width of the chest. Sliding doors are either the standard type having flat panels inset into the door frames, or a type having hori-

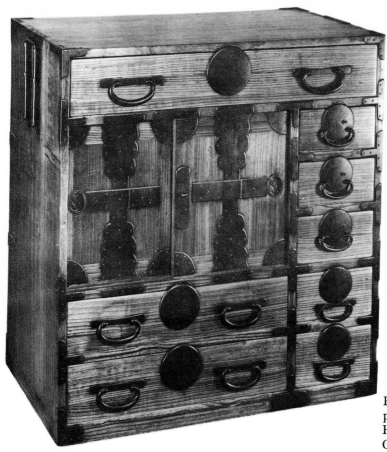

Fig. 12. Merchant chest, all paulownia. Late Meiji era. H. 82.5 × w. 79 × d. 39 cm. Clarke collection.

zontal or vertical slats across each door. The sides of some chests are also decorated with horizontal slats of wood.

The dimensions are fairly uniform. The standard single-unit merchant chest, for example, measures approximately h. 91 × w. 76 × d. 61 cm. It should be mentioned that wheeled merchant chests were also constructed and appear the same except for the integral addition of a wheel base.

WOOD TYPE: Since these chests were on display in shops, it was important that the wood be thick and of high quality. Most typical pieces are constructed entirely of paulownia, zelkova, or chestnut, or have drawer faces and sliding doors of one of these woods with the box(es) crafted of thick cryptomeria.

METALWORK: Thick, heavy metalwork is apparent and varies in style and artistry depending on the wood used and the area where the chest was built. Drawer handles can be in *warabite, kakute,* or *hirute* styles, and lockplates may be square or round or carved with a motif. Single-action locks were used on early chests, later changing to double-action locks. The top drawer always bears a lock, and the column of small drawers on the right is usually divided between those that bear small locks and those that do not. Iron carrying handles are attached to the sides of the chest. The sliding doors bear a vertical lock-receiving plate where an independent lock was formerly inserted.

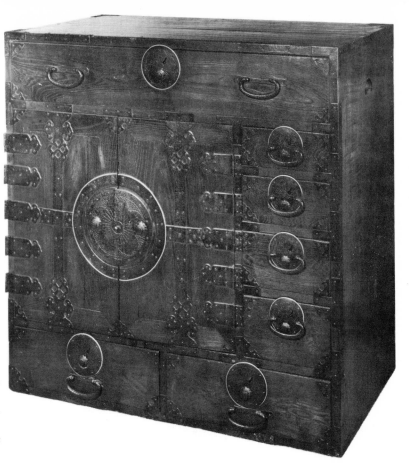

Fig. 13. Double-door merchant chest, one-piece, all zelkova. Note cherry blossom motif on lockplates. Late Edo period. H. 76 × w. 76 × d. 37 cm. Clarke collection.

FINISH: The finish depends on the wood type. In the case of paulownia chests, the natural wood was often left unfinished, though you can find restored chests of paulownia today to which a soft brown finish has been applied. Tansu constructed of the hardwoods zelkova or chestnut range in color from golden to reddish to dark browns. They were finished with natural lacquers to which natural dyes had been added.

DATING: Production began in the mid-Edo period and continued into the Taishō era. Construction and appearance did not change considerably during these centuries, except for local modifications. The earliest chests are constructed of extremely thick wood (at least 2.5 cm in thickness), with top and sides composed of single pieces of wood rather than parallel boards as seen in some later chests. Both drawer faces as well as the sides of the drawers are also about 2.5 cm in thickness, whereas later chests have thick drawer faces attached to slightly thinner sides. Metalwork is traditionally thick, but earlier chests are distinguished by simply designed handles and single-action locks.

REGION OF ORIGIN: Sado Island is where merchant chest production began in the mid-Edo period, but soon thereafter, these popular and highly sought-after chests were produced all along the northern Japan Sea coast, especially in the Niigata area.

Sea Chests
Funa-dansu

Among the smallest and most expensive of all Japanese furniture, these portable tansu, called ship's safes, sea chests, or captain's chests in English, are particularly impressive due to their construction of rich hardwoods and elaborate, heavy, carved metalwork. Dealers often tell you that sea chests (Figs. 14, 15) are rare, and thus demand higher prices. And, indeed, a limited number of these chests are encountered when perusing the offerings of antique shops and flea markets. In addition to the limited production of these chests, their sturdy construction, expensive hardwoods, and thick, hand-cut metalwork, all contribute to their high prices and value.

As their name suggests, some of these chests were used to safeguard valuables, documents, and money on Japanese ships that sailed in the Japan Sea during the Edo period and Meiji era. Others were used on land by sea trade merchants to store personal items. Commonly, these chests bear a family crest or a company's trademark on the face of the door, indicating that the piece was custombuilt. Three basic styles of chest evolved, but within these styles a wide variety of designs, construction, and decoration existed. Craftsmen applied their finest

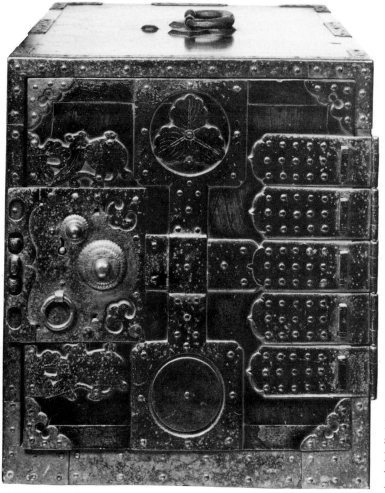

Fig. 15. Sea chest, *chō-bako* style, all zelkova. Mid-Edo period. H. 48 × w. 56 × d. 41 cm. Courtesy Hasebe-ya Antiques.

Fig. 14. Sea chest, *kakesuzuri* style, all zelkova. Mid-Edo period. H. 46 × w. 41 × d. 51 cm. Courtesy Hasebe-ya Antiques.

skills and artistry to these chests to produce some of the most handsome pieces found in the entire range of Japanese furniture.

CONSTRUCTION: Sea chests were constructed as small, sturdy boxes of which three distinct styles evolved. The *kakesuzuri* style consists of a box—approximately h. 46 × w. 41 × d. 51 cm—with a single door on hinges that opens to reveal a series of inside drawers (cf. Fig. 14). The *hangai* style—approximately h. 46 × w. 76 × d. 41 cm—has a full-sized front door that lifts off the chest. The interior contains several long drawers. The third style, *chō-bako*, usually measures about h. 48 × w. 56 × d. 41 cm (cf. Fig. 15). *Chō-bako* chests were quite diverse in design, but the most common configuration shows a box with a single horizontal drawer at the top front of the chest and doors beneath. These doors might be of the sliding type or of the double-door swinging type with hinges. Some *chō-bako* contain another level of drawers along the bottom of the chest front.

WOOD TYPE: Hardwoods, zelkova or chestnut, were favored for the box, doors, and drawer fronts of the exterior. The interior is often constructed of paulownia, if not the same hardwood as the box and exterior.

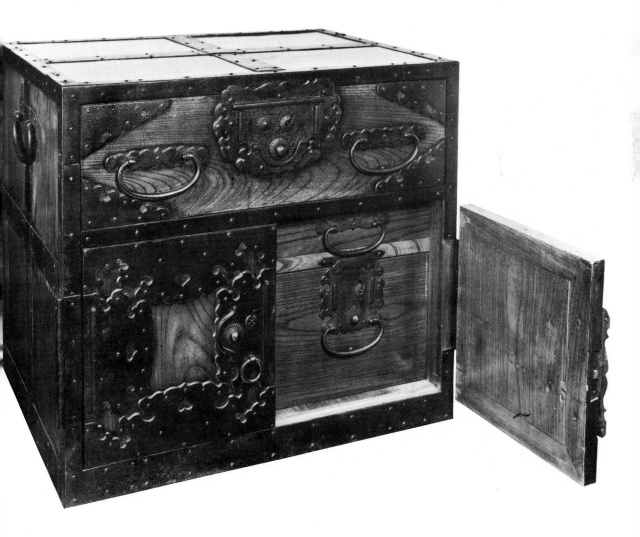

METALWORK: A rich array of highly decorative metalwork is evident on all styles of sea chests. More valuable chests exhibit very heavy (about 3 mm thick), hand-cut iron decorating door fronts and/or exterior drawers. Lockplates and decorative metal are made of heavy, hand-forged iron. Exterior drawer handles most often appear in the square *kakute* design, though some pieces have *warabite* handles. Interior drawers have either *hirute* handles or square handles resembling the exterior drawer handles. The door hinges are heavy and often carved in a motif matching the exterior decoration. *Kakesuzuri* chests have an iron carrying handle attached to the center of the chest top. The *hangai* and *chō-bako* styles have carrying handles on both sides of the chest. Some sea chests are entirely covered with a gridlike pattern of iron strips, which may be worked diagonally. It is said that these strips of iron were added to provide connecting support for the sections of wood forming the box of the chest. Since the wood pieces are extremely thick and heavy and since sea travel entailed much stress and movement, it is easy to see why craftsmen would brace the boxes. A family crest or trademark carved into a circle of metal may adorn the chest doors. The metal used is either brass or the same iron that appears elsewhere on the chest.

FINISH: Finishes range in color from rich honey browns to deep reddish browns. Since beautifully grained hardwoods were employed for the boxes and fronts, raw-lacquer-based finishes, sometimes combined with natural dyes, were applied so that the wood grain, often burled, would show through in striking contrast to the black iron decoration.

DATING: The earliest sea chests were built around the mid-Edo period, and production continued through the Meiji era. The oldest style is the *kakesuzuri*, which was first introduced in the mid-Edo period. From the end of the Edo period through the middle of the Meiji era, the *hangai* and *chō-bako* styles were also produced. With changes in governmental policies in the middle of the Meiji era that limited the size of ships and reduced cargo capacity, sea chest production started to decline, though some land-use models for sea trade merchants continued to be built. By the end of the Meiji era, however, production of all types was almost at a standstill.

REGION OF ORIGIN: Chests were produced along the Japan Sea coast at Ogi (on Sado Island), Sakata (Yamagata Prefecture), and Mikuni (Fukui Prefecture). These areas continued to dominate production throughout the Meiji era. According to many antique furniture dealers in Japan, a plentiful supply of old sea chests exists today on Shikoku and Kyushu, where many of these chests were apparently abandoned by travelers and traders who traversed the Japan Sea and Inland Sea.

Staircase Chests
Kaidan-dansu

To the person just beginning to explore antique Japanese furniture, the *kaidan-dansu,* or staircase chest (Figs. 16, 17) is one of the most delightful of discoveries.

A freestanding staircase with built-in storage compartments, this type of chest was used, most often in rural areas, to connect the ground floor and the loft of a home or shop. The large two- or three-piece staircase chest would have been used in large houses or shops, whose ceilings were higher than those of urban houses. As the staircase idea evolved during the late Edo period, clever craftsmen also realized the space efficiency of building compartments into the body of the staircase. In old Japanese shops, the chest stored goods and supplies, while in homes it was used for household articles. Today, innovative owners often use these chests as handsome freestanding libraries, with books, plants, and other objects arranged on the steps, while using the interiors for everything from stereo cabinets to closets for out-of-season clothing.

CONSTRUCTION: These freestanding staircase chests were built in three major styles: (1) as a single unit, (2) as a two-piece stacking chest, and (3) as a three-piece stacking chest. Some single-unit chests sold today are actually the top

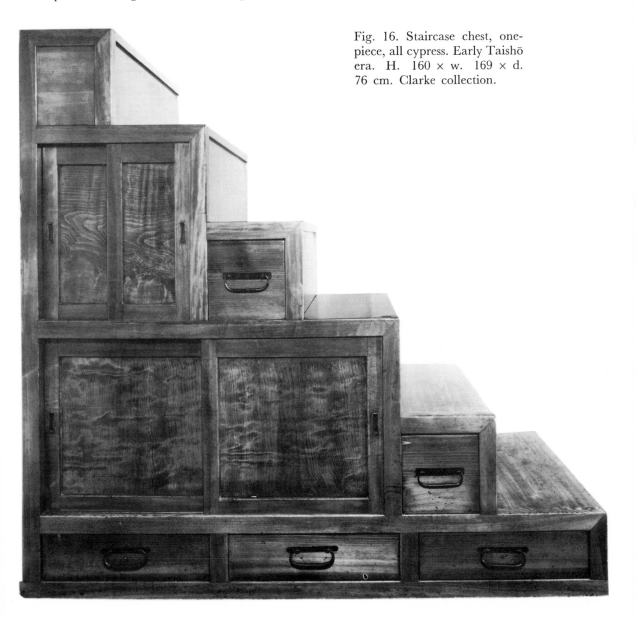

Fig. 16. Staircase chest, one-piece, all cypress. Early Taishō era. H. 160 × w. 169 × d. 76 cm. Clarke collection.

piece of a two- or three-piece chest. (See Chapter 2, Alterations, for how to determine whether this is the case.)

The number of steps on these chests varies, but generally, the single-unit chest has six or seven steps. The two-piece chest, usually, has a combined total of eight or nine steps. The three-piece chest is rarely found these days, but if encountered, it will be quite tall (about 220 cm) and narrow, with a combined total of ten or eleven steps. The (genuine) single-unit chest comes in various heights, ranging from about 122 to 168 cm. Depth (same as step width) varies for all types of staircase chests, but the average is about 76 cm. It should be noted that some very small single-unit chests (a bit over one meter in height) were also custom-built, but they are scarce today.

Compartmentalization varies from chest to chest. The average single-unit or double-unit chest usually contains two sliding door compartments, one at

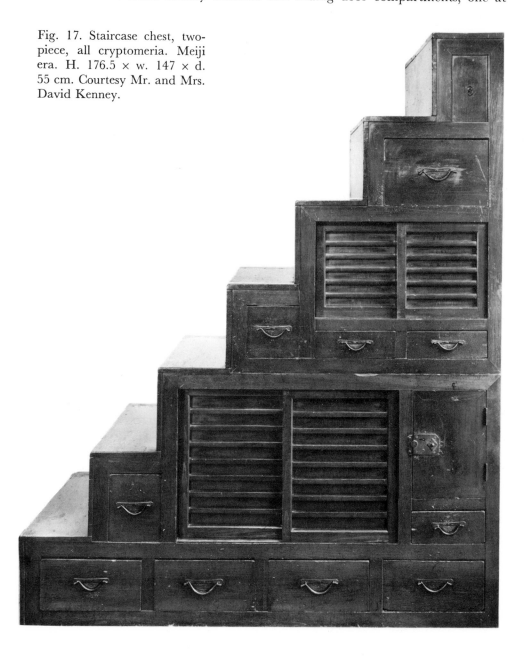

Fig. 17. Staircase chest, two-piece, all cryptomeria. Meiji era. H. 176.5 × w. 147 × d. 55 cm. Courtesy Mr. and Mrs. David Kenney.

the bottom of the tansu and another near the top. Drawers of various sizes are arranged in the areas around the sliding door compartments. Drawers are plain and undecorated, though vertical or horizontal wooden slats often appear on the sliding doors. The three-piece chests are often constructed as two staircase units with a chest of drawers in between.

Because these chests were special-ordered by families and shopkeepers to fit specific spaces, both models having stairs rising from left to right and those having stairs rising from right to left are available. Similarly, you too should consider carefully the direction of the stairs of the chest before purchasing it to make certain it conforms to the wall space and area where you plan to use it. The back of the chest (surface opposite the drawers) and the tall side (surface opposite the steps) are not finished, and their rough surfaces will show if the tansu is not stationed properly in the corner of a room.

WOOD TYPE: Because these chests required a lot of wood in their making, and since they were associated originally with rural use, expensive hardwoods were not used for the large frame but rather were often inset in the sliding doors or used as drawer fronts. The most commonly used woods were cryptomeria, cypress, and, in crude, country chests, pine. Extremely rare, but quite valuable, are staircase chests built entirely of a hardwood such as zelkova or chestnut.

METALWORK: Only metalwork associated with necessity is evident, that is, handles for the drawers, small indented finger grips set flush into the sliding doors, and, if a door is present, hinges and a simple iron lock. However, the degree of artistry on the metalwork varies from very simple *hirute* handles on one piece, to carved handles bearing an intricately carved dragon motif on another. Drawer handles have either a small handleplate or round handle disks at the base of each handle.

FINISH: Almost all original chests found today appear quite dark in color; although their original finishes were lacquer-based, they usually appear matte rather than glossy (except for the steps, which are polished smooth from years of use). Those which have been restored may have been treated with a finishing agent, which yields a highly polished surface. Many people prefer the dark, rough look of the original finish and choose to leave the finish as is unless structural restoration or refinishing is necessary.

DATING: Staircase chests evolved during the late Edo period in rural areas for local use. Earlier pieces may seem ungainly at first sight, with their height appearing disproportionately tall in relation to their width and length. Pine chests are usually older than those made of cryptomeria or cypress since pine was the wood most often used in the countryside, where these chests originated. Since the majority of the chests are built of cryptomeria or cypress, and since no major changes in construction and style occurred during the Meiji era, it is sometimes difficult to determine age, although thick wood for steps and drawer fronts usually indicates an older chest. Newer tansu show more modern metalwork—for example, drawer handles in the *gumbai* style rather than the older *warabite* or *hirute* styles.

REGION OF ORIGIN: Staircase chests originated in northern Honshu—specifically, the regions around Sendai, Niigata, and Yonezawa, and much of Iwate Prefecture. The reason for their development in these areas probably stems from the fact that the spacious country homes and shops in the north were constructed with a large space between the ground floor and the loft, which necessitated a staircase. (In late Meiji, some staircase chests were built for use in the southern areas of Japan, but they were typically smaller and more compact.) Later, production spread to Gifu, Toyama, Fukui, and Ishikawa prefectures as the influence of furniture craft from the Japan Sea coast reached these regions.

Trunks
Nagamochi

Early in the history of furniture development in Japan, trunks (Fig. 18) were being built in many sizes for many purposes. Their primary use in Japanese homes was for the storage of futon (quiltlike bedding) that was not in use as well as other cloth items such as blankets and floor cushions.

Two styles were used by the samurai class during the Edo period: (1) a family chest for storage, which is finished in black lacquer with a family crest stenciled in gold or red onto the front of the box, and (2) a small chest used as a costume box by nobles who studied Noh, which is unfinished except for a family crest stenciled in black on the front. During the Meiji era, simple unfinished chests were owned by people of all levels of society.

CONSTRUCTION: The trunk is a four-sided rectangular box with a hinged lid on top. Some trunks have two or three small drawers built into the bottom portion of the front of the chest. The tops, or lids, of the trunks are either slightly domed or flat.

Standard trunks are large, owing to their use for storing bulky bedding. Normally, dimensions run about h. 91 × w. 152 × d. 76 cm. The top, sides, and bottom are all of either single-piece construction or fitted-piece construction.

It should be noted that some shorter trunks were produced. These pieces are also called *nagamochi* even though it is somewhat of a contradiction in terms since *naga* means "long" in Japanese. Double trunks were produced as well, the usual form being two stacking trunks of identical dimensions. The combined height reaches about 152 cm, indicating that the height per piece is slightly smaller than the 91 cm of the average single-unit trunk. One other variation that developed was a trunk on wheels, which became known as a *kuruma-nagamochi* (Fig. 19). It can be easily distinguished from other wheeled chests discussed in this chapter by its lack of doors and drawers.

WOOD TYPE: Because they were used for storage of cloth items, many trunks, especially older ones, were made of paulownia, the wood traditionally used for storage of kimono and other fabric goods. However, a large number of trunks built of cryptomeria can be found. Unless specially ordered by a wealthy family, these chests were never constructed of hardwoods. Today, most pieces

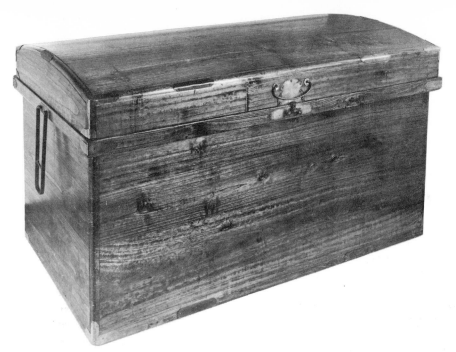

Fig. 18. Trunk, all paulownia. Copper fittings (excluding side handles) and all-paulownia construction indicate that the trunk belonged to a wealthy family. Mid-Meiji era. H. 74 × w. 140 × d. 70 cm. Clarke collection.

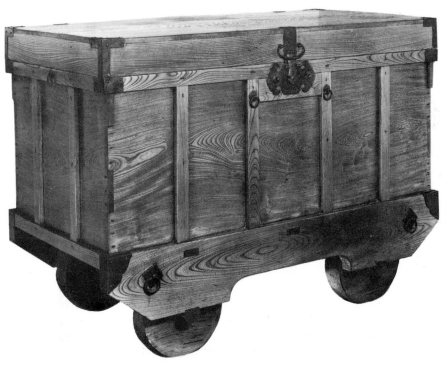

Fig. 19. Wheeled trunk, all zelkova. Late Edo period. H. 98 × w. 141 × d. 70 cm. Clarke collection.

you find, both early and later items, are constructed of either paulownia or cryptomeria.

METALWORK: A minimum of metalwork is used since construction is plain and simple and since the trunk was traditionally hidden away rather than kept out where it could be seen. Metal corner pieces appear at the corners for protection. If drawers are included at the bottom, they will bear plain, usually *warabite*, handles. A rectangular, iron carrying handle is always attached to each end of the trunk. A lock and handle (for raising the lid) are located in the middle front edge of the lid. Occasionally, thin vertical iron strips run down the front of the chest at two points equidistant from the sides. While iron is most common, some (usually paulownia) chests bear copper metalwork. Whether of iron or copper, the metalwork is simply designed with little artistry involved.

FINISH: With the exception of the lacquered trunks of the samurai, paulownia and cryptomeria trunks were left unfinished. Those sold in shops today have often received an application of stain or finish, which gives them a feeling of warmth and makes them more suitable for non-Japanese homes, where unfinished furniture is usually not used.

DATING: Trunks are among the first Japanese cabinetry developed, since simple boxes were the form which gave rise to the development of other styles and compositions. However, many early pieces did not survive because of their simplicity: they bore no particular features to be treasured by their owners. To the contrary, they were considered purely functional, and were discarded and replaced as the need arose.

As is the case with other old tansu, the metalwork offers some indication of age. Heavy ironwork indicates an older trunk. Likewise, a trunk composed of thick planks of wood is usually older. Since the trunks were neither stained nor finished, assuming the wood is still in its original, natural condition, newer trunks are quite light in color on the outside compared to the mellowed patina of older pieces. If the nails used at the seams are flatheaded, metal ones, the trunk is probably less than fifty years old. Older trunks have wooden pegs joining the seams.

Older paulownia chests are constructed of single pieces of wood for the sides, top, and bottom. However, cryptomeria trunks, both early and late models, show either pieced-wood or single-plank construction for the top, sides, and bottom.

Lacquered chests bearing stenciled family crests usually date to the Edo period and are not often found.

REGION OF ORIGIN: Most researchers tend to agree that trunks probably first evolved along the Japan Sea coast, between Yamagata and Niigata. The point of their origin is not too significant, however, since they were eventually produced in all of the tansu-producing regions of Honshu during the Meiji and Taishō eras. Additionally, since construction was so simple, many trunks were made non-professionally, by people other than carpenters, indicating that they were produced everywhere.

Wheeled Chests
Kuruma-dansu

Although the Japanese put wheels on cabinets for entirely utilitarian purposes, these wheeled chests (Fig. 20) today are favorites among collectors, who find them an interesting contrast to the many other styles of Japanese tansu. *Kuruma-dansu,* as they are called, became so useful and popular among the Japanese themselves that today you can find examples of cabinets to which wheels were obviously added at some point after construction to make the chests more convenient to use. Original wheeled chests—that is, those whose original design included a built-in wheel base and wheels—have a specially constructed bottom which is different from that of chests to which the wheel base and wheels were added later. (See Chapter 2 for an explanation of this difference.) The only exceptions are crude, rural chests and some early-Edo chests, both rather rare, in which the wheel base is an original part of the chest but constructed differently from that illustrated in Figure 34. Wheeled chests were used in both shops and

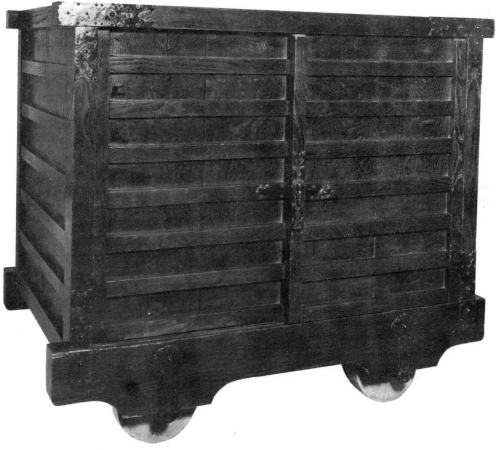

Fig. 20. Wheeled chest, all chestnut. Mid-Edo period. H. 103 × w. 122 × d. 72 cm. Clarke collection.

homes, so a variety of styles evolved with the basic form of a box on wheels. Those built for use in rural areas are plain but lovely, while those used by wealthy merchants or in the homes of the rich were more elaborately constructed, with the addition of purely decorative wood carving and/or metalwork.

CONSTRUCTION: The basic form consists of a large, four-sided cabinet built with a base containing four large wooden wheels. Horizontal support bars of wood are built into the frame along the top and bottom of the front and back of the chest, and extend slightly beyond the edges of the chest. While rural models appear simply as a large box with two sliding doors, chests built for the wealthy often include two or more drawers at the bottom of the chest just below the sliding doors, and sometimes a small, hinged door compartment. A few styles have no sliding doors but a set of drawers instead. And still others exhibit a prominent drawer arrangement with a small set of sliding doors, perhaps placed off to one side. However, these latter two types are regional variations; the standard style is that of prominent sliding doors with or without inner drawers and/or a door compartment. Interiors vary, with different arrangements of shelves and/or drawers inside. The sliding doors often display a series of horizontal slats spaced evenly from top to bottom. On many chests, the horizontal slat pattern is repeated on the side panels of the chest. Sizes vary from large to small, with dimensions either square or slightly rectangular in the direction of either height or width. (Do not confuse these wheeled cabinets with long, simple trunks on wheels, called *kuruma-nagamochi,* which are discussed under Trunks.)

WOOD TYPE: A variety of woods, excluding paulownia, were used. All-cryptomeria construction is common among rural chests, while others are made entirely of zelkova or have cryptomeria cases with zelkova faces and frames.

METALWORK: Metalwork is almost always minimal. A short vertical strip of iron and a short horizontal strip intersect at the midpoint of the two sliding doors. The vertical strip forms the backplate for the lock, and the horizontal strip bears a latching knob. Two iron receiving pegs extend through the vertical strip to the outside of the door to hold a large, separate lock. (A lock is rarely sold with the chest, however.) On fancier pieces, additional iron is located at the ends of the horizontal support bars and on the doors, if any are present. Often two iron loops with raised backplates are found along the bottom support bar. In former times, a rope was threaded through these loops to assist in pulling the chest. If the chest has drawers, the drawer handles will be of the curved *warabite* style, without backplates.

FINISH: The color of the finish varies depending on the wood used. Cryptomeria chests are usually quite dark, while the lacquer-based finishes of zelkova chests range from medium to reddish browns that don't obscure the hardwood grain.

DATING: Wheeled chests emerged between early and middle Edo, making them some of the oldest chests still found today. They were built in great quantities until the middle of the Meiji era when production leveled off quickly with the emergence of mass production techniques, which were used to create other,

more easily constructed tansu instead of these massive, old-fashioned chests. Early pieces are identified by thick, solid boards of zelkova wood and simple, heavy, impressive ironwork. Old rural pieces are primitive, but solid, in appearance, most often with the series of horizontal slats on the sliding doors continuing around the sides of the chest (cf. Fig. 20). The top of most wheeled chests is composed of two long boards placed lengthwise, or three or four panels placed widthwise.

REGION OF ORIGIN: Wheeled chests were produced at major tansu-production centers throughout Honshu, but the majority originated in northern Yamagata and Iwate prefectures.

SMALL FURNITURE

Hibachi
Hibachi

Although the hibachi, or brazier, originated with the ornate bronze pots on legs developed by the Chinese, the Japanese are usually credited with the development of the wooden hibachi. The earliest wooden hibachi used by the Japanese were rough cross-sections of thick tree trunks hollowed out and lined crudely with clay.

Early records show that during the Heian period hibachi were made of clay-lined cypress. These *hibitsu* as they were called (*hi* for fire and *bitsu* for coffer), were prevalent among the households of the nobility. It wasn't long before craftsmen began to improvise and apply their skills to these rough-hewn braziers. Some were decorated with carved Chinese characters or scenes, while others were rounded and polished by hand or carved into a pumpkin shape. After the development of lacquer techniques, it was fashionable to apply black, brown, or red lacquer finishes on round wooden hibachi. These lacquered hibachi were commonly found in temples and upper-class homes. Gold-leaf inlay, quite often of a bird-and-flower motif, also became popular for paulownia and cypress hibachi of the wealthy.

Hibachi of all sizes and descriptions played an important role in Japanese life, and the wooden *naga-hibachi* (literally, "long fire box"), popular in the nineteenth century, brought hibachi development to a peak in terms of design and execution. It was also at this time that Japanese potters produced numerous hibachi of blue-and-white porcelain. By the beginning of the Meiji era, hibachi were being made of wood, porcelain, and bronze, with designs ranging from the highly elaborate to the simple. Because of its popularity, the *naga-hibachi*, recognized by its rectangular shape, is the focus here.

Although the traditional role of hibachi in Japanese life was ostensibly to provide heat, they were also important from a social viewpoint. The offering of tea was (and still is) a significant part of Japanese hospitality, and the hibachi played the role of always keeping water hot for the unannounced arrival of guest or customer. A guest served tea was also seated close to the hibachi for warmth in winter, and incense sticks were sometimes stuck into the coals of the hibachi to give off a pleasant aroma for the enjoyment of the guest. In this

manner, for example, would a merchant and his client conclude their business over a cup of tea.

Likewise, since entertainment was taken care of outside the home, every establishment, from noodle shop to geisha house, had some form of hibachi for the comfort of its clientele. And in the Japanese home, the hibachi was important as the family gathering place. Japanese homes relied on hibachi as the main means of heat during cold months, so it was near the hibachi that families talked, ate, drank tea, and slept. And, as pictured occasionally in old Japanese scrolls or screen paintings, the master of the house enjoyed the privilege of sitting in closest proximity to the hibachi, where he might smoke, drink sakè, or enjoy other leisure pastimes.

Wooden hibachi are still used today in some rural areas of Japan, but in the cities heating methods have kept pace with the demands for comfortable modern housing—central heating or gas and electrical heating devices are the norm. Water for tea is boiled on a stove, and family life in Japan, as in many modern societies, has undergone decided changes in a direction away from the cohesiveness that was customary in the heyday of the hibachi.

CONSTRUCTION: *Naga-hibachi* produced during the late Edo period and Meiji era come in two basic styles. The Tokyo, or Edo, style (Fig. 21) is of simple design, with straight sides, and has small drawers arranged down one side of the front of the box, or across the bottom of the box, or in a combination of both. The Kyoto style (Fig. 22), also called *daiwa hibachi,* is similar in shape, but includes a thick shelf, or lip, around the top rim of the box. Like the Tokyo-style hibachi, the Kyoto hibachi contains drawers arranged in one of the three typical configurations.

The average size of *naga-hibachi* in either the Tokyo or Kyoto style is about h. 38 × w. 81 × d. 46 cm. The square indentation for the coals is fitted with a copper liner. At about the time *naga-hibachi* began to be produced on a large scale, various accessories for use with hibachi were also being made. Small, lidded boxes stored loose tea or incense. Small stands of copper or brass held a kettle for heating water for tea or sometimes a lidded box filled with hot water and set over the coals to heat small bottles of sakè. These accessories may or may not be included when you buy a hibachi. A compartment with a lift-off cover to one side of the copper receptacle stored pipes or other smoking materials.

WOOD TYPE: Predominantly zelkova and chestnut were used for *naga-hibachi.*

METALWORK: The only metalwork appearing on *naga-hibachi* are handles for the small drawers, quite often made of copper or brass although iron handles are not rare. The receptacle for coals was always made of copper; most *naga-hibachi* for sale today are fitted with new copper liners since original ones receiving a lot of use eventually corroded.

FINISH: Original finishes are usually of a brown hue. After years of use, the wood attains a mellow patina resulting from exposure to heat and smoke, sometimes obscuring the beautiful grain of the hardwood. Restored finishes are lighter, in order to show off the wood grain.

Fig. 21. Hibachi, Tokyo style, all zelkova. Mid-Meiji era. H. 38 × w. 84 × d. 46 cm. Courtesy Mr. and Mrs. W. M. Thompson.

Fig. 22. Hibachi, Kyoto style, all zelkova. Mid-Meiji era. H. 41 × w. 84 × d. 43 cm. Courtesy Hasebe-ya Antiques.

DATING: *Naga-hibachi* were produced abundantly throughout the nineteenth century. The use of thick pieces of hardwood in construction usually indicates an earlier rather than later piece. Dovetail joinery was used most of the time at corners, but earlier *naga-hibachi* sometimes show a plain, lap-butt joint.

AREA OF PRODUCTION: The two distinct styles of *naga-hibachi* originated in Tokyo and Kyoto, respectively, but were later copied in other parts of Japan. Large *naga-hibachi* were used primarily in shops, so were probably developed in proximity to areas of commercial activity. Smaller, portable *naga-hibachi* for use in homes were produced at many locations on Honshu.

<div align="center">

Kotatsu Stands

Kotatsu Yagura

</div>

Kotatsu are the small Japanese fireplaces that replaced the original *irori,* or large, square, sunken fireplace formerly built into the center of a tatami room or into the wooden or dirt floor of a kitchen. A wooden stand resembling a small table, called a *kotatsu yagura* (Fig. 23), was placed over the *kotatsu* area to support a cotton quiltlike cover. The wooden stand itself has also become popularly known as a *kotatsu,* though technically the term is not accurate.

Kotatsu stands have a long history, and though the charming wooden ones of the past are rarely used these days in favor of modern replacements, they were at one time an inseparable part of Japanese home and shop life. The placement of the *kotatsu* stand in earlier times was over a squared, sunken fireplace, but eventually the stand was placed over a hibachi, most often a round porcelain one, where coals were kept burning for warmth. The *kotatsu* stand was placed directly over the hibachi, and then a coverlet was spread over the top. The coverlet contained the heat, providing a warm place to sit. Today, old wooden *kotatsu* stands are often converted by imaginative owners into useful, attractive tables by simply placing a piece of glass over the open gridwork on top.

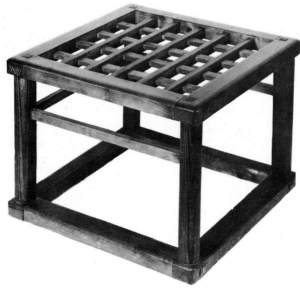

Fig. 23. *Kotatsu* stand, all cryptomeria. Late Meiji era. H. 33 × w. 46 × d. 46 cm.

In rural areas of Japan, new wooden *kotatsu* stands are still made. However, general use of these stands had decreased greatly by 1940, and after World War II, new materials were substituted for the wood—resulting in the aluminum stand with laminated tabletop popular today.

CONSTRUCTION: The *kotatsu* stand looks like a small, square, low table constructed of wooden slats on the top, which form an open grid. The four legs rest on a base composed of a square frame of wood that is the same dimensions as the "table" top.

The basic style of these stands remained the same over the years, with only small changes or innovations, such as the use of double cylindrical legs at each of the four corners or artful joinery at the corner seams. Iron nails were never used in *kotatsu*; only wooden dowels are found, supplemented by wood joinery. In general, the *kotatsu* stand retained its basic form and style over the years. The thickness of the wood used in the frame often varies, with cheaper stands made of thin, lightweight pieces of wood and more valuable stands constructed of thick wood.

The size of the *kotatsu* stand ranges from very small, about 23 cm square, to quite large, up to 91 cm square. The standard model measures about 46 cm square and 35.5 cm high. Height for all sizes of stand measuring 46 cm square and over is about the same since the same height was required for comfort in sitting around the stand. Very small stands, those ranging in the 23- to 30-cm-square category, most often have a height that approximates the width of the top. These very small stands were used only in warming the feet, whereas the cover over the larger ones could accommodate the entire legs of people sitting around the *kotatsu*.

The small stands, which were designed for portability, usually have a bottom, or floor, built into the frame. This construction allows for a small hibachi to be placed directly inside the stand (through means of a lift-up or vertically sliding door) and allows for easy moving of the stand and hibachi together.

Occasionally you may find *kotatsu* stands to which a floor, or bottom piece, has been added at a later date. This piece is most often a piece of iron, installed to protect the tatami floor from the heat of the hibachi. Unfortunately, these iron floors are usually nailed to the wooden stand indiscriminately, but they can be removed to restore the stand to its original design. *Washi*, or handmade Japanese paper, may line the bottom floor of the small *kotatsu*. These *washi* linings can be quite attractive, especially if the paper is decorated with calligraphy as it often is.

WOOD TYPE: The woods most commonly used for all types of *kotatsu* stand were cryptomeria and cypress. The stand was covered when in use, and was also susceptible to burn marks (sometimes evident as blackened lines, holes, or splotches) due to its proximity to the heat; thus, expensive hardwoods were not considered suitable as a construction material.

FINISH: The stands were not stained or finished, but the cryptomeria naturally darkens to a deep brown from exposure to the coal heat and smoke over the years.

DATING: *Kotatsu* stands were produced from the late Edo period through the Taishō era. Since style remained uniform during this time, dating can be difficult. In general, however, sturdily built stands of thick cryptomeria are probably Meiji pieces, and stands of thinner cryptomeria are most likely newer pieces. Cylindrical legs indicate late-Meiji and Taishō stands as opposed to the squared legs of earlier pieces. Most stands found today date from about 1900.

AREA OF PRODUCTION: *Kotatsu* stands were produced locally in villages all over Japan.

Money Boxes
Zeni-bako, Zeni-dansu

In the Edo period, the Japanese government distributed a small copper coin known as *zeni*, which was used throughout this period of some 260 years. The storing of *zeni* and other coins, especially by merchants, and the receiving of them as payment in public places necessitated the development of a money box, or safe. Simply designed boxes for this purpose are known as *zeni-bako* (Fig. 24), while the larger boxes, resembling small chests with drawers, are called *zeni-dansu*.

The Japanese developed a large range of boxes for safekeeping valuables, documents, and personal belongings in both homes and shops. Quite often the term money box is used indiscriminately to refer to any small box that contains a drawer or hinged top with a lock. The piece of furniture most frequently mistaken for a money box is the *suzuri-bako*, a very small, portable, lightweight chest that was used in shops during the Edo period and Meiji era to store ink, an inkstone, writing brushes, bills, and receipts. The chest's name is derived from *suzuri*, the inkstone against which the sumi inkstick is rubbed with water

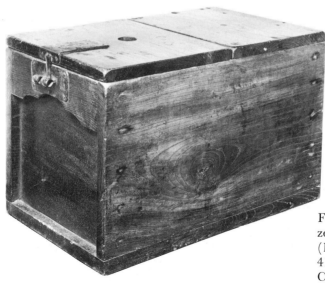

Fig. 24. Money box, all zelkova. Mid-Edo period (1772 inscribed inside). H. 41 × w. 61 × d. 33 cm. Clarke collection.

to form ink. These *suzuri-bako* most often have a locking hinged lid and a deep drawer with a small lock. It's quite likely that the locking drawer may have stored private or important papers; it probably would not have been used, however, to store money.

One way to differentiate money boxes and chests from *suzuri* boxes is to lift them. Money boxes and chests are extremely heavy even though small in size. The *suzuri* box, however, can be lifted quite easily, and is smaller overall than the money box or chest. *Suzuri* boxes always bear a small iron carrying handle on the top. If money boxes or chests have carrying handles, they are usually located on the sides. When you are looking at a small box, ask about its former use and compare its features with other boxes whose uses you know.

CONSTRUCTION: The *zeni-bako*, literally "money box," appears in three basic styles:

1. Plain rectangular boxes (average size: approximately h. 41 × w. 61 × d. 35.5 cm) with a simple slot or hole in a top composed of two sections of wood and a lock where the top meets the front end of the box. (Unlocking the padlock and removing the section of wood on top to which the lock hasps were attached allowed for easy access into the box.) Figure 24 is of this style.

2. A rectangular box with no slot, bearing only a lock where the hinged top, a single piece of wood, meets the box.

3. A rectangular box built with a wooden funnel (*masu*) on top for catching dropped or tossed money, used especially at temples and other public places.

The *zeni-dansu*, literally "money chest," bears small drawers, a typical configuration of which is one large drawer with two smaller drawers adjacent. Some, however, also have a small door with a lock, which opens to two or three small inside drawers. Key-operated locks appear on most of the drawers.

Some *zeni-bako* and *zeni-dansu* have secret drawers inside, while the chest style often has a secret storage compartment or area concealed behind a regular drawer. When old *zeni-bako* or *zeni-dansu* are purchased today, a few old coins may still be found lingering in one of these secret compartments.

WOOD TYPE: Fitting to their purpose—safekeeping money and coins—these boxes were always sturdily constructed of thick hardwood, either zelkova or chestnut.

METALWORK: If metal fittings appear on *zeni-bako* they are simple, usually consisting of very large iron studs near the side seams of the box. A simple lock or an iron hasp for receiving a lock will be evident where the top meets the front end of the box. Fancier boxes bear decorative iron strips on the top and may have the name of a merchant or a temple (if it was a temple collection box) carved into the front. On some, sturdy iron carrying handles of the *warabite* style are attached to both sides.

On *zeni-dansu,* iron corner fittings are evident on the box, and drawers bear either small handles or ring pulls. If a door is present, it usually is decorated simply with iron strips. Iron hinges attach the door to the box. At least one, and sometimes all, of the drawers bear iron locks and lockplates. A favorite motif for lockplates is, appropriately, the money pouch. *Zeni-dansu* most often have stout iron carrying handles (most often *warabite* style) on both sides.

FINISH: The hardwoods of money boxes and chests usually show dark brown, matte lacquer-based finishes.

DATING: Practically all money boxes and chests found today date to the middle to late Edo period, although some pieces produced in the early Meiji era follow the same style and construction. With the greater use of paper money in the Meiji era, the need for money boxes declined, and by the Taishō era, when Western ways were being adopted rapidly, wooden cash registers began to replace these boxes.

AREA OF PRODUCTION: Production of money boxes and chests in the Edo period was probably centered in areas of active trade and commerce—most likely the busy ports along the Japan Sea coast and the Kantō area. Later, production and use spread throughout Honshu.

Sewing Chests
Hari-bako

Every culture has its sewing boxes, baskets, or chests. The Japanese created a very efficient, tiny chest of drawers called *hari-bako* (*hari* for pin or needle, and *bako* for box). In addition to its function of storing sewing equipment, the Japanese sewing chest (Fig. 25) has also been traditionally associated with the safekeeping of small amounts of money, which the housewife hid away in the tiny drawers for special occasions or purposes. It is probable that modern housewives in Japan still save money by tucking it away in their sewing chests.

CONSTRUCTION: The sewing chest is simple, compact, and square or slightly rectangular, constructed with two tiny drawers across the top front of the chest and three larger drawers in succession beneath. It is easy to identify Meiji and Taishō chests because of a raised stand on one side of the chest which supports a small pincushion built into a tiny box. The stand also serves as a convenient upright arm for draping and holding kimono fabric in place while it is being sewn. Sometimes the pincushion box has a small wooden cover and often a tiny drawer built in beneath. The average size is approximately h. 46 (including pincushion stand) × w. 20 × d. 20 cm.

Practically all sewing chests made during the Edo period have a pincushion box built into a top corner of the chest rather than the stand style, which emerged later. Edo-period chests also tend to be a little smaller in size than their Meiji and Taishō counterparts.

WOOD TYPE: Most Edo chests were made of hardwood. By the Meiji era, sewing chests of zelkova, mulberry, and chestnut were most prevalent. Often, these chests were made of burled hardwoods, as is true of the vanities of this period; since both types of furniture are small, a limited amount of matching burled wood sufficed, making such wood popular and economically feasible.

METALWORK: Small, fine drawer handles are copper or brass, most often fashioned in a miniature *warabite* style. The smallest drawers of the chest most

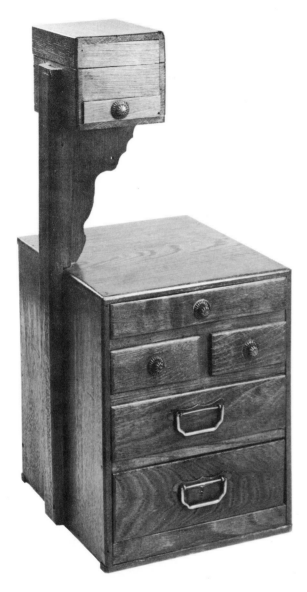

Fig. 25. Sewing chest, all zelkova. Taishō era. H. 44 × w. 19 × d. 20 cm. Courtesy Mr. and Mrs. W. M. Thompson.

often bear little pull knobs or *bura* pulls of copper or brass rather than handles. Metal nails are never used on sewing chests; wood should be fitted together with tiny wooden pegs.

FINISH: Black lacquer finishes appear on Edo chests, changing to golden brown lacquer or clear lacquer finishes over hardwoods on Meiji and Taishō pieces.

DATING: Sewing chests were used throughout the Edo period and the Meiji and Taishō eras and are still produced today in their basic form. Approximate age of a chest can be determined from the construction and finish: Edo pieces

are often characterized by a black lacquer finish. Meiji and later pieces typically have a raised pincushion stand and a light brown or clear lacquer finish through which the hardwood grain is visible.

AREA OF PRODUCTION: Edo-period chests were produced most likely on feudal estates for the women of nobility, but by the end of the Edo period, they were probably being made all over Japan by local craftsmen.

Tobacco Boxes
Tabako-bon

The smoking of tobacco was introduced to Japan by Europeans in the sixteenth century, and by the middle of the Edo period, smoking was widespread among both men and women. Early Japanese tobacco was quite strong and, as such, was smoked only in small amounts in slender pipes with tiny pipe bowls called *kiseru*. Although the first pipes were made of bamboo, pipe fashions later included lovely stems of burled woods with brass mouthpieces and pipe bowls. Other types were crafted entirely of iron, brass, or silver. Today, pipes of all descriptions are ubiquitous at flea markets and in antique shops.

With the popularization of smoking, accoutrements for the habit also developed. Small leather tobacco pouches were hung from the obi (kimono sash), and to these little pouches were often attached a short pipe in a case and sometimes even a tiny wooden ashtray hanging by a cord. For more stationary use in the homes, shops, and restaurants of the Edo period and early Meiji era, *tabako-bon* (Fig. 26), literally "tobacco boxes," were developed.

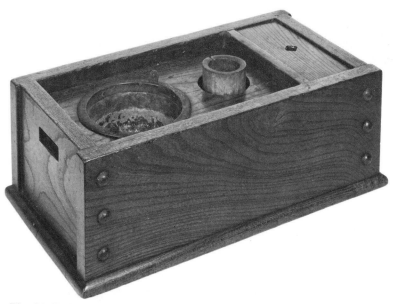

Fig. 26. Tobacco box, all zelkova. Mid-Edo period. H. 18 × w. 26 × d. 23 cm. Clarke collection.

CONSTRUCTION: These small boxes took on many shapes, forms, and sizes during their peak use in the Edo period. Most often, they were square or rectangular boxes, but round models resembling tiny wooden hibachi also appeared, as did fancy ones equipped with shelves and drawers. Woods and finishes also varied. Wealthy smokers of the Edo period owned elaborate, tiered, lacquered boxes, while plain wooden ones, which darkened naturally over the years, were used among the common people and became standard during the Meiji era. Whatever the shape or size, every tobacco box contained two essential parts: (1) a small round receptacle, like a miniature lightweight hibachi, where small bits of charcoal (*sumi*) were kept burning among ashes for use in lighting tobacco, and (2) a piece of slender bamboo, cut right below a joint, which was used as both an ashtray and a hand-held cuspidor. Formerly, some of these bamboo pieces had tiny lacquered lids. The top surface of many tobacco boxes includes a slightly recessed, flat piece of wood with two holes cut in it, one for a metal charcoal receptacle and one for the bamboo ashtray. The receptacles were most often made of copper or, for wealthier customers, bronze. Porcelain receptacles, looking like small, deep bowls, were used with tobacco boxes having no recessed shelf. Many of the metal receptacles resemble small pails, with a thin metal handle attached for ease in removing it from the tobacco box.

Some tobacco boxes are quite large and rectangular in size, reaching dimensions of h. 25 × w. 46 × d. 35 cm. Others are very petite, round wooden holders for the charcoal container and the bamboo cylinder, measuring no more than 20 cm in diameter. Still others appear simply as open, square wooden boxes with the porcelain charcoal container and bamboo ashtray placed freely inside. Some boxes have small lidded compartments or little drawers built in for keeping tobacco and pipes. One very unusual and imaginative style is made from the burl of the evergreen oak (*kashi*) tree, utilizing the natural depression in the burl as a receptacle for the charcoal container and bamboo cylinder.

WOOD TYPE: Black-lacquered wooden tobacco boxes were used extensively in the early to middle Edo period, being replaced later by simple wooden boxes of zelkova. Primarily hardwoods were used in all styles of tobacco box until the end of the Meiji era.

METALWORK: Tobacco boxes bear no metalwork other than small pulls if drawers are part of the construction or, occasionally on bigger boxes, large iron studs where seams are joined. Some have a wooden carrying handle built into the box across the top, which is made of the same wood as the box and is most frequently square in shape. Others show recessed hand grips designed into the sides of the box or perhaps have no grip at all, as in the case of the much smaller styles.

DATING: Production of these boxes ceased at the end of the nineteenth century, when cigarettes became fashionable and virtually replaced pipe smoking. Although women enjoyed smoking as much as men during the Edo period, the cigarette vogue, interestingly enough, was restricted primarily to men during the subsequent century.

AREA OF PRODUCTION: Tobacco boxes reached their peak in popularity and production in the middle to late Edo period. Since they were originally associated with the leisure class of the Edo period, they were most likely produced by craftsmen who worked on feudal estates. Later pieces produced in the Meiji era were made by craftsmen all over Honshu.

Vanities
Kyodai

Kyodai is the name given to the small vanity, or dressing table, used by Japanese women (Fig. 27). These vanities were in existence at least as early as the eighth century, long before tansu and other cabinetry for the middle class evolved in the latter half of the eighteenth century. These vanities must have been an important part of women's lives since they are pictured extensively in woodblock prints of courtesans and beautiful women of the Edo period and in photographs of women of the Meiji era. Elaborate vanities lacquered black with gold-leaf designs as well as simple, unfinished vanities served the purpose of storing combs, hairpins and hair ornaments, toiletries, powders, and oils. Portable and lightweight, the *kyodai* was placed on the tatami mat where the woman sat in front of it to execute her toilet. After its daily use, the *kyodai* was easily removed to a storage closet in the room.

By the beginning of the Meiji era, *kyodai* were being used by women at all levels of Japanese society, and their great popularity resulted in large-scale production of a variety of styles during the Meiji and Taishō eras.

CONSTRUCTION: Vanities of the Edo period are of two basic types: those used by women of the leisure class, which are made of lacquered wood; and those used by common women, which are simple wooden boxes with small drawers. The lacquered ones were the most numerous, but they are rarely found today. They are constructed as small square, or slightly rectangular, boxes usually no taller than 32 cm, containing a series of tiny drawers in various configurations. The top of the Edo-period vanity lifts off to expose a shallow compartment where a hand-mirror and a collapsible mirror-stand were kept. These mirrors, called *kokyō*, are fashioned in one piece with a round flat mirror head on a straight handle. They are made of silver, bronze, or nickel, which, when new or specially cared for, yields a clear, distinct image. On the mirror's backside, the metal is often engraved with Chinese characters or with scenes ranging from flowers and birds to Mount Fuji. (These mirrors can still be found today at flea markets and antique shops.) Accompanying many old vanities is a lacquered box shaped exactly like the mirror. When the *kyodai* was not in use, the mirror was placed in its lacquered box, the collapsible stand was folded up, and all were put away into the top compartment of the vanity.

By the time of the Meiji Restoration in 1868, vanities were becoming a little larger and were made of hardwoods to which clear or lightly colored lacquer-based finishes were applied. Eventually the *kokyō* and its stand were replaced by a glass mirror supported upright between two wooden arms and attached to the top of the vanity, or else constructed as a separate, freestanding, framed mirror that was placed on top of a chest-type vanity. Over the years, these sets (chest

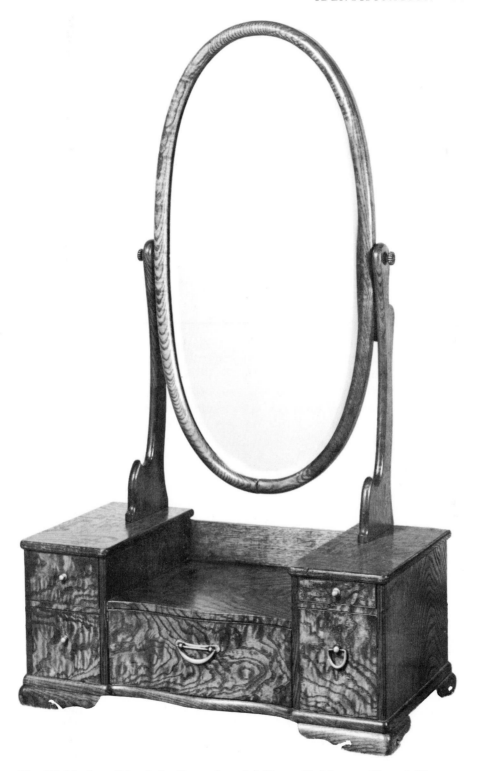

Fig. 27. Vanity, all burled zelkova. Late Meiji era. H. 90 × w. 53 × d. 25 cm. Clarke collection.

and matching mirror) have become separated, resulting in the sale of loose mirrors and mirrorless chests today. Sometimes, chests are sold with a non-matching mirror. On original sets, wood type on the sides and top of the chest and on the mirror frame should match, as should the finishes.

Although their size remained fairly consistent throughout the Meiji and Taishō eras—approximately 61 cm in total height—some vanities were more elaborately executed than others. For example, some are built onto small carved leg stands. The fronts of drawers on styles having drawers on either side of a flat table area may be slightly convex. The mirror supports may exhibit a fanciful curve in the wood.

WOOD TYPE: Vanities of the Edo period until about 1850 were made of lacquered hardwoods. From about 1850, and continuing throughout the Meiji era, zelkova, mulberry, and chestnut were used extensively. Burled wood for drawer and door faces is common. Taishō pieces sometimes show the use of a veneer, often of persimmon, on the faces of drawers or small doors. Although hardwoods continued to be used for vanities in the Taishō era, some were also built of cypress or cryptomeria, with veneer faces.

METALWORK: Handles for drawers and small doors are usually of copper, as are the small screws and knobs that secure the mirror to the wooden arms. Some vanities show a kind of pull (called *bura*) that is shaped like a teardrop.

FINISH: Black lacquer finishes appear on most Edo pieces until about 1850. Meiji pieces show light brown or honey-colored lacquer finishes that expose the hardwood grain or burl. Taishō pieces often show dark brown coloring if the wood was not particularly attractive.

DATING: Vanities can be dated primarily by their distinguishing features of construction, as outlined above. The mirrors on Meiji-era pieces are often beveled. However, it should be remembered that mirrors may have been replaced at some point, creating a little more difficulty in dating a piece. Some mirrors show silvery patches or hairline cracks, usually indications of old glass. Late-Edo and early-Meiji vanities sometimes have wooden dowel screws attaching the mirror to the support bars rather than the typical metal screws. Tall, slender mirrors usually indicate a Taishō vanity, while mirrors on most Meiji pieces are around 20 to 40 cm in height.

AREA OF PRODUCTION: Vanities were used even before the Edo period by women of the nobility and upper class. As a result, vanities were probably produced around Nara and Kyoto, the sites of the imperial court, and later in Tokyo (during the Edo period), where the feudal seat of power was located. When furniture acquisition by all classes of society increased during the Meiji era, vanities most likely came to be produced all over Honshu.

Quick Identification Chart

This chart, designed to provide quick, handy reference during the identification process, summarizes the typical, distinguishing features of each type of furniture introduced in this book. Meiji-era furniture is the focus, since it was during those forty-four years that the largest number of tansu were produced. All metalwork is iron unless otherwise noted. Since a range of lacquer-based finishes was used, the Finish column indicates only the characteristic color(s).

CLOTHING CHESTS

Furniture Type	Construction	Wood Type	Metalwork	Finish
Double-door Clothing Chest (*Ryōbiraki Ishō-dansu*)	Single unit or 2-piece stacking style; hinged, double, swinging doors on upper chest concealing 2 inner drawers; sometimes with door on bottom chest	All paulownia or zelkova; or cryptomeria box with door & drawer fronts of paulownia or zelkova	Distinctive circle & cross-bar motif on double doors; *warabite, gumbai, mokkō,* or *kakute* handles; protective corner pieces on box, drawer front, & door; side carrying handles	No finish or brown on paulownia &/or cryptomeria; if zelkova in part or whole, range of browns
Nihonmatsu Clothing Chest (*Nihonmatsu Ishō-dansu*)	Very large; 2-piece stacking style; 4 deep drawers & small door concealing 2 inner drawers	Cryptomeria box with zelkova drawer & door fronts	Heavy *warabite* handles; angular lockplates usually with a raised design & 2 large knobs; simple corner pieces on drawer fronts & box; side carrying handles	Dark box; reddish brown or honey brown drawer & door fronts with wood grain visible
Sado Island Clothing Chest (*Ogi Ishō-dansu, Yahata Ishō-dansu*)	Both styles: single unit or 2-piece stacking chest; 4 or 5 large drawers & door common on Yahata style; 4 large drawers plus several small drawers & door common on Ogi style	Cryptomeria box with paulownia or zelkova drawer & door fronts; or all paulownia	Highly decorative with fancily cut-out, square lockplates on Yahata style & "curly" edged lockplates on Ogi style; *warabite* or *hirute* handles; box corner pieces; large decorative corner pieces on drawer fronts; side carrying handles	No finish if all paulownia. Yahata style: dark box with burgundy drawer & door fronts; Ogi style: reddish-brown drawer & door fronts
Sendai Clothing Chest (*Sendai Ishō-dansu*)	Single unit or 2-piece stacking style; 4 drawers with or without small door; sometimes with *bō* (vertical bar with lock) across several drawers	Cryptomeria box with zelkova or chestnut drawer & door fronts	*Warabite* or *mokkō* handles; lockplate designs varied but highly decorative (flaring chrysanthemum motif typical); corner pieces on box & drawers; decorative vertical strip on *bō;* side carrying handles	Dark box; drawer & door fronts range from reddish to deep wine hues
Tokyo Clothing Chest (*Tōkyō Ishō-dansu*)	2-piece stacking style; 4 drawers, sometimes combined with small door concealing 2 inner drawers; 5-drawer style also found	All paulownia or cryptomeria; or cryptomeria or cypress box with paulownia drawer & door fronts	Simple, heavy *warabite* or *mokkō* handles; round or angular lockplates, simply designed, with a single knob; corner pieces on box & drawers; side carrying handles	Usually unfinished
Yonezawa Clothing Chest (*Yonezawa Ishō-dansu*)	Single or 2-piece stacking style; 4 drawers; small door concealing 2 inner drawers	Cryptomeria box with zelkova or chestnut drawer & door fronts	*Mokkō* or *hirute* handles; round lockplates (butterfly or cherry blossom motif typical), sometimes with *hakudō* ring; corner pieces on box & drawers; side carrying handles	Medium to dark brown box with door & drawer fronts ranging from orange and reddish brown to medium brown

OTHER CHESTS

Furniture Type	Construction	Wood Type	Metalwork	Finish
Kitchen Chest (*Mizuya-dansu*)	Large single unit or 2-piece stacking style; sliding-door compartment & often hinged door on upper chest with horizontal row of drawers beneath; large sliding-door compartment on lower chest	Cypress frames & cryptomeria boxes, with zelkova door & drawer fronts	Usually, thick *warabite* handles (or *hirute* handles on early Meiji pieces); studs on vertical slats on door faces; may have side carrying handles	Dark brown, non-glossy finish on most chests, though originally left unfinished
Medicine Chest (*Kusuri-dansu*)	Small to medium-sized chest with rows of small square drawers, often with 1 or 2 large drawers across the bottom; some styles have rows of drawers of graduating size	All paulownia; or cryptomeria boxes with paulownia drawers	Small ring pulls on drawers; *warabite* or *hirute* handles on large drawer, if present; simple lock often found on large drawer, if present	Unfinished
Merchant Chest (*Chō-dansu, Chōba-dansu*)	Sturdy single unit or 2-piece stacking style; 4 to 6 small drawers arranged in a vertical line on the right side of chest front; 1 or 2 door compartments	All zelkova, chestnut, or paulownia, or cryptomeria or cypress box with hardwood drawer & door fronts	Very heavy, simple handles in *warabite*, *hirute*, or *kakute* style; vertical lock-receiving strip on sliding door; simple lockplates in round or angular style; side carrying handles	If paulownia, unfinished; if hardwood, a shade of brown
Sea Chest (*Funa-dansu*)	Small solid chest of one of 3 basic types: *hangai* (full-face, lift-off front door exposing inner drawers); *kakesuzuri* (box with 1 hinged door opening to reveal inner drawers); or *chō-bako* (box with 1 top drawer above sliding doors)	Zelkova or chestnut box; inner drawers of paulownia or the same wood as box	Elaborate decorations on door; *warabite* or *kakute* drawer handles; carrying handle: on the top of *kakesuzuri* style, on the sides of the other styles	Reddish brown to burgundy to deep brown
Staircase Chest (*Kaidan-dansu*)	Single unit or 2-piece stacking style with storage cupboard built into the steps; 5 to 9 steps; cupboard area contains drawers & sliding door compartments	All cypress or cryptomeria; or cupboard fronts of zelkova with crypress stairs & cryptomeria case	*Warabite*, *kakute*, or *mokkō* drawer handles; copper or iron grips on sliding doors	Dark brown, non-glossy finish
Trunk (*Nagamochi*)	Long rectangular trunk with hinged lid, which may be slightly domed	Paulownia or cryptomeria	Iron or copper lockplate on front edge of lid, strips of iron or copper on corners of box & lid; side carrying handles	Unfinished; rarely, lacquered trunks are found
Wheeled Chest (*Kuruma-dansu*)	Large or medium-sized chest of simple design with sliding doors &/or drawers, mounted on an integral wooden wheel base	All zelkova, chestnut, cryptomeria, or cypress; or hardwood frames, drawer &/or door fronts & cryptomeria box	*Warabite* handles prevalent; vertical lock-receiving strip on sliding door	Reddish to dark brown finishes on hardwoods; dark brown finish on cryptomeria

SMALL FURNITURE

Furniture Type	Construction	Wood Type	Metalwork	Finish
Hibachi (*Naga-hibachi*)	Rectangular box (Tokyo style) or rectangular box with thick lip at top rim (Kyoto style); small drawers, placed across bottom, vertically along right front side, or in both locations	Zelkova or chestnut	Drawer handles of copper or iron; copper liner in coal receptacle area; side carrying handles, if present, of iron in *warabite* style	Medium to dark to reddish brown; old hibachi in original condition are darkened naturally from exposure to heat & smoke
Kotatsu Stand (*Kotatsu Yagura*)	Very small to large, always square; 4 legs support a latticed top; small models often have iron flooring	Cryptomeria	None	Unfinished; heat & smoke over the years create a dark brown patina
Money Box (*Zeni-bako, Zeni-dansu*)	Small, heavy rectangular box with a 1-piece lidded top or a lidded top in 2 pieces, with or without a conical apperture; may have small drawers and/or a small locking door	Zelkova or chestnut	Sparse metalwork; may have iron or copper strips around each corner, top & bottom; drawers may bear a small, simple iron lock; ring pulls on drawers; may bear small sturdy *warabite* carrying handles on the sides	Dark brown, non-glossy finishes
Sewing Chest (*Hari-bako*)	Small square boxes with tiny draw drawers & an upright arm holding a square pincushion box	Zelkova, mulberry, or chestnut, often burled, on drawer fronts; box usually of hardwood; drawer interior often of paulownia	Small copper ring or *bura* pulls on drawers	Honey to reddish brown, with burl or wood grain visible
Tobacco Box (*Tabako-bon*)	Small square or rectangular box or deep square tray; box style often has small drawers &/or a lidded compartment	Zelkova or chestnut	May have studs near the corner seams; tiny *warabite* handles &/or ring pulls of copper or iron if drawers are present	A range of browns possible, but usually a non-glossy dark brown
Vanity (*Kyodai*)	A small chest with tiny drawers or a vanity with a flat table area between 2 side sections of drawers & with a rectangular or oval mirror supported by 2 upright arms; earlier pieces have square or rectangular framed mirrors, either freestanding or attached to the top	Zelkova, mulberry, or chestnut, often burled; late-Meiji & Taishō pieces often have cryptomeria or cypress cases with veneered drawer fronts	*Warabite* handles, *bura* pulls, or ring pulls of copper	Golden to reddish brown

2 Evaluation

It is often difficult to put a precise age on a piece of furniture or to tell, for example, if the finish is original. Even antique dealers sometimes find it difficult to date a particular piece, or to pinpoint its exact area of origin. However, there *are* some general guidelines that can enable you to evaluate furniture accurately enough to make knowledgeable purchasing decisions. While the cosmetic appeal of a particular piece can provide a strong incentive to buy, further examination can yield valuable, additional information that may increase your appreciation of the item or, perhaps, dissuade you from purchasing it.

This chapter focuses on evaluating antique tansu since tansu represent the most popular and best-selling class of items among Japanese antique wooden furniture, but the basic principles are the same for other furniture types as well. Antique tansu, for the purpose of this discussion, include those built during the some 180 years from around 1750 in the Edo period, through the Meiji era, to the end of the Taishō era (1926).

While identifying the specific type and, therefore, use of a tansu offers some insight into its past and satisfies your curiosity, a closer examination will give you important insights into overall condition, wood type, finish, and metalwork. You can also determine whether anything is missing from the tansu or has been added later.

As you explore these areas, remember that many variables affect the value of a tansu. The most deciding factor is whether the piece is original or restored. An original tansu has undergone no restoration and appears with its original wood, metal, and finish. A restored tansu is one which has undergone some degree of restoration, whether it be the addition of only several pieces of new metalwork or whether an entire refinishing has been undertaken. Antique furniture dealers themselves must be extremely careful when selecting furniture in original condition to pass on to the consumer. Naturally, it is rare to find such furniture, yet there are pieces available through reputable dealers, and the prices attached to them reflect their rarity.

This chapter will help you understand how to determine original furniture from that which has been restored or had parts added to it indiscriminately. It will also help you learn how furniture in poor condition (with pieces of metal missing and finish damaged, for example) looked in its original condition so you can restore it faithfully. In the end, however, a professional eye is required for determining original tansu, so it is important to patronize reputable antique furniture dealers if an original tansu is what you want.

In most shops handling antique Japanese furniture, the majority of tansu and other furniture for sale is either restored or in need of some restoration. Reputable dealers can provide you with furniture that has been restored faithfully to the original conception of the piece. In general, prices on restored furniture should be lower than those for original pieces in good condition. While restored antique Japanese furniture will rise in value over time, pieces in perfect, original condition will yield an even higher return on your investment, if that is what you desire.

Whether furniture is original or restored, other factors must be considered when determining value. Age is a major factor, but often must be discounted if the piece is in poor condition. Thick wood and heavy metal are other factors enhancing value, but the age of the piece must also be considered. Unique styles, such as an all-hardwood double-door clothing chest, produced on a much smaller scale than, say, the four-drawer Yonezawa chests, have an obvious value attached to their rarity. Condition plays a major role since repairs and replacements for tansu are costly and often require the skills and artistry of craftsmen. As you begin your exploration of Japanese furniture, don't hesitate to ask questions, compare many pieces, and, most of all, to inspect them thoroughly.

General Construction

The construction of tansu, hibachi, and other wooden furniture varies primarily according to craftsmanship, age, and type of wood used. Two major methods of construction were used for tansu:

1. For the chest-of-drawers style, boards—each forming a single plane (top, side, back, or bottom)—were joined with simple parallel-edge joints, and glued and fastened with blind bamboo dowels sharpened on both ends (Fig. 28*a*).

Fig. 28. Major methods of tansu construction. *a.* simple corner box construction (note blind bamboo dowel holding together two boards on back; other dotted lines indicate direction of wooden pegs in each side). *b.* a type of wedged mortise-and-tenon construction.

Top and sides were joined together with simple corner box joints (pegged tenon, open mortise), and glued and secured with sharpened, fire-hardened wooden pegs. The back was also attached with glue and pegs so that it lay flush with the outer edges of the sides.

2. For chests with frames and panels (virtually all wheeled chests, Fig. 20, and kitchen chests, Fig. 10), a variety of elaborate wedged mortise-and-tenon joinery was used to fasten the frame pieces to one another (Fig. 28*b*).

As a general rule, antique tansu also exhibit the following predominant features:

> Use of Japanese hardwoods (zelkova or chestnut), Japanese softwoods (cryptomeria, paulownia, cypress, or pine), or any combination thereof

> Hand-forged handles (except for a few styles made after 1880, which were cast), and hand-cut metalwork both functional and decorative

> Handmade iron locks

> Handmade iron nails affixing the metalwork

To begin your evaluation of a tansu, first look at its overall appearance: check the wood type and its condition, check to see if all the metalwork is intact and all locks accounted for, and examine the finish (stain and/or any finishing agent or lacquer that may have been applied). Cracks, broken locks, missing or damaged metal, damage to the wood, or structural deficiencies (a missing small drawer or door, for example) can be detected in this initial examination of the tansu.

FRONT: The front, or face, of the tansu determines your first impression of the piece. The arrangement of drawers or doors, the type of metalwork, and the dimensions come together to create a certain look that, for many people, can be a very compelling factor in selection. While it is important that the piece you choose appeals to you, it is even more important to inspect the tansu thoroughly. In other words, it is pointless to purchase a tansu with a pretty face if the insides have been riddled by bugs, if the construction is unstable, or if it will require excessive time and expense to restore.

Note the overall design of the chest, what type of wood is used for drawers and/or door faces, and what sort of metalwork is evident. If you decide that the chest front is definitely inviting, you are ready to embark upon a thorough examination of the entire tansu and its components.

TOP AND SIDES: There are two basic methods of constructing the tansu top and sides: (1) fitting boards of wood together to form each side and the top; and (2) using a single board of uniform thickness for each side and the top. In most cases, the latter construction is preferable since it eliminates the potential for shrinkage between wood pieces, which can cause cracks; since it is visually more handsome; and since large, single sections of wood are more valuable than smaller pieces. However, thousands of tansu at the peak of tansu production in the Meiji era were built with pieced tops and sides.

Fitted-piece construction should not be considered a negative factor except in the case where the front facing boards on the top or the top and sides of the tansu are thicker than the remaining boards to give the illusion, from a

Fig. 29. Types of fitted-piece construction. *a.* thick facing piece followed by thin pieces, on top and sides. *b.* thick facing piece on top followed by thin pieces; uniformly thick pieces on sides. *c.* thick facing piece on top followed by thin pieces; thick facing piece on sides followed by tapered pieces. *d.* uniformly thick pieces on top and sides.

frontal view, that the tansu is built of thick wood throughout. Look at the edge where the top and side of the tansu join to see whether thinner pieces of wood were used directly behind the first, facing pieces. Typical fitted-piece construction variations are shown in Fig. 29. Tansu with uniformly thick wood across the top and sides, front to back, are of more value than tansu having only thick facing pieces.

BACK: The back is almost always constructed of cheaper wood than the rest of the tansu, except in the case of an all-cryptomeria tansu or one with an all-paulownia box. The back most often consists of several boards joined together, and not uncommonly some shrinkage is noticeable between them. Traditionally, the back was not stained or finished when originally produced. However, some tansu backs were stained at a later date, and often a difference in color from the other wood on the tansu can be detected. This is due, also, to the fact that different kinds of wood accept the same color differently; if the top and sides of the tansu box are made of a wood different from the back, the same color applied to both may appear to be two distinct colors.

DRAWERS: When inspecting a tansu, pull each drawer all the way out of the case. You will find that in tansu having a cryptomeria box and hardwood drawer fronts, the drawer sides and back will also be of cryptomeria. Cryptomeria is the wood most commonly used for drawer interiors due to its lower cost compared to other woods. Even when a tansu is constructed with a paulownia box and drawer fronts, the drawer interiors are sometimes composed of cryptomeria. The same would be true for a tansu composed entirely of a hardwood. So, even though a tansu may be labeled as "all-paulownia" or "all-zelkova," the drawer interiors most likely are made of cryptomeria.

In the majority of chests, the drawer fronts are thicker than the sides, back, and bottom of the drawers. This is standard. However, there are many tansu to be found where the thickness of wood on the front, back, and sides is uniform. This is especially common in paulownia chests, and implies a well-built, sturdy piece. At this point, when you are checking the wood thickness, you can also identify the kind(s) of wood used for the drawer fronts and interiors. It should be emphasized that normally drawer interiors were never stained or finished.

Next, notice the construction of the drawer front. A single piece of wood of uniform thickness, at least 19 mm, is most desirable. Two other methods of drawer-front construction were also employed. The first method is known as beveled drawer fronts. In this case, the front is composed of one or more pieces of tapered wood—thick at the top and thinner at the bottom—to simulate a uniformly thick drawer front. From the front, the drawer front appears to be thick. However, the piece has actually been cut at a slant on the inside from about one-third of the distance from the top of the drawer front to the bottom of it. Run your hand along the inside of the drawer front; a beveled drawer can be easily detected by the way the wood feels graded and thinned as your hand travels downward.

The second method of drawer-front construction is to use veneer. This practice is less common than the beveled drawer front, but is found when a tansu constructed of cryptomeria, for example, would appear more impressive by the placement of an expensive wood such as zelkova or burled hardwood on the drawer fronts. (Burled hardwood, although beautiful and highly prized, warps easily and, therefore, was often stabilized by use as a veneer.) The veneer method involves gluing a very thin piece of expensive wood onto inexpensive wood to give the illusion of a solid piece of expensive wood. Veneer can be determined in two ways: (1) by looking at the piece of wood on the drawer front from the inside; if the wood grain is not identical from both perspectives, the outside can be considered a veneer, and (2) by looking at the tansu drawer from a side view, where a thin seam between the veneer and the thicker piece of wood will be perceptible.

On some drawers, you will notice that the bottom extends slightly beyond the back wall of the drawer (Fig. 30). This design was intentional, an innovation of craftsmen who knew that wood used on the top and sides of a tansu box would shrink in the opposite direction of wood used on the bottom and sides of the drawers as it dried out over the years, causing the drawers to protrude slightly. The extra length at the back of the drawer was made to be cut down to permit a better fit of the drawer into the tansu box in this event (cf. page 113).

In general, a well-constructed tansu drawer has a drawer front of a single piece of wood of uniform thickness, at least 19 mm, with sides and back no

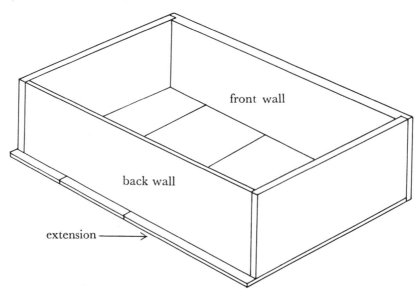

Fig. 30. Tansu drawer with floor section extended at the back.

less than 8 mm thick. The greater the thickness of the sides and back of the drawer, the sturdier the tansu. All drawers, including small inner ones behind a small door, should be checked to make certain that wood thickness and type are uniform throughout.

INTERIOR: The interior of the tansu is unfinished, and thus can provide some indication of age. Remove drawers and open doors to facilitate inspection. If the interior appears extremely light in color, it is a sign that the wood has not had sufficient time to age and darken; the piece may be a newer tansu. Older tansu exhibit a grayer or browner color inside, the result of aging. Of course, the inside surfaces are usually never exposed, so most interiors appear relatively light in comparison to the dark finish on the outside. It should be stressed, however, that some tansu dealers involved in restoration completely clean, and sometimes sand, the interior to return it to its original, perfect condition. In this case, the interior appears light and clean even if the tansu happens to be quite old.

Looking at the inside also helps you determine if wood has been replaced at any place on the box. Often replacement is necessary, and a professional repair job will not be noticeable from the outside if the tansu has also been refinished. If wood has been replaced, the grain of the new wood, when viewed from the inside, will not match and will appear lighter in color than older or original pieces around it.

Wood

Examining the wood tells you much about the value of the chest and the price you should be paying for it. The hardwoods, zelkova and chestnut, are extremely expensive. Paulownia, although a softwood, is prized in Japan and is often

expensive. Softwoods such as cypress, cryptomeria, and pine do not fetch the prices of the revered zelkova, chestnut, and paulownia. Softwoods have always been more abundant in Japan, they grow faster, and they are much easier to saw and plane for construction than hardwoods. In terms of tansu construction, they are not as strong over hundreds of years of use as zelkova or chestnut. A tansu, in any style, made entirely of zelkova is far more expensive and more valuable than one of softwood and hardwood combined or of softwood entirely. Therefore, it is important to be able to identify the various woods used. Since only six major wood types were used, two hardwoods and four softwoods, it is quite easy to familiarize yourself with the appearance and feel of each.

Although the use of single pieces of thick wood can indicate an older chest, it should be remembered that a chest composed of thinner wood is not necessarily of a later vintage. Often, the finances of a family determined the wood thickness, so sometimes you find examples of older tansu made of thinner pieces of wood. With the transition to saws and planes and advanced lumbering methods in the nineteenth century, the availability of thin timbers boosted production of low-cost, non-custom-built tansu. Since it may be difficult, then, to judge the age of a chest by its wood alone, metalwork, lock mechanisms, and construction will be your best indicators of age.

Wood Types: For the sake of convenience, wood types can be categorized as either hardwoods or softwoods. It is quite common to find a combination of hardwood and softwood used in the construction of one chest. For example, the box, or outer structure, often is composed of a softwood such as cryptomeria, while the drawer and door faces are made of a hardwood such as zelkova. Since the boxes of many chest-of-drawers styles were finished with a dark color, softwood was appropriate since it was cheaper and also because the knots found in these woods, probably considered unattractive, could be easily concealed with these dark finishes. Drawers and/or doors, on the other hand, were considered the personality of the tansu, so hardwoods were quite often employed to add character and charm. And, realistically, hardwoods provide durability for the drawer fronts, which receive the greatest amount of stress when drawers are opened and closed. The four softwoods and two hardwoods most commonly used in tansu construction are as follows:

Cryptomeria Cryptomeria, or *sugi*, is the softwood most predominantly used for tansu due to the fact that it grew prolifically in Japan. In the majority of chests having hardwood drawers and/or doors and a softwood box, the softwood is cryptomeria. This wood is of medium density, soft, porous, and wide-grained. Even in its unfinished state, grain striations of varied color, ranging from pale yellow to orange to brown are visible. Uneven or "striped" finishes result if light stains or finishes are applied; hence, this wood was virtually always finished with a dark lacquer-based coat.

Japanese cypress Japanese cypress, or *hinoki*, also a softwood, is more finely grained than cryptomeria, but was used traditionally in the same way on tansu, that is, as wood for the boxes. Japanese cypress was also used for other types of furniture that required inexpensive lumber, such as the steps of staircase chests. The grain colors, like cryptomeria, range in hue, yielding a similar "striped" pattern if the wood is stained a light color.

Japanese pine Japanese pine, or *matsu*, was not used nearly as frequently

as the other major softwoods, cryptomeria and cypress; however, it is common in furniture built for rural homes because it was cheap and readily available. Like pine in North America, Japanese pine also secretes a resin, even long after it has been cut, which makes it less than ideal for furniture construction.

Paulownia Special to the Japanese because of its use in cabinets for storing silk kimono, paulownia, or *kiri,* is a strong wood that has the capability of expanding and shrinking with atmospheric changes. Once you have seen a paulownia tansu, you will never forget the unique look and feel of this wood. In density, it is light, another factor making it a desirable material for furniture making. It is closely grained in a rather straight pattern, with the exception of its cousin *yama-giri* (literally, mountain paulownia). Unlike cryptomeria and cypress, which present a matte surface before finishing, paulownia possesses a slight glow in its unfinished state, the result of light resin secretions. Even though a softwood, paulownia is one of the most prized timbers in Japan, and furniture made from it is usually priced accordingly.

Chestnut Very similar in density and appearance to zelkova, Japanese chestnut, or *kuri,* is often difficult to distinguish from zelkova, especially if the woods have been finished. Chestnut, like zelkova, often appears on the faces of drawers and on doors. Although it takes a practiced eye to tell the two woods apart, they always are rated the same, commanding higher prices as a result of their strength, beauty, and appeal.

Zelkova With its beautiful, tight grain of a dense, nonporous nature, zelkova, or *keyaki,* is the most expensive of Japanese woods. One of the reasons for its high cost today is that, unlike cryptomeria, there just aren't many zelkova trees left anymore. When used in furniture, zelkova is a sturdy, long-lasting hardwood requiring little maintenance. It was used extensively on drawer and door faces for its rich and impressive beauty. Tansu and other furniture built with burled zelkova—wood taken from the knotty area near the trunk of the tree, noted for its handsome, clustered grain that appears wavy or curly— are especially coveted in Japan and by collectors and museums outside Japan.

MIXING WOOD TYPES: There seem to be no fixed rules about mixing wood types in Japanese furniture. A chest is built entirely of one wood, or of a combination of up to three different woods. Boxes are often constructed of cryptomeria or cypress, and drawers of zelkova, chestnut, or paulownia. However, as a general pattern, furniture without drawers, such as the trunk or money box, is usually constructed of the same wood throughout. On tansu with hardwood drawer and/or door faces, all faces on the entire piece should be of the same wood. If you see a tansu with, for example, three zelkova drawers plus one cypress drawer, you can be certain the latter is an addition to the original.

DAMAGE AND IMPERFECTIONS: Wood, unfortunately, is without defense against a number of elements that can affect it in sometimes disastrous ways. Fortunately, however, most damage can be repaired. When examining the wood of a tansu, watch for the following problem areas to make sure that you understand the true condition of the wood before making a purchase.

Bug damage Damage to the wood is the result of the wood-eating larvae of at least three species of Japanese moths and takes the following forms:

1. Moth larvae that leave cocoons in the cavities: This damage occurs pri-

Fig. 31. Bug damage. *a*. moth damage with cocoons in the cavities. *b*. moth damage showing cavity after cocoon has been removed. *c*. moth larvae damage showing interconnecting tunnels. *d*. moth larvae damage showing a tunnel that follows the wood grain.

marily in the softwoods cryptomeria and paulownia. It is discernible by the silky cocoon left behind by the moths as they exit from the wood. The cocoon is found inside a cavity in the wood that usually measures no longer than 25 mm in length and 6 mm in diameter. Often a portion of the cocoon is visible at the surface of the wood. The exit hole of the cavity is about 3 mm in diameter. (Fig. 31, *a* and *b*)

2. Moth larvae that form interconnecting tunnels: This type of damage, also predominant in cryptomeria and paulownia, is noticeable from very small surface holes (approximately 1 mm in diameter) clustered closely together that indicate a series of small connecting tunnels just under the wood's surface, which may or may not follow the wood grain. Unfortunately, the extent of this type of damage cannot be accurately detected until the surface has been sanded, exposing the tunnels beneath. Because of its wide-ranging maze structure, this type of infestation causes the greatest problems in terms of repair as it usually requires much wood replacement. (Fig. 31*c*)

3. Moth larvae that always follow the wood grain: This is the most common form of bug damage appearing on all woods, hard and soft. The damage usually occurs at or near the joint between two pieces of wood, giving rise to the possibility that the insects were more attracted to the glue in the joint than the

wood itself. Visible on the wood's surface are scattered holes approximately 2 mm in diameter. The larvae form tunnels of the same size that follow the grain under the wood's surface. Thus, the extent of the damage cannot be detected until the surface is sanded, but it generally is not as far-reaching as that described in (2) above. (Fig. 31*d*)

Bug damage may be of a surface type, meaning that holes are not eaten through the thickness of the wood, so it is a good idea to check the insides of drawers and the tansu interior for signs of such damage. One problem sometimes encountered is that of bugs living in the tansu but whose damage is not yet apparent. Therefore, any old furniture purchased should be thoroughly sprayed, *inside only,* with an insecticide safe for use on furniture (cf. page 94). Furniture purchased from reputable shops has usually been treated for bugs prior to sale. If bugs are latent and have not been treated, they can travel to and infest other furniture in your home as well.

Rodent damage Along with problem insects such as moths and bugs that infest grains, rats and mice also posed problems to wooden tansu in the past. The majority of this type of damage appeared on chests used for food or grain storage. Rats and mice tended to eat right through the wood to get at food or grain, causing a hole usually found near the corner or edge of a drawer where it meets the front frame of the box. Repairs for this kind of damage can be costly and time-consuming, so they should be a main consideration in the decision to purchase or not. In tansu where wood damaged by insects or rodents has been replaced prior to sale, the evidence is a piece of stripped-in wood whose grain pattern does not exactly match that of the surrounding wood. If the repair has been made professionally, such that it is not noticeable except upon close scrutiny, the tansu's value as a restored piece should not be affected.

Water damage Another common type of damage to wood is water damage. Sometimes tansu were put outdoors when not in use, where they were damaged by rain. Water damage appears as whitish, cloudy streaks or stains on the wood's surface, or as warping of the wood. Pieces that have suffered severe water damage are difficult to restore to their original condition, although the whitish stains can sometimes be camouflaged by sanding the wood and applying a stain cover. As a general rule, however, it is best to avoid furniture that looks as if it has been affected by water or rain.

Warps Warped wood, unfortunately, is common in Japanese furniture. The swings in climate from wet summers to dry winters in Japan put an enormous stress on wood, especially wood that has not been properly seasoned. (Seasoned wood has been cut, dried, and allowed to sit through several summers and winters so that its maximum shrinkage and expansion have occurred before it is used.) However, it should be remembered that wood will continue to change form slightly with climatic changes; notice, for example, the tight fit of drawers in the summer and the relative looseness of tansu doors in the winter.

Tansu craftsmen sometimes attempted to compensate for the use of new, unseasoned wood by cutting it thicker in hopes that the thickness would prevent warping. Sadly, we find today many tansu of gorgeous, thick zelkova that are, nonetheless, slightly to badly warped for this reason. Slight warps can be straightened, but badly warped wood is best avoided.

Cracks and splits Another side effect of dry winters is splitting and

cracking in wooden furniture. Some splits or cracks may, of course, be the result of trauma (such as the piece being dropped or hit), but most found are associated with the stresses of wood shrinkage. Cracks occur as a space between two boards or strips of wood that were originally joined to make a seam. Splits run along the grain of a single piece of wood. Most cracks and splits can be rectified by gluing and clamping or through wood stripping (cf. page 104). Therefore, they should not prevent you from purchasing a piece of furniture since a home repair job would not entail difficulty and a professional repair would not be too costly.

Metalwork

Metalwork refers to the handmade metal (almost always iron) affixed to tansu or other furniture for function and/or decoration. Functional metalwork includes locks and handles on drawers and doors, side handles on the box (necessary for portability in earlier days), hinges, and corner metal that protects the corners from bumps during transportation and also prevents scratching of the top wood surface on stacking styles. Decorative metalwork consists of small corner pieces attached to the four corners of drawer fronts, handleplates, lockplates or receiving strips for vertical locks, and any metal adorning small doors or other surfaces that is obviously decorative rather than functional. It should be remembered that some types of tansu exhibit metalwork, such as drawer corner pieces or door carvings, that is not found on other tansu.

Whether it's the highly decorative ironwork of a Yahata chest or the understated ironwork of a Tokyo clothing chest, the metalwork is one of the features that immediately appeals and affects your impression of a tansu. Thus, familiarization with styles of metalwork will help you learn which types of tansu normally carry which kinds of metalwork, and will also assist you in determining whether new metalwork has been added.

Tansu metalwork is almost always of iron, although quite a few types of small furniture, such as hibachi, vanities, peddlers' boxes, and sewing chests, are fitted with copper, bronze, or brass. Original metalwork on antique Japanese furniture is primarily hand-forged, hand-cut, and blackened with a *sumi*-based rubbing paste if the metal is iron. Some drawer handles of the middle to late Meiji era, however, were cast. Determining handmade metal is quite easy: each piece will usually be just slightly different from similar pieces on the same chest. Machine-pressed metal is precise and yields none of the artistic feeling of handmade metal. Since iron is the most prevalent metal used, the discussion here will center on iron fixtures, taking up first functional and then decorative ironwork.

DRAWER/DOOR HANDLES: Six basic styles of drawer/door handles, listed below, were used repeatedly on tansu and other furniture from the Edo period through the Taishō era.

Hirute This handle was produced primarily in two styles, one in which the iron of the handle is cylindrical, with a circular cross-section (Fig. 32a), and one in which the iron is faceted (Fig. 32b). The handle gets its name from its likeness to a water leech (*hiru*); with downturned "ears" on either end its

Fig. 32. Common handles. *a.* cylindrical *hirute. b.* faceted *hirute. c. warabite. d. kakute.*
e. faceted *mokkō. f.* cylindrical *mokkō. g. gumbai. h.* handle clips. *i.* ring pull with disk
plate.

shape resembles a water leech with a head at each end of its body. *Hirute* handles
are used primarily as drawer handles for tansu and small cabinetry. They are
not found as carrying handles or lid handles since their shape is inappropriate
for these functions. Faceted handles were cast rather than hand-forged, and as
such are found on furniture built from the middle of the Meiji era.

Warabite This handle (Fig. 32*c*) receives its name from the graceful shape
of the *warabi,* a Japanese mountain fern. *Warabite* handles are found on all types
of furniture and used on a large scale for drawer handles, door handles, lid
handles, and carrying handles. Of all Japanese cabinetry handles, *warabite* is the
most versatile and the most frequently used.

Kakute Aptly named (*kaku* means square), this handle (Fig. 32*d*) is squared and geometric in form and is used as a drawer handle on a host of tansu styles.

Mokkō The two Japanese characters for the word *mokkō* suggest the type of curled, winding vine tendrils found growing on watermelons, cucumbers, and the like. The word also suggests the curved form of a split gourd. Either is an apt description for these handles, which are made with three curved, scalloped edges. The *mokkō* handles were extremely popular on chests made in northern Honshu and most often appear in a faceted, scalloped shape (Fig. 32*e*) or in a cylindrical, scalloped shape (Fig. 32*f*). They were used in large, medium, and small sizes for drawers. All faceted *mokkō* handles were cast rather than hand-forged and are found on furniture dating from the mid-Meiji era.

Gumbai This term is used because the handles follow the same curve as that found on a type of lacquered fan (*gumbai*) that was used in samurai days to officially signal the start of a military contest. (Today sumo referees signal the beginning of the match with this fan.) The *gumbai* handle (Fig. 32*g*) is a later style, so tansu bearing them as their original hardware are usually dated from around 1880.

Ring pull The simple ring pull (Fig. 32*i*) is often found as a handle on inner drawers of tansu and other cabinetry and in larger form, as a ring to which was tied a rope for pulling the tansu, as on wheeled chests. The ring pull is also sometimes seen on large lockplates for facilitating the opening of a door bearing a heavy lockplate. The ring pull is always accompanied by a metal plate at its base (except when it is attached to a lockplate). These plates range from simple circular disks (predominantly with smaller rings) to elaborately cut and raised shapes (predominantly with larger, heavier rings). Another small pull used on small Japanese furniture is a teardrop-shaped pull, which is virtually always made of brass or copper and is fashioned of solid metal or metal wire. Ring pulls are often called *kan*. Teardrop-shaped pulls are sometimes called *bura* from their swinging (*bura-bura*) motion.

Whatever the style of handle used on a particular piece of furniture, it is always combined with either a handleplate—a flat piece of iron, plain or decoratively cut, attached behind the handle to the drawer surface—or round disks, one placed behind each end of the handle grip. In the latter case, iron handle clips (Fig. 32*h*) are pushed through holes in the disks and on through the wood to secure the handle to the drawer. Round disks used with handles are most often slightly raised or bubbled and do not lie flat against the wood's surface. Some tansu built at the end of the Taishō era show handleplates (as well as other metalwork) that look somewhat undersized in relation to the dimensions of the chest and in comparison to metal on earlier tansu. This is most likely related to the fact that, by the end of Taishō, tansu production and the number of craftsmen involved were both decreasing. The expense involved in producing hand-forged and hand-cut iron for the small output became too great, so to economize, tansu producers began using smaller and less decorative metalwork.

On many tansu you will find an iron buttonhead stud, or *atari*, attached to the wood at the point where a handle would hit the wood. *Atari* keep the handle from knocking against the wood and scratching it; thus, they are found primarily on larger tansu with heavy iron handles. Decoratively, however, very petite *atari* of copper were used on small furniture, especially vanities.

Fig. 33. Carrying handle on the side of a two-piece stacking chest, which swings up and fastens to two iron pins.

CARRYING HANDLES: Iron carrying handles are attached to the outside of many tansu to facilitate movement of the piece. Most commonly, one carrying handle appears on each side of the tansu, toward the top of the box. Some sea chests bear a single carrying handle on the top center of the box (Fig. 14). On two-piece, stacking tansu, carrying handles for the bottom piece swing upward and fasten to two iron pins on the top chest (Fig. 33). In this way, the carrying handle also serves the purpose of keeping the boxes aligned and unmoving when the drawers are opened and shut. Carrying handles for medium to large tansu show one of the following configurations: (1) vertically long, squared, or slightly rounded, handles that swing up and down (cf. Fig. 4); (2) vertically long, squared handles that rest in an upright position inside two pins, such that the handle will not swing but can be raised and lowered along a vertical track (cf. Fig. 1); or (3) vertically long, squared, flattened handles that slide up from within a recessed area at the top edge of the chest side. Concealed behind a thin iron plate and almost flush at the top, these last handles are not readily visible. This style of handle is not as common as the other two styles since it is found most often on tansu made in the Taishō era, after peak production was finished. It usually indicates a later piece.

Carrying handles on medium and small chests are most often of the *warabite* style. Often, on large tansu, two adjacent *warabite* handles are combined with a large, rectangular carrying handle on each side of the chest.

LOCKS AND LOCKPLATES: Two basic types of locks are found on tansu: (1) a single-action lock with a knob located on the outside of the lockplate that is pushed upward for locking; a key inserted into a keyhole and turned counter-clockwise unlocks the mechanism; and (2) a double-action lock, which is operated by a key that turns in one direction to lock the mechanism and in the opposite direction to unlock it. A knob on the lockplate is not found on double-action

locks. Single-action locks were used during the Edo period, but by the mid-Meiji era, double-action locks were beginning to be used, and by the Taishō era, double-action locks were used consistently.

As you see and examine more and more tansu, you will be surprised at the large variety of lockplate styles which adorn these chests. The distinct appearance of lockplates, be they simple and round, or large and intricately carved, provides strong evidence of the tansu's area of origin in most cases. Japanese ironsmiths used many motifs in decorating lockplates, taking inspiration from nature and myths. Regional symbols were also incorporated in ironwork, and the same crest or symbol was often called by different names in different regions, making the study of ironwork motifs complex.

Some dominant themes do commonly occur, including: (1) the sixteen-petaled chrysanthemum, (2) *tsuru-kame*, the crane and tortoise together, (3) cherry blossom, (4) temple dog, (5) ivy-leaf arabesque, (6) paulownia flower, (7) pine tree, (8) butterfly, (9) bamboo, and (10) tiger and bamboo. Other less common motifs are animals of the zodiac, characters from *The Tale of Genji*, money pouches (often mistaken for gourds because of their similar shape), and Mount Fuji.

Motifs were created by (1) etching a design or pattern directly onto the plate, (2) cutting out a design, or (3) shaping separate pieces that were then affixed to the surface of the lockplate for a three-dimensional effect. Small prongs inside the piece or tiny iron pins were used to hold these pieces to the plate.

CORNER AND FRAME IRON: The corners of the tansu boxes are traditionally protected with small iron corner covers held in place with iron nails. Corner iron was important in adding durability to corners where wear or damage could easily occur. In the case of two-piece stacking chests, corner pieces served to protect the boxes from touching each other and scratching the wood surface.

Iron strips or any pieces found on the face of the tansu box, while decorative in appearance, also protect the frame from any potential mistreatment. The thicker the iron on the corners and frame, the greater is the protection.

DOOR HINGES: Original, handmade hinges will be found on tansu doors that have not required hinge repair. They were used both on double doors and on small single doors. Hinges were originally affixed to the tansu with handmade iron nails. Because hinges receive considerable stress compared to other tansu iron, they are usually the first to wear out. It is important that, if a tansu needs new hinges, they be hand-cut and reproduced faithfully in the style and pattern of existing hinges. The addition of new, machine-cut hinges makes the tansu less valuable than one which bears handmade hinges reproduced in the distinct style of the remaining hinges.

DRAWER CORNER IRON: The corners of the outer drawers are traditionally decorated with iron pieces that complement the pattern of the lockplates, handleplates, and other iron on the chest. A number of corner styles exist, but the most common are simple, flat triangular pieces cut out slightly at the base and triangular pieces that are "bubbled," or raised, and cut out around the base. Other corner metal is highly decorative and large, such as that on Sado Island chests. Corner pieces are held in place by means of handmade iron nails.

DOOR DECORATION: Decorative ironwork in a variety of styles and motifs is found on the doors of many tansu. The ironwork should show consistency in style with other ironwork on the chest, especially with the drawer lockplates. Frequently, decorative ironwork on the door of a tansu that has become unusable will be transferred to the door of a second tansu to replace missing metalwork. It is important to check the ironwork on doors carefully and to look for inconsistencies in pattern, thickness, and age relative to other iron on the chest.

OTHER METALS: Although iron is the prevalent metal found on tansu, copper and brass were also used for fittings and to highlight lockplates. On smaller furniture, such as vanities and sewing boxes, copper fittings were used since they appeared more delicate and becoming to cabinetry used by women. Copper handles are found often on wooden *naga-hibachi* as well. Brass is used frequently in combination with iron. Usually brass is used to form a family crest encircled in iron somewhere on the front (especially on sea chests) or is used to emphasize tree leaves, flower petals, or animal motifs on iron lockplates (predominantly on Nihonmatsu clothing chests).

HOW METALWORK AFFECTS VALUE: On original tansu the construction, finish, and metalwork remain unaltered; the chest has required no restoration to change it, even slightly, from its original design. Furniture sold in good original condition is more valuable, and therefore more expensive, than that which has been restored or refinished. It is imperative to check all the metalwork on a chest being sold as an original to confirm that no substitute metal has been placed on it and that no switching of metal has occurred. Minor metalwork on old tansu often requires replacement by new handmade pieces to preserve the beauty, value, and usefulness of the chest. Unfortunately, replacements used are sometimes new machine-pressed steel painted black to simulate iron. If a tansu appears to have new metal pieces, the value of the chest is no greater than if the pieces had not been replaced at all.

In evaluating metalwork, start with the handles, and compare the handles on each drawer to make sure they all conform. Next, compare the handleplates or disks for match. Then, the pieces of metal on the drawer corners should be examined for consistency. If the tansu has a small door, examine the decorative metalwork to determine if it is in the style of other metal on the chest. The drawer fronts behind the door should bear small matching handles that are consistent with larger handles on the front of the chest. If there are locks on these interior drawers, they, too, should be consistent with the other metalwork. (Small locks on inner drawers are often simple in style and are not identical to those on outer drawers.) If the chest has very simple *warabite* handles and round lockplates but an embellished dragon motif is present on the door, a great inconsistency exists: most likely, the door, or at least the metal, has been replaced. Sometimes you can even detect fragments of metalwork that have been nailed right over pieces of original metalwork on a door. If this is the case, close scrutiny will show you that the metalwork is pieced, without pattern, and often of different thicknesses. Check hinges to see if they are intact and if they match. If there are side carrying handles, compare them for uniformity.

All locks on surfaces of equal size should be identical. View each lock from the inside of the drawer to discover whether the wood has been carved out or filled in to fit the lockpiece or, alternatively, whether the lock is original. If lockplates are highly decorative, compare the plates of each lock on the tansu for agreement of motif. All metalwork on a chest should show consistency in age, thickness, decorative theme, and condition. Therefore, if a tansu bears heavy iron handles and thick iron corner pieces on the box but shows thin, newer strips on a door, you can safely assume that the original door metal has been replaced. Physical and artistic conflicts are clear signals that metalwork is not consistent with the original intent.

Chests in good original condition having all their original metalwork are the most valuable. Restored tansu for which replacement metal has become a necessity can also maintain a high value if metal reproductions have been made by hand and are in keeping with other iron on the piece.

As a general rule, thick iron deems a tansu more valuable than thin iron. However, in some older tansu—for example, Edo-period chests—thinner iron may have been used. In this case, you must consider all aspects of the chest, not just the metalwork, in judging its value. Nevertheless, in the majority of cases, the thickness, design, and craftsmanship of the metalwork compares favorably with other features of the chest, including overall construction, the type of wood used, and the thickness of the wood. The condition of the metalwork, the amount which has had to be replaced, if any, and the fidelity in any reproduction, all play a part in the price of a chest.

Finishes

Most Japanese furniture is finished with some type of lacquer or else has no finish at all. Unfinished kitchen chests, paulownia clothing chests, and paulownia and cryptomeria trunks are still found today. Through years of use and exposure, these chests have developed a soft, natural patina. Among paulownia tansu are pieces that look unfinished but, in fact, have been treated with a natural dye taken from the Japanese *yashabushi* tree. The dye is rubbed into the wood to delicately highlight the grain, and often yields a barely discernible, pale sheen.

The early finishes used on tansu were most commonly lacquer-based ones, often combined with organic, natural dyes. It can be difficult to determine whether a finish is original since many partial touch-ups and even overall coats may have been applied through the years. Additionally, new products approximating real lacquer make judgments even harder. Nevertheless, in evaluating finishes, you can look for uniformity in color (even if the finish is worn away as it often is in older pieces) and the absence of a highly polished, "varnished" finish, which often results when modern sealing agents are used.

Natural lacquer finishes combined with natural dyes were capable of producing a variety of colors ranging from the even, mellow, reddish-browns of Yonezawa chest fronts, to the dark, rich browns found on most staircase chests. It is helpful to familiarize yourself with the colors most often found on various tansu styles, since finish is often an indication of a tansu's region of production.

Naturally there will be some overlap as craftsmen were apparently imaginative about experimenting with dyes, lacquers, and techniques and sometimes borrowed ideas from other areas.

The process of Japanese lacquer finishing is highly complex, with many different methods and techniques employed throughout the history of Japanese furniture. Since detailed information on lacquer processes can be found in other publications, this discussion will attempt only to present general information to aid in identification.

Japanese lacquer is a natural product (the sap) of the Japanese *urushi* tree (although other types of lacquer trees exist all over Asia). A strong and sticky substance, lacquer traditionally was applied in many coats to the wood, requiring long intervals for drying between applications. Lacquer itself, when filtered of impurities, contains no natural color, so the black lacquer so often associated with Japanese furniture is the result of either iron oxides or *sumi* (a charcoal soot derived from pine or burned sesame or rapeseed oil) added to the first application. Other natural dyes, also, were added to raw lacquer and applied as a base coat to the wood. The shiny finish on some lacquered furniture is the result of much polishing after each application of lacquer, especially after the final coat.

Because of the strength of lacquer and the number of coats applied, lacquer finishes are quite enduring. Although they may lose their shine and appear cloudy or dull in later years due to exposure and dryness, lacquer finishes provide a protective coating on the wood that is far more effective than stains. However, the shrinking and expanding of wood under the lacquer, even if the wood has been treated and sealed prior to the application, often causes cracks in or chipping of the finish.

Thick lacquer applications are commonly found on cryptomeria tansu to cover what would have been considered ordinary grain and unattractive knots, and to add strength to the soft wood. However, even on the most beautiful zelkova, lacquer finishes can sometimes be found. If you plan to refinish a tansu on your own, keep in mind that thick lacquer finishes are very hard to remove; reapplying lacquer is an art of its own requiring skill and experience. It is often impossible to revive the original gloss to a lacquer finish that has gone dull, since the dulling has occurred from within the lacquer layers. Even if lacquer finishes are mended professionally for cracks or chipping, the mend will always show since it is impossible to exactly reproduce and match new lacquer to old.

Lacquer finishes in impeccable condition are expensive, while dulled, chipped, or cracked finishes greatly reduce the price on a piece of furniture. A tansu showing an original finish in very poor condition (i.e., with areas of discoloration, worn spots, or unintended stains and markings) is of much lower value than one exhibiting a perfect finish, whether original or restored.

Missing and Added Parts, Alterations

After examining hundreds of tansu and hibachi, you will discover that some furniture on sale has been remodeled. Nothing does more to destroy the value, integrity, and history of old furniture than adding unintended parts or attempting

to cover up missing parts. Professional repairs and replacements performed with deference to the original furniture design are quite different from the added pieces and cover-ups to be explained here. Faithfully restored furniture has value, but there is little value attached to furniture that has been remodeled and thereby rendered historically incorrect.

The most common transgressions warranting caution on the part of the buyer are listed below.

MISSING BARS ON BŌ-DANSU CHESTS: The *bō-dansu* is a very popular style of chest since the wooden bar, or *bō*, which vertically covers a series of drawers is usually decorated with attractive metalwork (cf. Fig. 6). Also, the vertical bar divides the drawers to create a pleasing symmetrical pattern. Apparently, although appealing, the bars were formerly considered a nuisance as they hindered easy access into the drawers: it is rare today to find a *bō-dansu* with its original bar attached. Bars were left off tansu for long periods of time and were subsequently lost or left behind when the chest was moved.

The addition of a replacement bar at a later date usually can be determined from differences in the wood type and color of finish on the bar and on the chest. Also, variance between the metalwork design on the bar and that on the rest of the chest is probable. While many replaced bars are harmonious with the tansu style, adding to the chest's value rather than detracting from it, the buyer should be conscious of replaced bars that conflict with the age and style of the tansu.

The most serious problem occurs when a bar hasn't been replaced and the *bō-dansu* is sold as a regular tansu. In this case, the drawers, which originally would have been recessed slightly into the frame of the box to allow space for the bar, are pushed forward, flush with the face of the tansu. Take a drawer out, and you will see that a small piece of wood has been added to the back of the drawer to prevent it from sliding back into its original position. You will also notice that the drawer fronts seem bare. The bar, with a lock at its top end, would have covered these drawers, so the drawer fronts have no individual locks as seen on other types of tansu. Therefore, any time you discover large tansu drawers without locks, explore the probability that the chest was originally a *bō-dansu*.

Another clue in determining if a chest is missing its bar is the presence of iron receiving-pieces on the central top and bottom of the box frame where the bar was once attached. Put your finger under the top piece of metal and you can feel the hole in the wood of the frame that would have received the bar lock's bolt. If these iron pieces have been removed, nail holes and a variation in wood color are apparent. The best advice concerning *bō-dansu* is simply this: if the bar is missing, don't purchase the chest unless you know for certain that it is a rare piece and that a complementary bar would be worth the cost of reproduction.

MISSING METALWORK AND LOCKS: Metalwork missing from a tansu constitutes an unfortunate, and often expensive, loss. A missing handle, broken hinge, or damaged lockplate is not easily replaced since it usually requires the skill and knowledge of a craftsman if they are to be reproduced with respect to the original intent of the design. If a tansu is missing important pieces of metal

it is best to avoid purchase. Reputable dealers usually replace any missing metal prior to sale, but it is difficult for the average person to find identical metal pieces for a chest with missing metal.

It is usually immediately obvious whether or not a tansu is missing a drawer handle or several hinges, but it is not always so simple to tell whether locks are missing from small drawers. It is easier and cheaper for a dealer to replace a wooden drawer front than to have a new iron lock made that is identical to the one missing. Also, the absence of a lock on a small drawer isn't as noticeable as it is on a large drawer. When inspecting a chest having numerous small drawers, check for nail holes and small cavities, evidence of original lock mechanisms, in the frame surrounding the drawers; the presence of such holes indicates a new drawer front.

SEPARATED TANSU: Many very large tansu were built in sections to facilitate construction and transportation. Particular types of tansu, such as staircase and kitchen chests, often take the form of two (and occasionally three) separate pieces that stack to form a complete unit. It's not difficult to see how these pieces may have become separated over the years with the transitions in family life and the moving of households. As a result, separated tansu sections often end up being sold as individual pieces of furniture. Rarely are two-piece, stacking clothing chests separated, but it's not unusual to find separated staircase or kitchen chests or, occasionally, wheeled chests.

Staircase chests Tall single-piece chests and two-piece stacking chests are common styles of staircase chests, but there is also a rare three-piece stacking style. The most obvious indication of a separated multi-unit staircase chest is its height—too short to connect the ground floor and the loft of a house.

Usually the top unit is put on sale since the bottom unit has a large, flat top surface, which, in combination with just two or three stairs, is awkward in appearance. The top unit, on the other hand, appears as a balanced, small staircase. A two-piece staircase chest is usually joined by several vertical, rectangular wooden pegs that keep the two sections aligned correctly; the squared holes into which these pegs fit are found on the bottom edges of the top section, near the corners.

Kitchen chests In the case of kitchen chests, if the separated top or bottom section is sold alone the wood on the top of either is likely to appear in unusually good condition, bearing none of the familiar nicks and marks of normal wear and use through the years and appearing in better condition than the fronts and sides of the chest. The reasons for this are that the top surface of the top unit is out of reach, since kitchen chests are very high, and the bottom unit's top surface is protected by the top unit sitting on top of it. Often these surfaces were not even stained because they were not seen.

Other evidence of a separated tansu is found in the proportions. A two-piece kitchen chest, when stacked, has somewhat similar width and height dimensions—for example, h. 160 × w. 120 cm. However, a separated section appears much longer than it is high, with less pleasing proportions. Besides kitchen chests, sometimes bottom units of stacking wheeled chests, showing the same unusually low height vis-à-vis width, are also sold singly.

A check of the side carrying handles can offer further evidence of separated chests. These carrying handles serve two purposes: In the case of a single-unit chest, their function is simply to facilitate carrying the tansu. In the case of a stacking chest, handles on the bottom unit serve the additional purpose of holding together the top and bottom pieces. In the latter case, the handle on each side swings upward to fasten to two small iron pins (cf. Fig. 33) and thereby prevent the top piece from sliding. If a single-unit tansu for sale bears the small iron pegs that would have received a handle from a unit below, you can be certain that it was originally part of a stacking tansu. If the iron pegs have been removed, two holes will be evident; and if the holes have been filled with wood putty, this, too, will be noticeable. A discussion of tansu is never without its exceptions, and in the case of side carrying handles we find another: not all stacking chests with side handles on the bottom piece had a receiving fixture on the chest above it. This is especially true for later tansu of the Taishō era.

ADDED PARTS:

Legs and stands Except for reproductions of Nara- and Heian-period furniture, which have legs and stands showing Chinese influence, the great majority of Japanese furniture from the mid-Edo period onward did not bear legs. Only in the case of tea-ceremony shelves and some household shrines are legs part of the construction. In traditional cabinetry, then, legs, stands, or feet are not found. Legs or a stand on tansu or hibachi are most certainly recent additions. Unbelievably, sword chests, sea chests, and small trunks have been found at shows and shops with newly acquired legs and stands, so beware! These additions severely detract from the beauty, original design, history, and value of the piece.

Moldings and decorations Decorative wooden moldings and other non-functional wooden decorations are sometimes attached to the fronts of chest drawers. Any decoration that doesn't conform to the standard of a particular tansu style is an obvious travesty and an assault on the character of the chest. Small wood carvings from temples, such as dragons or lions, are sometimes added to the top of a trunk or the face of a drawer. Other common additions include cheap, carved-wood family crests placed conspicuously on the furniture.

New nails New nails in the metal of old chests are easily distinguishable from old, handmade nails. Machine-cut nails made of steel are shiny, of uniform size, precisely tapered on the shaft, and usually flat-headed, though there are round-headed nails, too. Old iron nails are slightly uneven overall, including heads beaten into a slightly rounded shape by hand. Thus, when nails need replacing in the metalwork of a chest, as they often do, new nails must be used if extra old nails are not available. Many restorers buy old, irredeemable chests solely for the purpose of using their nails on restorable chests. When old nails are unavailable, one alternative is to use new steel nails with rounded heads approximating the size of the original ones. These nails can be blackened after they are inserted. Though new nails are aesthetically inferior in the eyes of the tansu connoisseur, they are, nonetheless, unavoidable if there is no ready supply of old, matching iron nails.

Added wheels Although the wheeled chest is one of the most appealing and popular of all Japanese chests, it is important to determine if its wheels are part of the original construction. The merchant chest was frequently mounted

onto a wheel base in later years, probably the result of personal needs or the belief that it would enhance the chest's value and appeal. A reputable antique furniture dealer will be agreeable to turning a wheeled chest on its back to allow for inspection of the wheel base.

Unless a wheel carriage has been added by a careful and skilled craftsman, attention to the following points should allow you to determine reliably if the wheels are original or not:

1. If the front and back rails are each made of a single board and are integral to the structure of the chest, the wheel carriage is probably original (Fig. 34). If each rail is composed of a single board but forms only a base upon which the chest rests, you should investigate further.

2. If the two axles extend up to the bottom of the chest itself, that is, above the level of the top of the wheels, this is an indication that they are original. Otherwise, except very occasionally in the case of some old Edo-period or crudely constructed chests, the wheels have been added on later.

3. If the finish on the entire chest looks original, does the finish on the box match that on the carriage rails? On original wheeled chests the wood surfaces are all stained the same color.

4. The exposed wood on the underside of the chest should look the same age as that of the wheel carriage. Newer wood appears lighter as compared, for example, to the unfinished interior of the tansu box.

5. If the underside has been painted a dark color or rubbed with mud, you should wonder what is being hidden.

6. If the wheel carriage and the tansu box are made of the same type of wood, it is a positive indication of an original structure. However, be aware that zelkova was sometimes used for the carriage because of its strength, even though the box may have been made of different wood.

ALTERATIONS:

New tansu made from old tansu It has, unfortunately, become a practice among some sellers of antique Japanese furniture to build new tansu from the wood of antique tansu and call the new tansu an "antique" because of the age of the wood. The giveaway of such chests is usually new metalwork since old wood is usually salvaged from a chest which has damaged, irredeemable metalwork. While the wood may be very striking indeed, the piece cannot be considered an antique; its value is the same as any new piece of furniture.

Altered finishes A tansu in original condition still bears the finish applied when it was built. When restoration is necessary due to damage or wear to the finish, it should always be done with respect to the original finish. Painted finishes or those having an "antique" look (darkened corners and roughly painted wood) lessen the value of the chest. One new finish often seen is orange or red paint that has been applied directly over the original, probably worn and scratched, finish. Paint is used because it is far cheaper and because its application is easier than refinishing the piece correctly. On such painted chests the corners of the drawers are usually slightly blackened. The entire result renders the piece valueless as an antique. Any new finish should be executed with fidelity to the original inasmuch as possible, with the aim being to reinstate the original color and appearance.

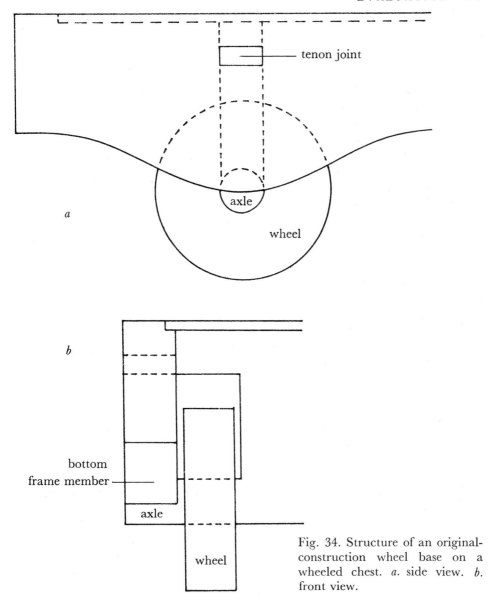

tenon joint

axle

wheel

a

b

bottom
frame member

axle

wheel

Fig. 34. Structure of an original-construction wheel base on a wheeled chest. *a*. side view. *b*. front view.

A Note on Pricing

One of the certain things known about tansu, especially originals, is that their prices continue to go up! One American tansu collector and enthusiast started collecting rare, antique tansu in 1963, when $200 bought quite a masterpiece. His collection today, just twenty years later, has many times increased its value. Although he began collecting because he needed furniture, he was excited by what he found, and he soon became a serious collector and an expert.

The excitement continues and is still apparent today as more people collect tansu and prices of antique Japanese furniture increase from year to year. Not

Tansu Evaluation Checklist

Construction

1. Is the overall construction sturdy and without glaring structural problems?
2. Does construction appear to be original throughout?
3. Are all drawers and doors accounted for?
4. Are the sides and top of the tansu of uniform thickness throughout?
5. Is the construction of the fitted-piece type or the single-board type?
6. Are drawer fronts of solid pieces of wood (i.e., over 19 mm thick)? Or, on the inside, do they feel thicker at the top than at the bottom?
7. Are the sides of the drawers at least 8 mm thick?

Wood

1. What types of wood are used?
2. Have new pieces of wood been added anywhere?
3. Are large cracks, splits, or warping evident?
4. Is past or present bug damage apparent?
5. Is water damage or warping evident?
6. Has veneer been used anywhere?

Metalwork

1. Is the metalwork in good condition?
2. Do all similar pieces look consistent in shape and thickness?
3. Is any metal machine-pressed?
4. Are any pieces missing, broken, or deteriorated?
5. Are all locks accounted for and intact?
6. Do lockplates and lock mechanisms (single- or double-action) help indicate age?
7. Are the nails used to affix the metalwork handmade of iron?
8. Are the motifs on decorative metalwork consistent throughout?
9. Does metalwork throughout appear to have been painted?
10. Is the metal thick (over 1 mm), moderately thick (1 mm), or thin (less than 1 mm)?

Finish

1. Does the finish look original?
2. Has stain or a finish been recently applied?
3. If finished with thick, opaque lacquer, is the lacquer in good overall condition, or are cracks, chipping, and dulling evident?
4. Is the finish in overall good condition?

Other

1. Have any non-original, unintended parts been added?
2. Could the tansu have originally been part of a double chest?

everyone can afford to be a collector or provide the space that a tansu collection demands. However, owning a tansu can add beauty to a home and can offer utility as well.

Numerous aspects affect the price of any particular piece, as discussed earlier in this chapter. Condition, rarity, and quality of construction influence the price greatly, as does a professional restoration. Other variables exist as well, and can play an important role in how tansu are priced. For example, often huge tansu can be purchased at what appear to be cheaper prices because their size limits their use in many homes. Likewise, small tansu—those easily used as tables in living rooms and bedrooms—command higher prices, and sometimes are overpriced because of their popular dimensions. Fashions in certain styles are also a factor. For instance, in the last five years prices have risen at a particularly rapid rate for staircase chests, kitchen chests, and sea chests. Sea chests are becoming rare, but staircase and kitchen chests have gained great popularity owing, probably, to their utility, or in the case of the staircase chest, its unique structure.

As this chapter has outlined, it is well worth your while to familiarize yourself with the various styles and features of tansu before deciding on your first purchase. A comparison of prices at shops and flea markets will help you form an idea of how much money buys what kind of tansu. For the connoisseur who wants original tansu in perfect condition, such tansu are available—at a price. What the connoisseur gets is a reliable investment. While the purchase of antique chests in good condition represents a sure investment since prices keep moving upward, the widely produced styles of Meiji-era tansu are best viewed as high-quality furniture with some potential of increasing in value over time.

It is advisable to look at as many tansu as possible, to compare features and prices, and to keep in mind the ideas brought forth in this chapter, summarized by the checklist opposite, as you set about your exploration.

3 Restoration

Restoring Furniture at Home

The savings involved in restoring a piece of antique furniture at home rather than purchasing it in a restored condition is a great motivation for many collectors of antique furniture. If your first attempt at restoration is with Japanese furniture, it is advisable to begin with a small, simple piece before advancing to a large, more elaborate piece. A wooden hibachi or small tansu is good for the beginner, as are any other small pieces, such as money chests or sewing chests. Although a tansu is used as the example in this chapter, the basic restoration procedure presented can be applied to any piece of wooden furniture.

The information here covers a proven, step-by-step procedure for complete restoration of a typical tansu, such as those introduced in Chapter 1. The objective here is to restore the piece to as close to its original appearance as possible, using modern materials and techniques to reduce the amount of time that the traditional methods would require. The true purist uses old methods and materials, but most probably for ethical reasons. The procedure described here will yield a finished piece with all of the beauty and durability of the original.

The instructions included in this restoration procedure anticipate virtually any problem you might encounter. Naturally, not all the steps will be required for every piece since each piece of furniture has different needs. With the help of Chapter 2, however, you will have purchased a tansu at a price that reflects not only its intrinsic value but also the amount of work required for restoration. The procedure is arranged so that you can simply skip steps that are not necessary for your piece of furniture.

Before beginning, think carefully about what you want the finished piece to look like. If you are not sure how your tansu looked originally, visit antique shops to get an idea of the colors of the finishes used. This is especially helpful in the case of a tansu whose box was originally stained a different color from the drawers. Many people like the "antique" appearance of a tansu that bears the scars and marks of use.

If your tansu is in basically sound condition structurally and the wood surfaces and their finishes are intact, you may want to consider the following "mini-restoration" procedure as an alternative to complete restoration:

1. Clean the tansu thoroughly, inside and out, with a solution of TSP (trisodium phosphate). This will remove dirt, old wax, and loose particles of finish.

The TSP wash is sufficient preparation for touch-up staining of the wood surfaces; sanding is not necessary. The wood surfaces will appear lighter and smoother after the TSP wash.

To use TSP put four liters of very hot water in a pail. Add one cup of TSP crystals and mix until dissolved. Apply the TSP solution liberally to the wood surfaces with a scrub brush. Using firm pressure scrub in the direction of the wood grain. Some suds will develop as you scrub the solution across the wood. When all surfaces have been scrubbed, wash away the residue and suds with a sponge and clean water. Wipe off excess water with a clean soft cloth. Let the piece dry, away from the sun, for twenty-four hours.

2. Wipe the cleaned tansu surfaces with an oil-based stain that matches the original color. The wide range of stain colors available will allow you to closely approximate the original color. Apply the stain to the wood with a clean soft cloth. Allow to dry twenty-four hours.

3. Wax the outside, stained surfaces with a good-quality furniture paste wax. Apply the wax with a soft cloth, working with the grain of the wood. Allow the wax to stand about fifteen minutes per surface, and then buff with a clean, lint-free cloth. (Wax in this way at about six-month intervals.)

It should be noted that the use of shoe polish as a finish for the outside surfaces is sometimes presented as a short cut to the three steps above. Shoe polish is not suitable for wood since it is designed to be flexible and, therefore, is formulated primarily from softer waxes than those found in high-quality wood waxes; in short, it does not offer adequate protection. Additionally, shoe polish becomes dull and lifeless rapidly, necessitating frequent reapplications. Some shoe polishes contain silicone (for its water-repellent properties), a substance which should never be used on furniture since it penetrates deeply into the wood and prevents the proper application and adherence of finishes, stains, or quality waxes.

4. Polish the metalwork with stove polish, but remember that loose rust should be removed from metal with steel wool (0 grade) before you begin polishing. Apply the polish with a soft cloth. Allow it to sit for a couple of hours and then buff with a clean cloth.

You are now ready to decide whether the piece pleases you as is or whether you want to embark on a restoration project. The restoration procedure is not difficult, but it does require time, especially your first project, even with modern materials and tools. The best results are obtained by those who work carefully and are willing to take the proper time for each step. In fact, if there is any one secret to achieving satisfactory results, it is to take your time. A rush job will almost always end in mediocrity. On the other hand, a carefully restored piece with only minimal care will provide enjoyment and utility for generations.

There is an inclination among first-time restorers to purchase a cheap tansu as a practice piece for a trial restoration before attempting the procedure on a more valuable antique. However, since this represents a substantial time investment in a piece with which you may never be completely happy, it may be more practical to begin with a small piece that you like and will use. Even if you have no prior experience in woodworking or furniture refinishing, following the restoration instructions carefully and allowing the proper amount of time for each step should produce a beautifully finished piece of furniture.

Materials and Tools

The materials and tools listed below are sufficient to solve any of the diverse problems that may be encountered in your restoration project. Not all materials will be needed for every restoration, since each piece of furniture has its own specific needs. Therefore, read through the restoration procedure before purchasing materials or tools that may be unnecessary for your particular project. First decide what kind of restoration your piece actually needs, and then go shopping.

All materials and tools listed are available in the United States at well-stocked hardware or craft stores. In Japan, neighborhood hardware stores and supermarkets stock many of the supplies, and most supplies can be purchased at the following Tokyo stores:

Ito-ya, 2–7–15 Ginza, Chūō-ku, Tokyo
Tel: 561–8311
A handyman's paradise, this store has eight floors of supplies and tools. English is spoken. (Open every day of the year)

Tokyu Hands, 12–18 Udagawa-chō, Shibuya-ku, Tokyo
Tel: 476–5461
This handsome store caters to the young but has an extensive range of "do-it-yourself" supplies and tools. Someone in every department speaks English. (Closed 2nd and 3rd Wednesdays of each month)

Kawamoto Paint Store, 7–21–1 Roppongi, Minato-ku, Tokyo
Tel: 404–0666
This shop has a large selection of stains and related products; most of the restoration supplies can be purchased here. The proprietor speaks English. (Closed Sundays and national holidays)

Sanwa Byora, 4–2–5 Toranomon, No. 3 Matsuzaka Bldg., Minato-ku, Tokyo
Tel: 433–1706
A discount hardware shop specializing in nails, hardware, and hand tools, Sanwa has been in this location for thirty years. Tools can be special-ordered if they are not in stock, but it's best to know the name of what you need in Japanese, as no English is spoken. The staff, however, is willing to help you hunt for wares or use the numerous tool catalogues at the shop. Power tools are not kept in stock but can be ordered. Discounts on hardware and tools range from 30% to 60% off regular retail prices. (Closed Sundays and national holidays)

In the list of materials and tools, the abbreviations I (Ito-ya), TH (Tokyu Hands), K (Kawamoto Paint Store), and S (Sanwa Byora) have been used to indicate where the supplies can be purchased. For the few products available only in the United States, a Japanese substitute is given. Brand names are mentioned for products recommended for use in this restoration. (When shopping in

Japan, you can call many of the supplies by their English names.) Figure 35 shows the tools used in the model restoration.

Materials

bamboo skewers

cans or glass jars: several clean, shallow containers

Cashew: one 80-ml can; available in a range of colors from clear to wood colors to black (I, TH, K)

cloths: clean, soft, lint-free

Elmer's glue: regular or wood glue, one medium-sized container (I, TH)

enamel spray paint: one small can of flat, black paint. (Japanese stores use the term "no gloss" for flat or matte colors.) (I, TH, K)

insecticide: use any brand of spray insecticide designed for use on wood (look for a picture of a wood-eating worm or termite or a wood-grain pattern on the front of the can). Buy a spray can with a long needle-like, attachable nozzle to permit penetration into bug holes. (I, TH)

iron sheets: if necessary for making replacement part (I)

nails: one package of about 30 steel one-inch (2.5-cm) finishing nails (I, TH, S)

oil-based stain: one 260-ml bottle (enough to cover an average tansu). The brand used in this restoration is Kampe. (I, K)

paste wax: Butcher's Boston Polish Wax (available only in the U.S.) is recommended. If using a Japanese wax, ask for *katai*, or hard, wax. Japanese waxes are generally softer than the American wax recommended here but will do the job. Wax comes in metal tins and keeps indefinitely if tightly sealed after each use. (I, TH, K)

plastic or rubber gloves: disposable plastic gloves on a tear-off roll are available, but standard rubber gloves can be reused many times (I, TH, S)

sandpaper: silicon carbide or aluminum oxide papers are the most durable. Approximately five sheets each of rough, medium, and fine grit (15 sheets total) are needed for an average tansu. (I, TH, K)

Scotch tape: one roll

sponge: Cell-O brand is recommended (TH)

stove and grill polish: Butcher's brand (available only in the U.S.) is recommended. An old-fashioned Japanese product called *wanisu*, which is derived from coal tar, can be substituted.

steel wool: sold in continuous rolls, which can be cut off as needed. Have on hand one roll of 0000 grade, one roll of 00 grade, and one roll of 0 grade. The grade is marked on the package. Do not substitute scouring pads or similar products. (I, TH, K)

tarpaulin: one sheet large enough to spread under the tansu and work area. Cheap plastic can be bought from large bolts cut to the size needed. (I, TH)

TSP (trisodium phosphate): one box, 400g, in crystal form (Yoneyama Yakuhin Kogyo, 252–4571)

turpentine: one liter (I, TH, K)

waterproof sandpaper: two sheets of at least 400 grit (I, TH, K)

wood putty powder: one box, approximately 200 g (I, TH)

wood strips: two 2 × 4 in (5 × 10 cm) pieces and, if needed, pieces cut to size to repair cracks (I, TH)

wooden chopsticks: four pairs

Tools

belt sander (TH)
block of wood: approximately
 10 × 10 × 2.5 cm (TH, I)
C-clamps (optional)
center punch (I, TH, S)
claw hammer (I, TH, S)
cold chisel (I, TH, S)
ear protectors (optional)
electric drill (I, TH) (optional)
hacksaw (I, TH, S)
hand sander (I, TH, K, S)
hand saw (I, TH, S)
metal file or grinding wheel (I, TH, S)
metal shears or tin snips (I, TH, S)
metal straightedge (I, TH)
nail puller: slant-headed electrician's
 wire clippers are ideal (I, TH, S)
nail set (I, TH, S)
needlenose pliers (I, TH, S)
orbital sander (I, TH, S)

pipe (or bar) clamps (TH, I)
pocket knife (I, TH)
putty knife (I, S, TH)
safety goggles (I, TH)
Sandvik #400 sanding file (I, TH)
 (optional)
screwdrivers: have three (very small,
 medium-sized, and large) on hand
 (I, TH, S)
scrub brush: hard natural bristles
 work better than plastic
Surform plane (I, TH)
tap hammer (TH, I, S)
toothbrush: an old, used one
vacuum cleaner
vise (I, TH)
weight: concrete block, several bricks,
 or the like
white felt-tip pen (I, TH)
wood chisel (TH, I, S)

Supplies for Special Problems

The following shops sell precut metal parts, should you opt to use them:

Shimizu Shoten
2-14-33 Akasaka, Minato-ku, Tokyo
Tel: 583–3330/5294
This shop has a large selection of metal parts (including handles, metal corners, knobs, pulls, nails, etc.). No English is spoken so take a sample or drawing of what you need. (Closed Sundays)

Hori Shoten
2-5-2 Shimbashi, Minato-ku, Tokyo
Tel: 591–6301
This is an old-fashioned shop selling a variety of metal items including keys for locks, handles, metal plates, etc. No English is spoken. (Closed Sundays and national holidays)

If you need an unusual type or large quantity of wood for your restoration project, investigate the numerous wholesale lumber shops along the main street starting at Ichi-no-hashi intersection and going toward Mita. You'll know you're there when you see stacks of lumber everywhere. While you can find what you need at almost any of these wholesale stores, a favorite is:

Shimura Shoten
1-6-1 Mita, Minato-ku, Tokyo
Tel: 451–0504

Fig. 35. Tools used in the restoration project.

a. pipe clamps
b. vise
c. tin snips
d. metal shears
e. needlenose pliers
f. slant-headed electrician's wire clippers ("nail puller")
g. Surform plane
h. hand saw
i. hand saw for fine work
j. hacksaw
k. claw hammer
l. tap hammer
m. screwdrivers
n. hand sanders
o. ear protectors (optional)
p. safety goggles
q. Sandvik sanding file (optional)
r. putty knife
s. metal files
t. cold chisels
u. center punch
v. nail set
w. pocketknife
x. wood chisel

A visit to this shop, built in mid-Meiji, is well worth the trip. The present owner, Mr. Shimura, speaks no English, but he adores wood and will take you up several flights of laddered stairs to lofts supported by giant zelkova beams to show you prize pieces of old wood. If possible, take with you a piece of the wood you want to match, or know the Japanese name of the wood type you need. Remember that wood is expensive in Japan, and even a small piece of cryptomeria can be costlier than you would expect.

Restoration Procedure

A late-Edo double-door clothing chest (Fig. 36) is used as the model for this furniture restoration procedure. Constructed entirely of paulownia, this tansu was selected as the restoration model since it has drawers, hinged

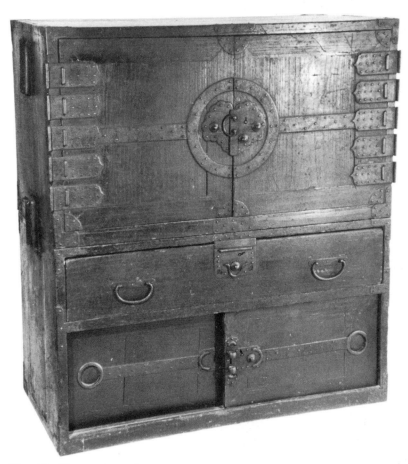

Fig. 36. The tansu to be restored: a two-piece double-door clothing chest in original unrestored condition. Note that the original lacquer-based finish, now darkened with age, completely obscures the paulownia grain.

doors, and sliding doors, representing a variety of construction features, any of which may be found on numerous tansu from the late Edo period and the Meiji and Taishō eras. The tansu bears an average amount of ironwork and was originally finished with a dark natural lacquer. Because the chest is of late-Edo vintage, it reflects features other than those typically associated with the broad range of Meiji-era double-door clothing chests as outlined on page 55. Restoration of this tansu took approximately forty hours of actual labor excluding drying times for glue, putty, stain, and finish (since such times vary from piece to piece).

Read through the entire procedure first to get a basic idea of which steps apply to your particular piece of furniture. The sequence (Fig. 37) will then flow smoothly once you proceed with the actual work.

Tansu Restoration

Preparatory Steps

1. Fumigate
2. Check fit of drawers
3. Remove metal from drawers, doors, and box
4. Remove locks and lockplates
5. Code metal parts

Metal Restoration

6. Straighten metal
7. Clean metal
8. Make metal replacement parts
9. Finish metal

Wood Restoration

10. Replace and strip in wood
11. Repair cracks and splits in top and sides of box
12. Repair cracks and splits in back of box
13. Adjust fit of drawers
14. Repair cracks and splits in drawer bottoms
15. Reglue joints
16. Prepare for finish removal
17. Remove old finish
18. Clean
19. Stain
20. Seal
21. Wax

Reassembly

22. Replace metal parts
23. Replace drawers and doors

Fig. 37. The restoration procedure at a glance.

1. Fumigate

Wood-eating moths are a tansu's number one enemy. Even if there is no visible bug damage on your tansu, which is somewhat rare, it is likely that it is or could be under attack, or harbors eggs that will later hatch into the wood-eating larvae of several moth species common in Japan. To protect your tansu, as well as the rest of your furniture, fumigating the entire tansu before bringing it into the house is a must. An all-purpose bug spray, or one specifically designed for termites and moths, should be applied through a needle-like tube (sold with some sprays) into all visible holes, inside and out, and along all cracks, joints, and seams from the inside. Remember to wipe off excess spray that may leak out onto the tansu's surface. The thin tube attachment allows you to reach into holes and crannies, so a thorough application can be made. Spray the interior of the tansu (without the needle-like tube) after removing all the drawers. Replace the drawers and spray their interiors. After spraying, put several mothballs in each drawer, and close all drawers and/or doors. The tansu should remain this way for at least a couple of days, or until you are ready to begin work. (By the time the restoration procedure is finished, the distinct smell of insecticide will have subsided.)

Note: Remember to handle insecticide with caution, directing spray away from your eyes and nose. Always fumigate outdoors. Bring the tansu indoors only after the entire piece has been sprayed and closed up.

2. Check fit of drawers

Fairly frequently, the tansu drawers will protrude from the box. This is usually the result of shrinkage of the box as the wood lost moisture over the years. Since virtually all wood shrinkage occurs across the wood grain (Fig. 38), the depth

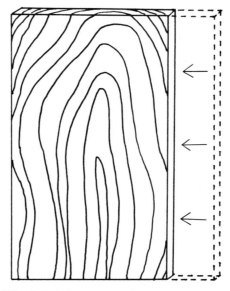

Fig. 38. Wood shrinkage occurring across the wood grain.

of the box will shorten as shrinkage occurs, while the wood of the drawer sides and bottom, having its grain longitudinal to the depth dimension, will not shrink measurably. Mark the backs of those drawers that protrude excessively so you will know which ones to shorten in Step 13. Also mark each drawer as to its position in the tansu (this can be done in pencil on the back of the drawer) so that drawers can be returned to their proper spaces when the restoration is completed.

Note: Check to make sure there is not any dirt or trash behind protruding drawers which is hindering their complete closure. It is frustrating to shorten a drawer only to discover that the real problem was a wad of paper trapped behind it.

3. Remove metal from drawers, doors, and box

This is a time-consuming step, especially if the nails holding down the metal are deeply imbedded and heavily rusted. Nails are also much more difficult to remove from hardwoods (zelkova and chestnut) than from softwoods (paulownia, cryptomeria, and cypress). It is possible to refinish your tansu without removing some of the metal, and this is the time to decide if you will remove all of the metal, or just some part of it, before proceeding.

Generally, it is better to remove the handles and handleplates, locks and lockplates, and decorative metal from the drawers and doors because of the difficulty of evenly sanding and finishing around them. The time gained by leaving the metal on will usually be spent later in hand sanding around the metal, especially if it is irregularly shaped or has cut-outs.

Since the exposed wood surfaces of the box are fairly large and the metal parts (usually only corner pieces and carrying handles) most often have straight edges, this metal can be left on the box. Extra care will be required, however, in sanding as close as possible to the edge of the metal, and in avoiding sanding away the metal itself, especially the nailheads. If the box requires woodworking, such as repairing cracks or replacing damaged wood, it is better to remove the box metal. Metal removal usually results in a neater job in any case. The one major exception is side carrying handles. Usually these are attached with heavy clips of iron, similar to cotter pins, which are difficult to remove since they must be bent straight from the inside of the box. In the long run, it is much easier to leave these handles on and work around them.

The most useful tool for extracting the nails is slant-headed electrician's wire clippers, hereafter called nail puller. Grip the nail under the head with the point of the puller and then rock back on the slant head to lever the nail up and out (Fig. 39). Save all nails. If two or more nail sizes are present, group the nails by size and note where they were used. Always wear safety glasses or goggles when pulling nails, as nailheads sometimes pop off at very high velocities. Lever the nail puller against the metal, *not the wood,* to prevent scarring of the wood surface.

If you cannot get a grip on the nail under its head, position the edge of a small cold chisel (or very small screwdriver) against the nailhead where it meets the metal part and strike it sharply with a mallet or hammer, once or twice on each side of the nail. This will loosen it enough to enable you to work the nips of the nail puller under the head for a firm grip.

Each drawer handle is attached with two metal clips that extend through the drawer front and are bent back on the inside (Fig. 40). Use a screwdriver to lift the ends of each clip away from the back of the drawer front (Fig. 41) and then, with needlenose pliers, straighten the ends out perpendicular to the wood surface (Fig. 42). The handle can then be pulled off the drawer, drawing the two clips through the wood and the handleplate. A claw hammer, or the nail puller, can be used to lever the clips out in stubborn cases (Fig. 43).

Note which, if any, metal parts need to be replaced (often the bottom corners of the box do) and lay the metal aside. Metal that has rusted through in places and missing pieces will need to be replaced. Cutting and replacing new metal is discussed in Step 8.

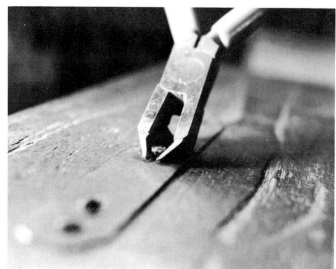

Fig. 39. Levering a nail out with nail pullers.

Fig. 40. Handle clip bent back on the inside of a drawer front.

Fig. 41. Lifting up end of handle clip with a screwdriver.

Fig. 42. Straightening ends of handle clip with needlenose pliers.

Fig. 43. Pulling out handle clip (and handle) with a claw hammer.

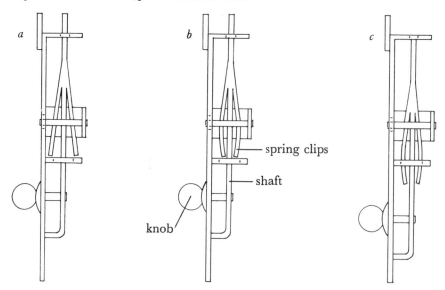

Fig. 44. Disarming a lock mechanism (side view). *a.* single-action lock in locked position. *b.* locking mechanism disarmed by bending spring clips inward towards shaft. (Shaft and external knob will now move up and down freely without use of a key.) *c.* disarmed lock in unlocked position.

4. Remove locks and lockplates

If the tansu locks are fastened to the wood with nails or studs, these should be removed in the manner described in Step 3. Some locks, often those produced in late-Meiji and Taishō, were attached without the use of nails (with the exception of possibly one or two small nails at the top of the shaft guide plate). These later locks have slanted spikes on the back side, which are driven into the wood at an angle. They are usually easily removed by gripping the top of the lock with pliers and pulling up and out. Occasionally it is necessary to loosen them slightly before removing them. If a knob is present on the lockplate, you can tap it upwards with a hammer; otherwise, insert the key (or any other small piece of metal, such as a long nail) into the keyhole and tap it upwards with a hammer. Lock mechanisms are attached to or formed as a part of the lockplate, so the entire lock mechanism and lockplate will come away from the wood as one piece.

If you have keys for the locks, it is advisable to make sure they work while you have the locks off the chest. If you don't have keys or don't wish to use the locks, it is a simple matter to "disarm," or disengage, them without doing permanent damage. Bend the spring clips together with a pair of needlenose pliers (Fig. 44) so that they slip easily inside the retaining ring without having to be forced together with a key.

5. Code metal parts

As each piece of metal is removed, mark it on the back with a white felt-tip pen to indicate the metal part's position on the tansu. All metal parts, with

the exception of drawer handles, can be turned over and marked on a flat part of the backside. Handle position should be marked on one of the clips that attach the handle to the wood; if a handle is marked directly, it will be difficult later to polish the handle without concealing its marking.

A simple code can be used for the metal parts. For example, you can number the drawers consecutively from top to bottom, and left to right, as you face the tansu. Indicate the metal position on the drawer with L for left and lower, R for right, and U for upper. Thus, the lower left corner metal on the top drawer is marked "1 LL." Since you will likely be dealing with handmade metal, pieces that look identical will actually be slightly different. If you know where the metal was originally, you know it will fit into its original place perfectly when it is time to reassemble everything. This is especially important for hinges because swinging doors will not fit properly unless the hinges are replaced exactly right.

From this point, metalwork restoration, Steps 6–9, and wood restoration, Steps 10–21, proceed independently until Step 22. Follow the steps in sequence or, if you like, skip ahead to Step 10 and restore the wood first, before tackling the metalwork.

6. Straighten metal

Metal pieces that have flat surfaces sometimes become distorted during the process of removal from the tansu. The first step in restoring metal parts is to restore the metal to its original shape. This is easily accomplished by tapping the metal back into shape with a small tap hammer, in the following manner.

Lay the metal piece on a hard flat surface (such as a work table or concrete

Fig. 45. Flattening a metal part with a tap hammer.

block), and hammer it flat, using only enough force to accomplish the job (Fig. 45). Do not, of course, flatten pieces that were originally formed with ninety-degree bends, such as corner pieces. Tap each flat surface back into shape, one by one, and then restore the ninety-degree bend by hand, shaping the angle with pliers. In the case of very thick metal, it may be necessary to hammer against a hard right-angle edge, such as that of a work table, around which you can shape the metal.

7. Clean metal

Remove any loose rust from each metal part with a piece of sandpaper of about 100 grit, being careful not to sand away your location markings. During this process, lay aside any pieces that must be replaced. This will include any broken pieces and those so badly rusted that part of the metal has corroded away. You may also have to replace pieces missing from the tansu when you purchased it. Replacing metal is discussed in Step 8.

The objective of metal cleaning is simply to rid the metal of apparent rust deposits. The surface pitting and small imperfections found on old iron is what differentiates it from new iron, and is part of its charm, so do not attempt to sand the metal to a completely smooth surface. Wash all metal pieces with soapy water after the loose rust has been removed. Rinse, pat the pieces dry with a rag, and then spread them out on newspaper to dry thoroughly.

8. Make metal replacement parts

Any metal part can be duplicated, but complicated or difficult pieces, such as locks and handles, are jobs for a skilled craftsman and are beyond the scope of this procedure. Presented here are methods of making replacements for pieces originally made from a single sheet of iron, including virtually all the pieces you will encounter with the exception of locks and handles.

Cut and drill the metal　Secure a sheet of iron of the same thickness as the metal piece to be replaced. If you have the old piece, hammer it completely flat so that you can use it as a pattern. If an original piece is missing, make a cardboard pattern by studying similar pieces on the same tansu or by tracing an identical piece. For pieces that bend, such as box corner fittings, it is necessary to flatten them for tracing and rebend them later. It is best to use iron that has developed a thin layer of surface rust so that the surface texture will be similar to the remaining original iron. New iron can be kept outside a few weeks and allowed to weather to a slightly rusted texture.

Lay the pattern flat on the iron sheet and trace around the edges using a felt-tip pen; a sharp object, such as a punch, with which you can etch the pattern; or a brass or aluminum "pencil" made specifically for this purpose. After the pattern has been transferred to the iron sheet, cut out the new piece with metal shears or tin snips (for metal less than about 16 mm thick). For thicker metal, place a cold chisel at the edge of the pattern and hit it soundly with a hammer. Continue this until the pattern is cut out. Alternatively, a hacksaw or jeweller's saw can be used to cut thick metal.

Mark where the nail holes should be located. Using an electric drill, if available, drill the holes, using a drill bit designed for metal drilling and of the

same diameter as the nails to be used. In the absence of an electric drill, use a hand drill; or, using a hammer, simply punch holes with a nail slightly larger in diameter than the ones to be used to affix the piece of metal.

Shape and bevel the metal Using a grinding wheel, or a metal file, smooth off any burrs on the edges of the metal, and true up the edges to the exact shape of your pattern. Many metal pieces on tansu have beveled edges, so note which edges should be beveled. To bevel the edges, use a grinding wheel or metal file to file down the edge of the metal until a slight angle is formed. When the angle matches that of the original the beveling is complete.

Next, flatten out any distortions in the new piece that may have occurred during the cutting process. If the piece you are replacing is completely flat (for example, a drawer corner or handleplate), you are ready to proceed to the next step.

Other pieces, such as bottom box corners, have one ninety-degree bend, and, therefore, the replacement pieces must be bent to the appropriate shape. This is most easily accomplished with the help of a vise. Clamp the new piece into the vise, carefully aligning the top edge of the vise with what will become the new angle of the bend. Then gently hammer the protruding end down until it lies flat on the top edge of the vise.

However, in the case of the top box corners, two bends are required. Make the first bend along the top bar of the T shape (Fig. 46*c*), then re-clamp one edge and bend along the stem of the T (Fig. 46*d*). If you do not have a vise,

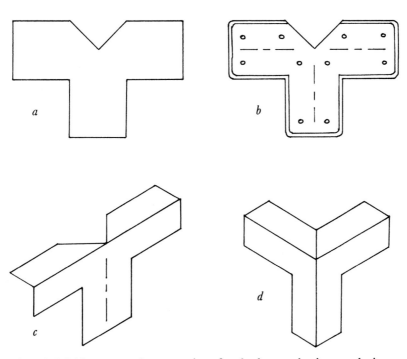

Fig. 46. Making a metal corner piece for the box. *a*. basic metal piece. *b*. nail holes and beveled edges added. *c*. first bend along the top of the T. *d*. second bend along the stem of the T.

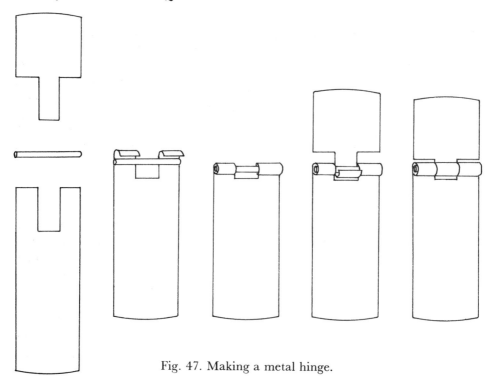

Fig. 47. Making a metal hinge.

the job can be accomplished by, using existing nail holes in the piece, nailing one edge of it onto a piece of hardwood having a right-angle edge. Bend the metal by tapping it with a hammer, and then remove the nails. Remove any loose rust with sandpaper.

To make a new (replacement) hinge, trace the outline of an existing hinge directly onto a sheet of iron. You will need to unroll the ends that curl around the pins to get the exact size. Cut out the hinge. Roll the extending ends of the two hinge pieces around a pin of the appropriate size (such as a nail shaft) with pliers (Fig. 47). Some trial-and-error adjustment of the degree of the roll will be necessary to get the fit exactly right. Needlenose pliers are particularly useful in making these adjustments. To make the hinge pin, clip off the head and pointed end of a nail of the appropriate size with the nail puller.

9. Finish metal

This procedure is for furniture with iron fittings that need to be blackened. If the iron is in good condition, skip the spray painting and proceed directly to the polishing. Brass or copper parts can be easily cleaned and polished with commercial products.

Arrange all iron pieces face up on sheets of newspaper. From a distance of about 8 cm, spray one even coat of flat black enamel on the metal. Turn over handles and spray undersides, but first cover your location markings on the handle pins (with a piece of Scotch tape, for example) so they will not be obliterated by the enamel.

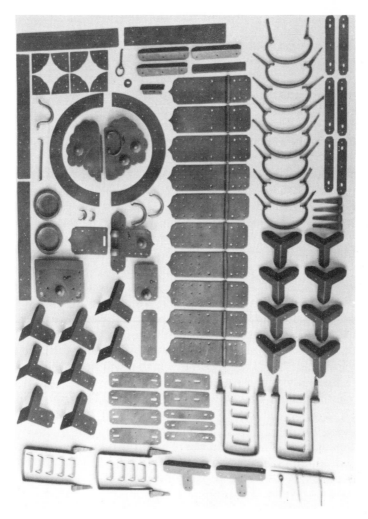

Fig. 48. Finished metal parts ready to be replaced on the tansu.

Allow the paint to dry thoroughly (a couple of hours is sufficient for most spray enamels), and then apply paste stove-and-grill polish to all surfaces of the metal that will be visible when replaced on the tansu. Use an old toothbrush to work the paste into crevices or uneven surfaces. Let the polished metal sit at least an hour; then buff it thoroughly with an old, rough-textured cloth (old towels work well). The spray paint will cover any shiny spots on new pieces or those caused by overzealous sanding. The stove polish will impart a protective, slightly metallic finish that closely resembles the appearance of the original. The finished metal parts for the model tansu are shown in Figure 48.

After refinished nails are replaced on the tansu, they may need a bit of a touch-up if the hammer nicked the painted surface or if they are new nails. Simply use a large, black felt-tip marker and dot on color where needed.

10. Replace and strip in wood

Replace wood　Occasionally, due to physical or insect damage, a piece of wood on the tansu needs to be replaced. It is always best, if possible, to replace the entire board that bears damage, and it is always best, if possible, to use wood of the same age as that being replaced. Of course, the wood should be from a tree of the same species. New wood accepts finish at a different rate and in a different way than old wood, and matching the color will, therefore, be troublesome if the replacement strip or piece is new.

If you know when you buy the tansu that you will have to replace some wood, try to obtain from the seller an old piece of wood of the appropriate size and kind. Many shops and dealers are happy to oblige this kind of request provided the wood needed is not a large, expensive piece. If an old piece of replacement wood is not available, a cheap, scrapped tansu of the wood you need is another alternative. (The metal, especially the nails, can also be recycled.) Old tables, too, are a good source for replacement wood, especially zelkova. If none of these options works out, you can purchase aged wood at some lumber stores. If you go to a lumber store, it is advisable to take a piece of the tansu wood you are trying to match with you.

If you are going to replace an entire piece of wood, remove that piece from the tansu. Do this carefully, from the inside, using a wood block and hammer, following the same procedure described in Step 12. The thickness of the new piece should match the pieces to which it will be attached. Saw the new piece out slightly larger than the old, and gradually work it down to the exact size using a Surform plane or a knife, and/or a sander. Then glue it to the edge(s) of wood next to it and clamp it in place, leaving it clamped for twenty-four hours.

If only a small area of a large piece of wood is damaged, or if bug damage occurs in two adjoining pieces along the joint (fairly common in paulownia tansu), it is usually better to strip in a thin piece of wood.

Strip in wood　Wood stripping is useful for boards that have sustained some damage but not enough to require an entire replacement board as discussed above. A wood strip is placed within an existing piece of wood, and as such, its thickness does not have to match the thickness of that wood. This is because the replacement strip need only be recessed to a depth which allows it to lie flush with the surrounding wood. Therefore, a damaged area can be cut out just deep enough to remove the damage and allow a thin replacement strip to fit flush into the cavity.

If possible, plan to strip in a piece of wood the entire length of the panel (that is, in the direction of the wood grain), even if damage is apparent only at one edge or in the middle. The grain will match much better and, in most cases, the repair will be unnoticeable. The model tansu for this restoration necessitated stripping in wood into a board on the back of the piece. In this case, the wood strip is the same length as the panel in which it will be placed and is just slightly (about 1 cm) wider than the area affected by the damage.

Measure the widest part of the damaged area. Then, on the replacement piece of wood, measure the same width across, add 1 cm extra, and draw a straight pencil line down each lengthwise side according to this total width. Place the strip over the damaged area so that the damage is centered under-

neath. Clamp the strip into place at the center of one end. Next, place the metal straightedge on top of the strip, lining it up with either edge. And clamp into place (cf. Fig. 49) at the end opposite the first clamps. Press down firmly on the straightedge at its unclamped end, and with a sharp knife, cut through the replacement strip and into the damaged wood at the same time along the edge of the pencil line. (Remember, the depth you cut into the damaged wood need only match the thickness of the replacement strip.) Then, repeat this procedure along the other pencil line. When the cutting is finished, remove the clamps, the straightedge, and the wood strip.

Now use a wood chisel (Fig. 50) to carve out the damaged area between the lines. If one or both of the ends of the replacement piece will be visible on the finished tansu, be careful to chisel the ends of the damaged area down to the exact same depth as the thickness of the replacement piece. (The middle area is not so critical: you can regain the proper depth by gluing thin wood shavings

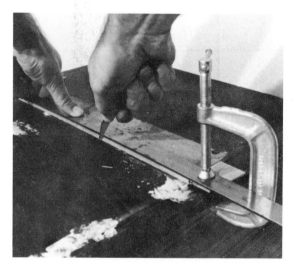

Fig. 49. Cutting the damaged wood piece with a sharp knife, metal straightedge, and clamps (C-clamps used here). (White patches are wood putty, Step 16, applied immediately before stripping in the wood, so putty and glue could dry simultaneously, thereby saving time.)

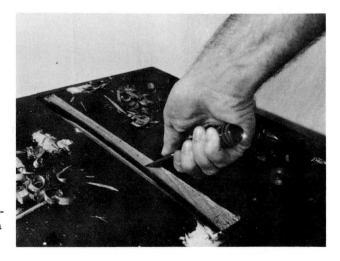

Fig. 50. Carving out bug-damaged wood with a wood chisel.

flat in the cavity at intervals of 6 cm.) When the proper fit is attained, glue in the replacement strip and either hammer it flush using a wood block, or press it firmly by hand into the cut-out space (Fig. 51). Lay a weight on the middle of the strip, and let the glue set for twenty-four hours. After the glue dries, apply wood putty along the two seams of the replacement strip (Fig. 52) according to the procedures outlined in Step 16.

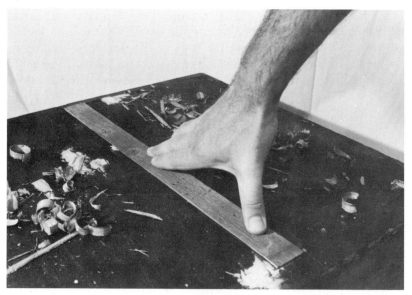

Fig. 51. Pressing in the replacement strip of wood.

Fig. 52. The replacement strip of wood after wood putty application.

11. Repair cracks and splits in top and sides of box

Cracks are usually caused by wood shrinkage, rarely by physical trauma. Cracks commonly occur where pieces of wood are joined lengthwise, on the sides, top, and back of the box, and on bottoms of drawers. They can also occur when boards are constrained from shrinking as a unit by the pegs at joints or when they are restricted by the horizontal piece of wood at the bottom of a side

Fig. 53. A vertical *crack* between two boards (starting at the horizontal bottom strip) and a vertical *split* in a board (just above the metal corner fitting).

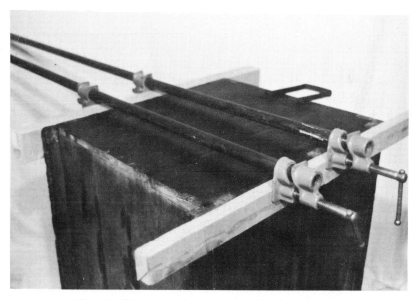

Fig. 54. Closing a glued crack with pipe clamps.

(Fig. 53). Splits in the wood itself, as opposed to cracks between joined boards, are less common because the joints usually give first; but splits can result from the same stresses as cracks and are repaired in the same way.

To begin the repair, carefully wedge the blade of a screwdriver into the crack to open it up wide enough to force glue deep into it. Apply wood glue to the crack and work it down through the crack (a wooden toothpick works well). Too much glue is better than too little. Remove the screwdriver and clamp the crack shut firmly with pipe or bar clamps (Fig. 54). Place a two-by-four or other sturdy wood strip between each end of the clamp and the tansu to protect the edges of the tansu from the clamps. Space the clamps to spread the force evenly along the seam being glued. Before making the final turn on the clamps, make sure that the two sides of the crack are perfectly aligned and flush. Check by running your finger across the crack. If one side feels higher than the other, place a flat wood block on the high side, along the edge, and hammer the wood block until the higher side is aligned with the other. A little care at this point will save a great deal of sanding time later and will pay off in much better results overall. When the sides are properly aligned, tighten the clamps firmly, and wipe off all excess glue that was squeezed from the crack. Again, taking a couple of minutes to make sure all stray wet glue is removed will save time later spent trying to sand off hardened glue. The glue develops its maximum strength after forty-eight hours, when it is completely dry, but it is usually safe to remove the clamps after twenty-four hours, when the glue is ninety percent dry.

In the case where a vertical crack occurs in the side of a tansu at its bottom, horizontal strip of wood (Fig. 53), this wood strip must be removed and shortened by an amount just slightly more than the width of the crack. The strip is usually secured by two or three large wooden pegs driven up into the boards forming the side of the box. These pegs are visible from the bottom. You may also find iron or steel nails, which were added later by a well-meaning repairman. A long strip of wood with nails is sometimes difficult to remove, but it can be coaxed off by prying with a large screwdriver. Work from the inside of the bottom strip (to avoid marring the outside, visible surface), wedging the screwdriver into the seam and levering it back and forth. Using a hand saw, saw off one end of the strip. At this time, also, saw off the peg protrusions flush with the inside of the strip; they cannot be reused, and the strip will simply be glued back to the side without the use of pegs. (Note: If the crack or split is not very wide, say less than 16 mm, the end of the wood strip can be carefully sawn off while it is in place. The pegs remain intact and have enough give to accommodate the small adjustment required when the crack is closed.)

Proceed to glue the crack or split as described above. Clamp until dry. Glue the long bottom piece back on and clamp until the glue has set. Again, make sure the edges are aligned as evenly as possible.

12. Repair cracks and splits in back of box

If there is only one crack between boards on the back of the box, and it is clean and has straight, parallel edges, the easiest remedy is to strip in a piece of wood of the appropriate width (see technique for wood stripping in Step 10). However, if there is a split in a board or one or more uneven cracks between boards (Fig.

55), or if the wood has buckled, the best and easiest solution is to remove the back and reglue it, relieving all the stresses caused by shrinkage.

The boards making up the back are attached to the top, sides, and bottom with wooden pegs and to each other with flat bamboo strips used as dowels (cf. Fig. 28). Frequently you will discover extra nails added at a later date. Remove any nails first with the nail puller. Then note the positions of the pegs and at these points tap the back boards away from the box with a wood block and a hammer, *from the inside* (Fig. 56). (Note: Sometimes the pegs along the top have been inserted from the top rather than from the back. In this case, loosen the

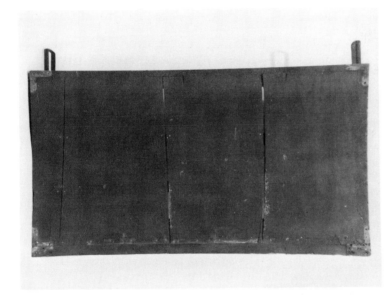

Fig. 55. Uneven cracks on the back of a tansu.

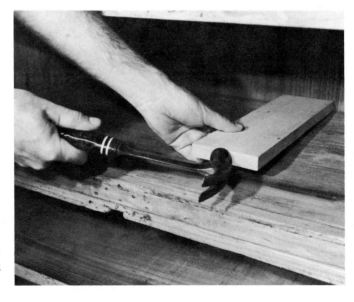

Fig. 56. Tapping back boards off the box from the inside.

bottom and side pegs first, and then grasp the back boards and pull down and away from the top.)

Clean all the boards thoroughly with a damp rag to remove dust and dirt, which impede glue adhesion. Obtain a piece of wood of the same variety and, preferably, of the same thickness and length as the boards on the back, and of a width slightly greater than the sum of the widths of all cracks and splits on the back. Apply glue to all contact surfaces. With the box on its face, lay the back boards back on the box *in the same order* (although not the exact same places) they were taken off. Align one edge perfectly with one side of the box and nail this edge down with one-inch (2.5-cm) finishing nails spaced at ten to thirteen

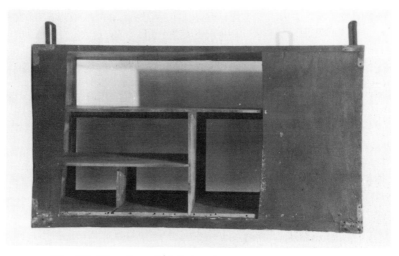

Fig. 57. Two boards left in place on the tansu back.

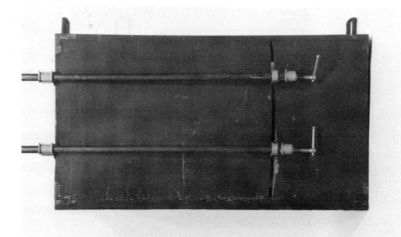

Fig. 58. Crack, resulting from realignment of back boards, to be filled with stripped-in wood.

centimeter intervals (the purist will use wooden pegs here). Push the remaining boards snugly up against one another (they will fit together perfectly) and add the new board to the other edge.

For the tansu used as the model for this restoration, a combination of this procedure and wood stripping was used as follows: Two of the four pieces of wood were removed, cleaned, reglued at their seams, and clamped together in place while being nailed back onto the tansu back according to the method outlined above. One section of wood was left in place at the far right edge of the tansu back (Fig. 57), to form a single straight crack between it and the other three sections of wood fit snugly together to the left (Fig. 58). At this point, a strip of wood was stripped into the crack, following the technique outlined in Step 10. Figure 59 shows the replacement strip viewed from the interior of the tansu.

Lay a board with a weight on it across the middle of the tansu back to keep the boards from buckling, and clamp the boards together with pipe clamps, making sure they are properly aligned. (The new piece of wood should overhang slightly at one edge; it will be trimmed flush later.)

Now nail all the boards to the top, the bottom, and the sides. Use one-inch (2.5-cm) finishing nails spaced at ten to thirteen centimeter intervals. Counter-

Fig. 59. The replacement strip of wood as viewed from the interior of the tansu.

sink the nail heads below the surface with a nail set (Fig. 60). To do this, drive the nail into the wood with a hammer until it is almost flush with the surface. Then take the nail set, line it up with the head of the nail, and tap it down with the hammer so that it drives the nail just below the wood's surface. Fill all holes resulting from this procedure with wood putty by working the putty evenly into the holes (Fig. 61) with a small putty knife. When the hole is filled, wipe away any excess putty on the surface and allow to dry. Let the glue set between

Fig. 60. Countersinking a nail head using a nail set and hammer.

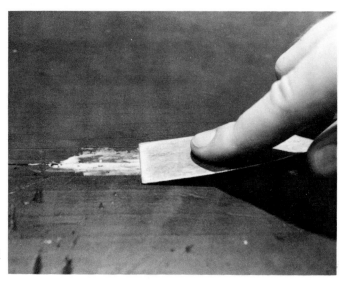

Fig. 61. Filling a nail hole with wood putty.

the clamped boards for twenty-four hours; then remove the clamps. Carefully cut away the excess wood on the new edge with a hand saw (the last little bit can be sanded flush during later sanding procedures).

13. *Adjust fit of drawers*

The most common problem with drawer fit is protrusion from the box when in a closed position. If a drawer sticks out too far, there is nothing to do but shorten it so that the front will fit flush with the face of the chest. First look at the back of the drawer.

Some tansu makers anticipated the shrinkage problem and compensated for it by setting the drawer's back wall slightly inside the back edge of the drawer bottom (cf. Fig. 30). If the drawer is made in this way, it is a simple matter to saw off the protruding lip to produce the desired results. Don't worry that you will cut off too much. If necessary, small, thin pieces of wood can be glued to the outer surface of the drawer's back wall to prevent the drawer from becoming recessed as a result of an overzealous cut. Wooden chopsticks are a handy material for these pieces. In this case cut a chopstick into four pieces, each about four centimeters in length. Glue one piece to each corner of the drawer's back wall.

If the drawer was constructed without an extension of the bottom floor board(s) at the back, saw away the entire back wall from the side walls and bottom. You will have to remove the thin pieces of the sides and bottom that remain on this back board. (They will break off easily by hand.) Reglue the back wall in its new inset position. Then nail the back wall to the side walls (from the side), where they meet. Nail length should be about twice the thickness of the wood. This procedure results in shortening the drawer by an amount equal to the thickness of the back wall, which will be more than adequate. If the drawer becomes too short, glue several thin slivers of wood to the drawer back, enough to bring it back out by the desired amount for a flush fit.

14. *Repair cracks and splits in drawer bottoms*

Remove any added nails from the bottom of the drawer. Remove the bottom boards by tapping from the inside with a wood block and hammer. Follow the same procedure as that for repairing backs (Step 12). Usually, however, no extra piece of wood will be required since the thickness of the drawer's side walls is sufficient to cover the shrinkage resulting from closing the cracks.

15. *Reglue joints*

Some tansu joints were simply pegged together when they were built and some were glued and pegged. Today it is not unusual to find joints that have worked loose over the years, especially joints which undergo considerable strain, such as the butt joints that attach the fronts and sides of drawers. Any joints that feel loose to the hand should be spread slightly with a screwdriver (Fig. 62), filled with wood glue, and clamped tightly. Allow the glue to set for twenty-four hours; then remove the clamps. Remember, as always, to completely wipe off excess glue after the clamps have been tightened.

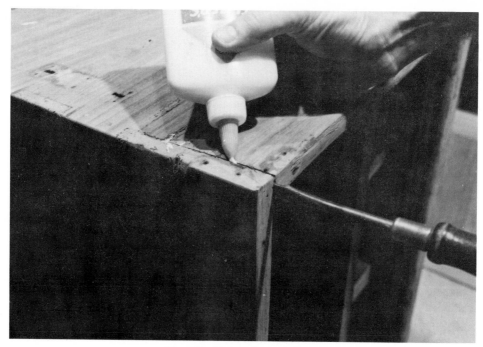

Fig. 62. Gluing loose joints.

16. Prepare for finish removal

Fill any deep scars, surface imperfections, large bug holes, cracked knots, or small surface cracks, including those around stripped-in wood, with wood putty. Paste made from wood putty powder is probably the best product for this job and is easy to prepare: mix a small amount of the powder (about a teaspoon) with enough water to form a thick paste. Force the paste into the cavities that need filling with a small spatula. Deep cavities require two or more applications to fill completely, because all wood-putty compounds shrink to a certain degree as they dry. Let the putty dry thoroughly, at least one day, between applications.

(Note: Prepared wood-putty fillers are available in cans and tubes. While easy to use, these products accept stain less readily than the wood. Of the prepared putty fillers, colored wood fillers, available in a range of lines in the U.S., are recommended. Such putty fillers are not produced as yet in Japan.)

17. Remove old finish

A variety of finish removal products are available but are not recommended for use in removing old stain and finishes from tansu, except possibly in the very unlikely event that a tansu has been painted with a coat of paint so thick that sanding it off would take excessive time. Finish removers in general are messy, expensive, not very effective on traditional finishes found on old Japanese furniture, and usually require great care to use safely. You will save time,

energy, money, and possible damage to the wood by avoiding finish removers altogether.

Most traditional finishes are removed relatively easily by sanding. Rubbing sandpaper on the wood surface produces thousands of tiny scratches in the finish, eventually removing it altogether. Sandpaper coarseness is measured in grits: very rough paper is 50 to 80 grit, medium paper is 100 to 180 grit, and fine paper is 220 to 400 grit.

In the case of tansu bearing thick applications of lacquer-based finishes, the base coat (raw, colorless lacquer) and the subsequent layers of lacquer, most often black lacquer colored with *sumi* (charcoal), are extremely difficult to remove. Sanding this type of finish is still probably the best removal method, but if you want to sand down to the bare wood, it will require a considerable investment of time and sandpaper.

Three methods of sanding can be considered: (1) hand sanding (requiring a lot of time), (2) machine sanding with an electric orbital sander, and (3) machine sanding with an electric belt sander.

Whichever sanding method you choose, these basic rules should be followed:

1. Start with a grade of sandpaper between 120 and 150 grit.

2. Use progressively finer grades of sandpaper until you achieve a flat, smooth surface, free of visible sanding scratches.

3. Sand all wood surfaces of the entire piece of furniture with each grade of paper before progressing to the next grade to avoid missing a surface with any particular grade.

4. Dust thoroughly or vacuum the tansu between each change of sandpaper grade to remove any grit from the previous grade.

Start with a medium-grit paper (150 for paulownia, 120 for other woods). If this does not remove the old finish fast enough, try a coarse grit for the initial removal step. In rare cases, it may be necessary to start with a grade as coarse as 60. As a rule of thumb, however, the proper grade of paper will completely remove the finish from a typical drawer front (about 90 × 20 cm) in about fifteen minutes when using an orbital sander. Change the sandpaper when you notice that the finish is wearing away slowly and when the paper looks worn and is smooth to the touch.

After removing old finish, the objective of further sanding is to remove surface imperfections (including sanding scratches) and prepare the surface for staining and sealing. Progressively finer grades of sandpaper are used to accomplish this. If you feel that some of the scars and marks of use on a chest lend character, proceed immediately to a finer grade of paper after the initial removal of the finish. It is quite possible, however, to sand away all the surface marks if you wish the wood to look exactly as it did when new. The only limitations are the thickness of the wood itself (extensive sanding on originally thin wood will result in an even thinner piece) and your patience with the sanding operation. As a guide, a typical two-piece clothing chest can be completely sanded with an orbital sander in about five to eight hours. Softer woods, such as paulownia, are sanded more easily and quickly than hardwoods like zelkova or chestnut. A typical progression of sandpaper grades for paulownia

is usually 180 to 220 to 400; for other woods, it is usually 120 to 180 to 240.

Sanding is as important as the finish itself in achieving a fine furniture finish, so do not succumb to the temptation to skimp on time given to this operation. The finish will magnify any scratches left on the wood surface from the sanding process, making them more visible, so if you prefer not to see surface imperfections on your finished piece, sand them out now. (This does not necessarily apply to color imperfections, which can be adjusted in the staining procedure.) Few things are more frustrating than having to resand a freshly finished surface because of haste in the original sanding operation.

The last, finest grade of sandpaper used in the final sanding is largely a matter of personal preference. When using an orbital sander, a grade of 220 or finer will not leave visible scratches on softer woods; a grade of 180 or finer will not leave visible scratches on hardwoods. The finer the grade of the final sanding, however, the smoother the surface will be. The grain pattern will become progressively clearer and more sharply defined as finer grades are used.

Note that when sanding cryptomeria (and sometimes cypress) the large difference in density and hardness between the softer and harder parts of the grain makes it mandatory that you sand with gentle pressure on the sandpaper. If too much pressure is applied, the softer parts of the grain will wear down much faster than the harder parts; the result will be an uneven surface with the raised areas corresponding to the hard part of the grain.

Finally, never use a rotating disk sander of the type often sold as an accessory for electric drills to sand furniture. This kind of disk sander inevitably leaves curved scratches and gouges in the wood.

Hand sanding If you want to tackle the job by hand, use a sanding block, which can be no more than a piece of wood about 10 cm square and 4 cm thick. Assemble enough sandpaper of each grade to completely sand your piece of furniture. As a guide, an average clothing chest requires five sheets (22.5 × 27.5 cm in Japan, 9″ × 11″ in the U.S.) of each of the three grades—rough, medium, and fine.

Cut the sandpaper sheets into strips the actual width of the block and wrap a strip around the block, holding the paper taut against the sides of the block as you rub it across the surface to be sanded. Hand sanding must always be done *in the direction of the wood grain.* Commercial hard rubber or metal sanding blocks, with a mechanism for holding the paper taut, can also be used. A hand-sanding tool called a Sandvik can be useful for sanding close to the edges of metal, such as side carrying handles, that is difficult to remove. Apply only medium pressure when hand sanding; the work will progress more rapidly and you will leave fewer scratches to sand out as you progress from the coarser to the finer grades of sandpaper.

Hand sanding can be especially helpful for hard-to-reach areas, and for small furniture, such as vanities or sewing boxes. Although most surfaces of most tansu can be sanded successfully with an orbital electric sander, the features of some tansu (such as bars or slats on doors, the wheels of wheeled chests, or the tiny drawers of medicine chests) require hand sanding in addition to orbital sanding.

Sanding with an electric orbital sander Orbital "finishing" sanders are very easy to use, offer a considerable savings in time and energy over hand sanding, and leave a surface that is flat and smooth. An electric orbital sander, 10,000

rpm or more (Fig. 63), will make the sanding operation faster, more pleasurable, and arguably more professional in terms of surface smoothness. To start, lay a strip of sandpaper across the sanding plane of the sander and clamp it into place at either end (Fig. 64). A sheet of 23 × 28 cm sandpaper can be cut into three identical strips that fit the sanding plane exactly. (In the U.S., paper pre-cut to fit this sander can be purchased, but it is more expensive than buying the standard sheets and cutting them yourself.)

You can begin sanding on any surface of the tansu. Turn on the sander before applying it to the wood surface. The sander can be moved across the surface of the wood in any direction. Be sure to keep the sandpaper surface

Fig. 63. An electric orbital sander.

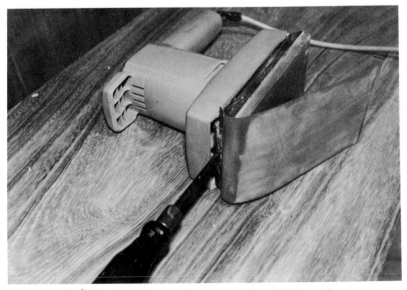

Fig. 64. Attaching sandpaper to the orbital sander.

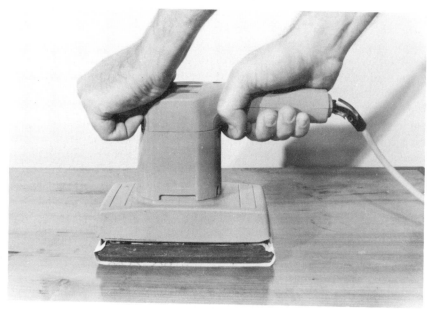

Fig. 65. Proper position of the orbital sander on the wood surface.

flat against the wood (Fig. 65). You may be tempted to tilt the sander up on an edge to remove a difficult spot or stain, but this will only result in a gouge in the wood surface. Sand all surfaces evenly, finishing with the fine-grade sandpaper.

Sanding with an electric belt sander　　Belt sanders (Fig. 66) use continuous loops, or "belts," of sandpaper which come in standard sizes and are easily attached to the machine (see the instructions that come with the machine). If you plan to restore several pieces, and especially if many large, flat surfaces are involved, you might consider purchasing an electric belt sander.

Though this sander requires more skill and more strength to use properly than the orbital sander, it removes finish faster than the orbital sander and leaves a flatter surface. The heavy and unwieldy nature of the belt sander requires constant concentration during the sanding process; a short lapse or slip will result in a deep gouge. Properly used, however, the belt sander is more efficient than the orbital sander, especially for large, flat surfaces. It is important to stress, however, that using the orbital sander is probably the best idea for a beginner so that basic sanding techniques and experience are gained before progressing to the belt sander. In either case, the final sanding prior to staining/sealing should be done with an orbital sander, or by hand sanding, as it is practically impossible to achieve as fine a surface with the belt sander alone. The primary value of the belt sander is in removing old finish quickly and working a deeply scarred surface down to flat wood rapidly.

As in the case of the orbital sander, turn the machine on prior to placing it on the wood surface. Work the sander back and forth in long, *very even strokes in the direction of the wood grain* (Fig. 67) and concentrate. As with other methods of sanding, start with a rough grade of sandpaper and work with ever finer grades until the job is completed.

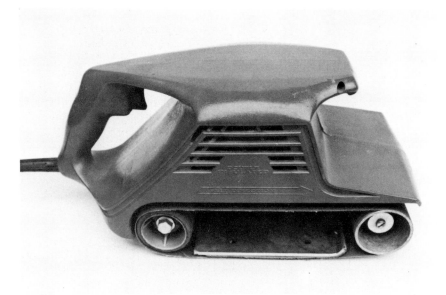

Fig. 66. Electric belt sander.

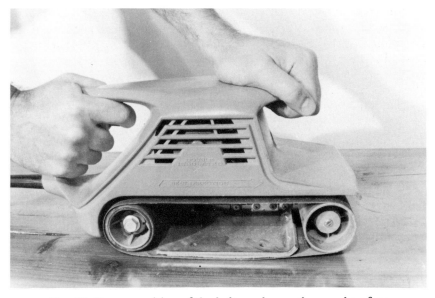

Fig. 67. Proper position of the belt sander on the wood surface.

18. Clean

Now that the surfaces to be stained and finished have been sanded flat and smooth (Figs. 68, 69), it is imperative that all subsequent operations be carried out in as clean and dust-free an environment as possible. Dust particles can cause unsightly dimples in the finish.

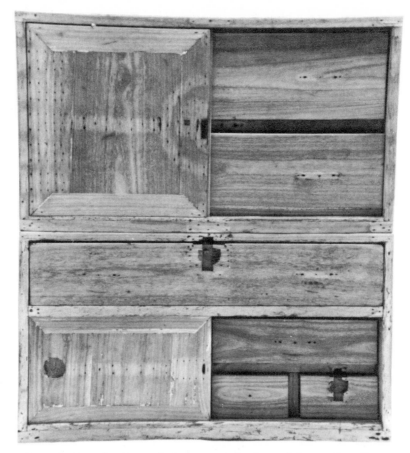

Fig. 68. Completely sanded tansu ready for staining and sealing. (Right-hand doors have been removed to show sanded drawers inside.)

Fig. 69. Close-up view, after sanding, of the strip added to the back of the tansu.

First, vacuum the tansu box and all the drawers, inside and out, as well as the area in which you are working.

Next, wipe all surfaces of the tansu with a sponge or lint-free cloth that has been moistened sparingly with turpentine. This is a good opportunity to check the sanded surfaces for any remaining sanding scratches or excess glue from cracks or joints that have been repaired. The turpentine tends to make these imperfections more visible (as will the final finish). Be particularly watchful for excess glue. Glue will not accept stain and will, therefore, show up as light spots or streaks in the stained wood. Now is the time to sand away any such potential problems, but be sure to clean again thoroughly after all sanding is completed.

After the cleaning operation allow the tansu to dry thoroughly, at least six hours.

19. Stain

Staining refers to the application of color directly onto the wood surface. Because of the nature of the stain ingredients, staining requires protection of the hands and the area in which you are working. Wear a rubber or disposable glove when using stains and cover the floor with newspaper or a plastic tarpaulin. Oil stains will dye your fingers and carpet, as well as the wood on your tansu. Work in a well-ventilated room.

Before you decide on the color for your tansu, remember that hardwoods (e.g., chestnut and zelkova) accept stain evenly and easily, whereas application of stain to softwoods (e.g., cryptomeria and cypress) often results in the color appearing striated, since the soft, porous areas of the wood absorb more color than the harder, grained areas. Therefore, you may want to seal softwood after sanding and prior to staining, by applying a light coat of clear Cashew thinned with turpentine. Mix together one part clear Cashew and three parts turpentine and combine well. The mixture should be of a watery consistency, so keep adding a little turpentine at a time until you achieve this consistency. Apply the thinned Cashew mixture over the wood surfaces in the direction of the grain with a clean lint-free cloth. Allow it to dry twenty-four hours.

To begin staining, pour a small amount of stain, about 100 cc, from the bottle into a shallow can (e.g., a well-washed tuna fish can) or a glass jar. Do not use plastic cups or containers as solvents soften some types of plastic. Cap the stain bottle tightly and set aside, away from your work area. Using stain from the can or jar, wipe stain directly onto the wood with a clean lint-free cloth or sponge. Starting in one corner (Fig. 70) and working with the grain, apply it evenly across one entire surface before proceeding to the next. If you are unsure about the resulting color or mixture of colors you have chosen, try it first on an area that will not be visible, such as the back of the chest or the bottom of a drawer. Different colors of stain can be mixed together in any proportion to achieve the final desired color. Oil-based stains can be diluted with turpentine, but this is usually neither necessary nor desirable. However, if you are mixing colors, remember to make a note of the proportions used so that you can duplicate the color if you happen to run out halfway through the job and need to mix more.

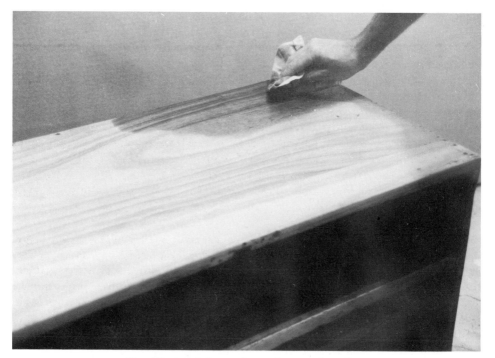

Fig. 70. Applying stain to the wood surface.

You may want to stain the box of a chest a different color from the drawers in order to duplicate the original look of the piece. If this is the case, it is best to stain first all the drawer fronts and then all the surfaces of the box; or, you can reverse the order and do the box first, drawer fronts second. The drawer sides and interiors are not stained, but some show a little color along the sides where they meet the drawer front. It is a good idea to stain the sides of the drawers just for three or four centimeters from the front; this way, the spaces around the drawers will appear the same color should, for example, the tansu drawers contract slightly in winter. Oftentimes, the drawer sides are made of cryptomeria, while the drawer fronts are of a hardwood. If this is the case, several additional stain applications on the sides may be necessary to darken them to the color of the hardwood fronts.

Apply as many coats of stain as you wish to achieve the color you want, but let each coat dry at least a couple of hours before putting on the next. Remember that the color of the finished piece will be closer to the color you see when the wood is wet with stain, than to the color of the stain when it has dried. Strive to achieve an even color on each surface.

It is sometimes necessary to touch up lighter areas with extra stain because different parts of the wood soak up stain at different rates. This is especially true with cryptomeria, whose porous soft areas absorb stain more deeply, and thus appear lighter, than its harder, grainy areas. Be sure to blend in the edges of any touch-up staining.

Allow the tansu to dry thoroughly, at least overnight, after the last coat of stain has been applied.

20. Seal

Sealing refers to the application of a finish that protects the wood from moisture and imparts a degree of gloss to the surface, making the grain pattern clearer and more visible. By using a finishing sealer called Cashew, it is possible to obtain any degree of gloss you desire, from a matte, hand-rubbed sheen to a mirror finish. Before you start, make sure your work space and your tansu are as clean and free from dust as possible. Work in a well-lit, well-ventilated area.

Cashew is very viscous, like cold honey. You will need to dilute it with turpentine in a clean shallow can or glass jar. Mix thoroughly about one part Cashew with two parts turpentine. (Alternatively, oil-based stain can be used to replace all or part of the turpentine as a thinner if a darker color is desired.) Bamboo skewers (resembling long toothpicks) make excellent, disposable stirring sticks.

The easiest way to apply the Cashew sealer is by wiping it on with a clean lint-free cloth. Apply it liberally in even strokes going with the grain of the wood until you have covered one entire surface. Wipe off any excess with a cloth, and then proceed to the next surface. The Cashew coats will be slightly tacky or sticky as they dry, so work should proceed evenly and smoothly.

If drawer fronts have been colored differently from the tansu box, and you are now using Cashew diluted with oil-based stain (rather than turpentine), remember to dilute with the proper, different stain colors for separate application. If you are using Cashew thinned with turpentine for all wood surfaces, naturally the same mixture can be applied to both the box and the drawer fronts.

Allow each coat of the Cashew mixture to dry thoroughly, at least twenty-four hours, before applying the next. Three coats are usually sufficient for sealing, unless the wood is extremely porous. The wood is completely sealed when you no longer see dull spots. Further coats will add to the gloss and to the protection of the surface. Allow the final coat to dry a minimum of two days. The coats of Cashew must dry slowly from the inside to the outside, and although the last coat may feel dry to the touch before twenty-four hours has elapsed, underlying coats may still be in the process of drying. Do not rush the time on the sealing step.

If you find the final appearance to be too glossy, or if there are excessive dust particles in the finish, you can buff the finish easily by hand with very fine (0000 grade) steel wool. Cashew finishes are always very glossy, so buff the finish at this point if you wish to achieve a look closer to the original finish. Use medium pressure, working in even strokes along the wood grain. If still more of a matte finish is desired, use a coarser grade of steel wool (00 grade) and buff in the same fashion, being careful not to buff the finish off completely. As a general rule, it is always best to start with the finest grade of steel wool (0000 grade) and frequently check the appearance by wiping the surface lightly with a dab of turpentine on a lint-free cloth to remove the dust. Remember that waxing the tansu, the next step, will create a slightly glossier surface than that achieved through the sealing and buffing process.

Although a very glossy "piano" finish is not typical of original tansu finishes, if it is what you prefer, follow these steps: (1) Apply one or two more coats of the diluted Cashew mixture on top of the first three coats; (2) allow at least two

days' drying time between coats and preferably three or four days after the last coat; and (3) "wet" sand the surfaces with waterproof sandpaper on the orbital sander. For this procedure, use at least 400-grit *waterproof* sandpaper. The higher the number of the sandpaper grit, the glossier the finish. Sprinkle water moderately on the tansu surface, start the sander, and, using very gentle pressure on the sander, apply it to the wood surface, keeping it constantly in motion. You only want to smooth the very top layer of the final coat, not sand through any of the coats. Stop frequently and wipe the surface with a damp rag to check your progress. Always sprinkle on more water before beginning to sand again, and do not allow the surface to dry out while you are sanding. When you are satisfied with the gloss, wipe the surface thoroughly with a damp rag and allow to dry.

It should be noted that although an extremely glossy, or piano, finish may be your preference, it will not approximate the original condition of the tansu since the only glossy finishes used originally were achieved through the use of numerous lacquer coats and most often only on drawer fronts. Boxes were traditionally finished in a matte to medium-glossy finish achieved through the use of processed raw lacquer mixed with natural dyes.

21. Wax

After the finished surfaces of the chest have been buffed to the desired degree of gloss and allowed to dry completely, apply a coat of good-quality paste furniture wax using a clean soft cloth. Wax can be applied directly from the can with 0000-grade steel wool if a less glossy surface is desired.

Apply the wax in a thin, even coat and allow it to dry to a hazy appearance (approximately fifteen minutes per surface) before buffing with clean soft cloths. Turn the buffing cloth often while working, and when one cloth is completely soiled, change to a fresh cloth. It is best to work at temperatures above 21° C (70° F).

A thick coat of wax should also be applied to the outer, unfinished surfaces of the drawers. This will provide some measure of protection against drying and cracking and will facilitate smooth sliding of drawers. (Note: Never apply wax, oil, or polishes to the unfinished *interior* of the drawers. An unseen film from these agents can soil or cause bad odors in clothing and other items stored in the drawers.)

22. Replace metal parts

You are now ready to affix all metal parts to the tansu. By this step, the removed metal parts should have been coded, straightened, cleaned, and finished. If it was necessary to make new replacement parts, these pieces will have been cut, shaped, cleaned, and finished, and are now also ready to attach to the tansu.

Metal is replaced using the nails put aside when the metal was removed. If a door is present on the tansu, door metal should be affixed before reattaching the door to the tansu box. Nail all the flat metal pieces, corner pieces, and lockplates back on to their original locations on the tansu box and drawers. The old nail holes serve as a good guide for reattachment, especially for hinges. Sometimes the nail holes will be too large if their previous occupants rusted and ex-

panded. If this is the case, insert a sliver of wood (a round toothpick works well) into the hole, clip it off flush with the surface, and tap in the nail. The entering nail will force the wood sliver to split around it, securing it in the hole.

Handles should be attached last. Insert the handle clips (through the handle-plate or disk) into the existing holes in the wood and push them through (tap with a small hammer if necessary) until the handles are in the proper position. Then insert a screwdriver between the clip ends, bending one up and one down, at least halfway back to their original positions. With needlenose pliers, bend over the ends of the pins to about a ninety-degree angle so that they will remain correctly positioned when they are hammered flat. Proceed to hammer the pins flat against the inside of the drawer front.

23. Replace drawers and doors

The final step is to replace the doors and drawers on the tansu box(es). Using the nails you removed from the door hinges, hammer the hinged door back into

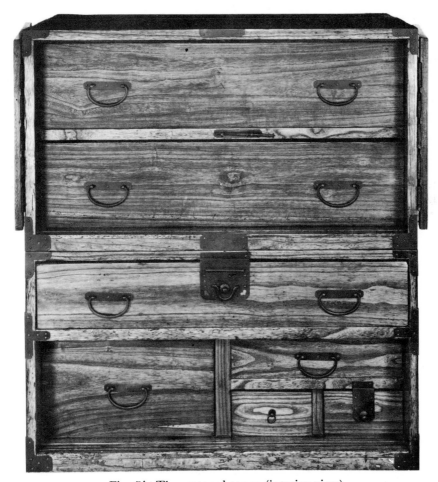

Fig. 71. The restored tansu (interior view).

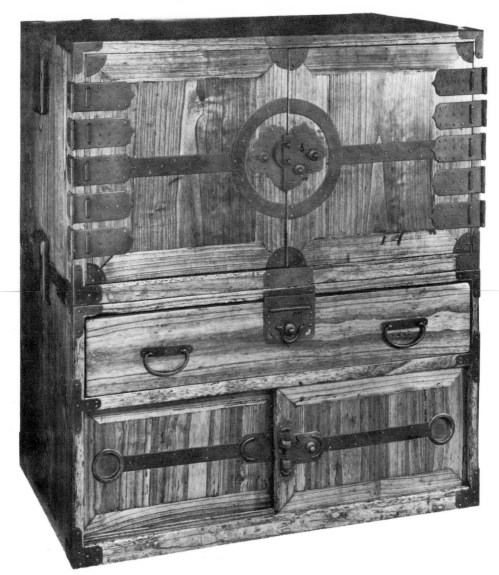

Fig. 72. The restored tansu.

its original position. Put drawers back into their original spaces. Give the entire piece a final wipe with a soft cloth.

You are now prepared to stand back and bask in the praise of envious friends when they discover that you did it all yourself.

4 Care and Maintenance

Traditionally, simple cleaning, or dusting, with a soft cloth was all the care that was given Japanese furniture. This simple approach is still the best method for maintaining both original-condition and restored pieces of furniture on a daily basis. However, an increasing number of tansu are becoming a part of homes where room temperature is centrally controlled, often resulting in a very dry atmosphere. Furniture situated in such an environment needs additional care—waxing or oiling—at six-month to one-year intervals to insure continued durability of the finish and luster through the years.

Because furniture in original condition may have been subject to one of a number of old-fashioned finishing methods, always ask about the finish when you purchase a piece of furniture to find out what sort of care may be required. Finishes derived from natural oils, for example, require an oil treatment (either tung oil or boiled linseed oil), whereas tansu finished with lacquer-based agents should be polished with a hard wax.

Regardless of the finish, antique furniture will retain its beauty if you follow these pointers:

1. Avoid exposure to strong, direct sunlight. Such exposure causes the finish to change color over a period of time.

2. Avoid extremely dry conditions. Wood needs moisture, so it is best to place the furniture in a room away from direct heat. If dryness is unavoidable, use of a humidifier during winter months will help prevent warping.

3. Check periodically for the appearance of insects. If you see any tiny holes on the wood surface (or piles of fine wood dust on the floor nearby), fumigate the furniture immediately. Use an insecticide spray designed for wood-eating bugs which has a long needle-like attachment that you can put into the holes to saturate the bugs and any eggs. Remember to wipe the wood surface with a clean soft cloth after spraying to remove any residue. It is a good idea to keep a small packet of mothballs in a drawer or back corner of a chest if it is not housing clothing currently in use. This will usually prevent bugs from settling in and laying eggs.

4. Do not use commercial furniture polishes or scratch covers to polish your furniture. These products leave a soft film on the surface of the finish, which temporarily looks lustrous but actually attracts luster-dulling dust particles. Polishes offer no protection to the wood. An all-over dusting of the outside surfaces of the furniture with a soft cloth several times a week is all that is necessary.

If your piece of antique furniture has been restored according to the method in this book, the only additional care required is a good waxing every six months to a year with a good-quality furniture wax. Butcher's Boston Polish Wax is recommended as it is a hard wax that imparts a durable finish with a soft patina. To wax a tansu, apply wax directly from the can with a clean soft cloth to the outer surfaces of the chest. Let each surface sit for fifteen minutes before buffing with another clean soft cloth. Buff briskly, along the wood grain, and remember to turn the buffing cloth frequently and to change to a new one when it is completely soiled.

For restored furniture with oil-based finishes, boiled linseed oil (available, already boiled, in bottles or cans) or tung oil yields the best results. Mix one part oil with one part turpentine to thin it (it is quite thick and viscous in its undiluted state). Apply the mixture to the wood surfaces with a clean cloth, rubbing the oil into the grain firmly. The wood surfaces will look quite shiny just after application. Let the tansu sit for thirty minutes to allow the oil to penetrate, then rub briskly with a clean cloth to remove any excess oil.

Despite your best intentions, minor accidents can mar your furniture. The following tips cover a range of solutions to minor damage short of resorting to complete refinishing or restoration:

SCRATCHES AND NICKS: Small scratches and nicks can be covered effectively by waxing the surface with wood wax following the directions above. Larger scratches and nicks that expose wood can be colored in with a commercial scratch-cover polish. Pour a small amount of the scratch cover onto a clean cloth and rub it into the freshly scratched, light area of the wood until it darkens. Wipe off any excess polish around the area of the scratch.

GOUGES: Gouges naturally cause more concern than surface scratches since they are inflicted more deeply into the wood. Available in the United States for this type of problem are "lacquer" sticks (also called "wax" sticks) that come in a range of colors. Soften the tip of the stick with a little heat (a match will do) and then press into the gouge until it is filled. Use a putty knife (with care) to smooth the surface of the filled gouge, and with a cloth, wipe away any extra filler that may have adhered to the surrounding wood surface. The stick is composed of hard wax and a plasticizer, which, when cool and dry, yield a hard, somewhat lustrous finish.

BURNS: The most common burns to furniture are caused by cigarettes. Cigarette burns can be remedied with "lacquer" (or "wax") sticks. If the burn is deeper than 2 mm, gently scrape away the charred area with a knife point, and apply the filler stick as for gouges, explained above. If a burn is fairly shallow, rub it softly with 0000-grade steel wool or 400-grit sandpaper until the black discoloration wears away. To match the surrounding wood color, mix together artists' oil paints to attain the appropriate shade and smooth it into the burn area with a fingertip. When the paint has completely dried, at least twenty-four hours later, apply wood wax and buff.

WHITE RINGS: Most white rings on furniture surfaces are caused by heat or water. Heat rings and water rings usually do not penetrate the surface, but they can still be difficult to remove.

For water rings, dampen a soft cloth with water and dab on a teaspoon of regular toothpaste (or a mixture of equal parts toothpaste and baking soda). Rub the affected ring area briskly for one or two minutes, and then wipe with a clean, damp cloth. After the area has dried completely, apply a wax coat and buff.

Heat marks can sometimes be removed by mixing one part warm, boiled linseed oil (it can be heated slowly in a pan on the stove) with one part turpentine. Rub the mixture liberally into the heat mark with a soft cloth and allow it to sit at least three hours. Remove the oil with a cloth dipped in white vinegar. Wax the area after the vinegar wash has dried. If the mark is especially stubborn, apply the mixture with 0000-grade steel wool in place of the soft cloth, rubbing gently for a few minutes in the direction of the wood grain. Remove the oil with a cloth dipped in white vinegar. After the vinegar wash dries, apply wax.

FUNGUS: Wooden furniture stored in damp places often becomes a breeding ground for fungus, which appears as white, spotty areas. To remove these, mix two parts white vinegar with one part water. Dampen a sponge with the mixture and wipe the affected areas until no fungus remains. Several applications may be necessary. (A solution of equal parts household bleach and water may be substituted for the vinegar mixture.) Rinse the surface with a sponge or rag dipped in clear water, and allow to dry. Apply wax or oil, depending on the original finish.

Antique Shops in the Tokyo Area

All shops are open daily except where indicated otherwise. When purchasing antique furniture from shops, remember to ask for a certificate of authenticity, which will state the item, its origin, and its age. Certificates, provided by all reputable dealers, are important for insurance claims or in the event you wish to sell your piece.

Akasaka Area

Edo Antiques (*Kobijitsu Edo*)
2–21–12 Akasaka, Minato-ku, Tokyo
Tel: 584–5280
The owner of Edo Antiques, Mr. Murakawa, is very experienced in the complete restoration of antique Japanese furniture. His showroom displays a large number of beautifully restored tansu and hibachi. Since Mr. Murakawa supplies tansu to dealers abroad, his stock changes rather quickly. He speaks English and is willing to bargain. (Closed Sundays)

Fuso Antiques (*Fusō Bōeki*)
Akasaka New Plaza, 1st floor, 7–6–47 Akasaka, Minato-ku, Tokyo
Tel: 583–5945
This well-known shop sells a selection of antique furniture and other items. Most of its tansu have been restored or are in need of restoration. The restored pieces are sometimes rather hastily done, so it is wiser to purchase unrestored items. Prices are reasonable, and the staff is willing to bargain. Fuso also has a small warehouse of tansu located at Tengenji, 2–38–1 Ebisu, Shibuya-ku (tel: 442–1945), but an appointment is necessary. (Shop: closed Sundays)

The Gallery
1–11–6 Akasaka, Minato-ku, Tokyo
Tel: 585–5019
A charming shop run by an American, Patricia Salmon, The Gallery often has a few pieces of Japanese furniture for sale among the large assortment of Chinese and Japanese porcelain and screens. Most pieces of furniture in the shop have been restored or are in need of some restoration.

Azabu Jūban Area

Antiques Nishikawa
Azabujūban House, 2–20–14 Azabu Jūban, Minato-ku, Tokyo
Tel: 456–1023
This shop's specialty is high-quality antique porcelain, but there are usually three or four good-quality antique tansu for sale at any given time. Mrs. Nishikawa, the owner, maintains a warehouse where you can view a greater selection of tansu. Some English is spoken. If you want to make an appointment to visit the warehouse, call the warehouse in Japanese directly (07496–2–0775). Mrs. Nishikawa will not bargain unless you are purchasing in quantity, and even then the discount is much less than that found at other shops.

Hasebe-ya Antiques (*Komingei Hasebe-ya*)
1–5–24 Azabu Jūban, Minato-ku, Tokyo
Tel: 401–9998
This shop specializes in sea chests and sells high-quality, original-condition antique furniture. The owner, Mr. Hasebe, is an authority on Japanese furniture and speaks fluent English, as does his staff. His shop is worth visiting just to see his collection, which is of museum quality and includes many pieces of furniture that cannot be seen elsewhere. Prices reflect the high quality. Mr. Hasebe holds two sales a year with large discounts. He is willing to bargain. (Closed Sundays)

Hongō Area

Soma Kobutsuten
1–7–16 Honkomagome, Bunkyō-ku, Tokyo
Tel: 828–2344
This tiny little shop is affectionately known by many as "the Hongō-dōri junk lady," since it is run by an old woman and her two sons on Hongō-dōri, the large street that runs in front of the main campus entrance to Tokyo University. The best buys here are porcelain hibachi, but in a locked room next to the storefront entrance is a supply of tansu and wooden hibachi, which you can ask to see. Condition of the furniture for sale varies, but it is usually fairly priced. Nothing has been restored. You can recognize the shop by the porcelain hibachi stacked four or five high in rows all along the outside of the shop. Inside, items are stacked, rather precariously, to the ceiling, but all you have to do is point to have something shown to you; Mrs. Soma herself scurries up mountains of debris to pull down a basket or a tobacco box you might like to see. A visit to the shop is quite an experience, but you must go frequently to come upon real finds. (Open 9:00 A.M. to 9:00 P.M.; closes occasionally without notice)

Hotel Shops

The Hotel Okura in Akasaka and the Imperial Hotel near Hibiya Park have independent antique shops located in their shopping arcades, where tansu and other furniture are for sale. Since the shops cater mostly to foreign tourists, prices tend to be high. However, the reputation of both shops is good, and the tansu sold are generally in good condition.

Kamakura

The House of Antiques
1449–32 Kajiwara, Kamakura-shi
Tel: 0467–43–1441
A visit to this interesting mountaintop shop is well worth the trip. Mr. Yoshihiro Takishita, the owner, has assembled a high-quality selection of furniture and other antiques, which he has housed in two huge farmhouses that were brought to Kamakura, piece by piece, from northern Japan. Mr. Takishita speaks fluent English (as does his assistant) and is happy to show and explain his antiques to those who have made an appointment by telephone prior to visiting. Many tansu sold by Mr. Takishita are original; others have been restored faithfully.

Kamiyachō Area

Irori
1–7–4 Azabudai, Minato-ku, Tokyo
Tel: 586–8105
This small shop sells primarily antique furniture. Some pieces are in original condition, and others have been restored. Prices tend to be high, and bargaining is not usual. However, the owner is quite knowledgeable about Japanese furniture and sells good-quality pieces.

Magatani Arts and Antiques Plaza
5–10–13 Toranomon, Minato-ku, Tokyo
Tel: 433–6321
The young Magatani brothers have recently opened a tansu gallery in the basement of their crafts and antiques shop, where they sell both restored and unrestored tansu. The Magatanis speak English and are willing to bargain. Stock turnover is rapid. (Closed Mondays)

Nanshu-do Co., Ltd.
41 Tomoe-cho, Shiba, Minato-ku, Tokyo
Tel: 431–0645
This shop sells antique furniture along with other antiques and fine art. The furniture selection is not large but is of very good quality. A little English is spoken, but usually there is no bargaining. (Note: Numerous other antique shops are scattered along the same street as Nanshu-do, which is the large street where Kamiyachō station is located. While most of the shops deal in porcelain and small antiques, some regularly stock tansu and hibachi.)

Kanda Area

Japan Old Folkcraft and Antique Center (*Tōkyō Komingu Kottō-kan*)
1–23–1 Jimbochō, Chiyoda-ku, Tokyo
Tel: 295–7112/5
This building boasts five floors of antiques, occupied by fifty-five dealers. Among them are a number of tansu dealers, who often offer good buys. Unfortunately, each floor is supervised by only one or two dealers, who can offer you a standard 10% discount on the wares of other, absent dealers but know little about the items. Few sellers speak English, which poses no problem if you only want to know prices. But if you want to bargain, obtain specific information, arrange for delivery, or contact

an absent dealer for any of these purposes, it is best to have a Japanese-speaking friend accompany you. In general, the dealers present as accurate information as possible on their furniture, but remember that most are not sophisticated antique dealers but, rather, old-fashioned junk dealers interested in moving their wares. Many of them also sell from stalls at the weekly flea markets around Tokyo.

Meguro Area

Antique Gallery Meguro
Stork Bldg., 2nd floor, 2–24–18 Kamiosaki, Shinagawa-ku, Tokyo
Tel: 493–1971
This antique market of sorts, covering 740 square meters, houses a number of small antique shops. Most shops sell a little of everything, including tansu. Many of these dealers have shops elsewhere as well as warehouses you can visit. Most dealers will negotiate prices if you are purchasing an expensive item, and many speak English. (Closed Mondays)

Shirogane Antiques
5–13–38 Shiroganedai, Minato-ku, Tokyo
Tel: 446–4360
This shop specializes in items from the Kyoto area with a selection that includes tansu, porcelain, scrolls, screens, hibachi, and woodblock prints.

Tsurukame Antiques
7–2–3 Ebara, Shinagawa-ku, Tokyo
Tel: 781–4523, 785–0663
An appointment is necessary to visit this shop, which is part of a large house where the owners, James Luttrell, Dennis Engelman, and Masahiro Ikeguchi live. Mr. Luttrell and Mr. Engelman, two Americans, started this shop about ten years ago. All furniture is restored with great care to approximate the original appearance of the furniture. A complete and thorough restoration, inside and out, is done on each piece, and Mr. Luttrell and Mr. Engelman provide accurate information on all aspects of the furniture they sell. Tsurukame has frequent exhibits and sales on the second floor of the Kato Gallery, 5–5–2 Hiroo, Shibuya-ku (tel: 446–1530), and you can be placed on their mailing list for announcements of these sales by calling Tsurukame.

Roppongi Area

Japonesque
2–25–1 Nishi Azabu, Minato-ku, Tokyo
Tel: 486–6340
The owners, Sandra and George Godoy, sell many tansu among their other offerings of screens, scrolls, and dolls. Most of the tansu are in original condition and have been carefully cleaned prior to sale. The Godoys hold four exhibits each year; otherwise, their wares can be seen anytime by appointment.

Kojima Antiques
401–44 Mamiana-cho, Azabu, Minato-ku, Tokyo
Tel: 588–1944
This shop is only open on Saturdays and Sundays, but appointments can be made for weekdays. The selection is small but of high quality. The specialities are tansu and screens.

Kurofune
7–7–4 Roppongi, Minato-ku, Tokyo
Tel: 479–1552
This shop is owned by an American, John Adair, who sells tansu and other Japanese antiques. Some tansu sold here are in original condition while others have been restored usually faithfully. All furniture is labeled with information on age, region of origin, wood type, and price. (Closed Sundays)

Nakamura Antiques
2–24–9 Nishi Azabu, Minato-ku, Tokyo
Tel: 486–0636
Mr. Nakamura, formerly a partner at Kamon Antiques, now runs a shop that sells a variety of antiques. There are usually many tansu in a range of conditions. Tansu that have been "restored" should be carefully checked for workmanship.

Okura Oriental Art
3–3–14 Azabudai, Minato-ku, Tokyo
Tel: 585–5309
This lovely shop sells antique furniture and other Japanese antiques. Its young and creative owner, Kenji Tsuchisawa, and his staff also provide consultation on decorating, interior design, and architecture. He and his staff speak English and are willing to bargain. Most of the tansu sold here are in good, restored condition. (Closed Mondays)

Shibuya Area

Antique Gallery Kikori
Hanae Mori Bldg., B1, 3–6–1 Kita Aoyama, Minato-ku, Tokyo
Tel: 407–9363
Warehouse: 1–9–1 Hibarigaoka, Hoya-shi, Tokyo
Tel: 0424–21–7373
Mr. Saito, the owner of Kikori, has a limited but usually interesting selection of tansu and other antiques in his gallery in Omotesando. He also maintains a large warehouse where tansu in a range of conditions are stored. Most tansu sold at the gallery are restored, and some are rebuilt from wood of other, old tansu, so it is a good idea to inquire about the history of pieces before purchase. Tansu at the warehouse are, for the most part, in need of restoration. Mr. Saito speaks some English and is willing to bargain. (Warehouse: closed Sundays)

Kamon Antiques
4–3–12 Shibuya, Shibuya-ku, Tokyo
Tel: 406–1765
The owner, Mr. Ohgoshi, has a nice selection of tansu, screens, scrolls, and porcelain. He is also very helpful in assiting customers who are trying to locate a particular piece. Mr. Ohgoshi and his staff speak English and are willing to bargain.

Oriental Bazaar
5–9–13 Jingumae, Shibuya-ku, Tokyo
Tel: 400–3933
Antique furniture is not a specialty of the Oriental Bazaar, but there are pieces for sale, often at reasonable prices, so it's worth checking their stock every now and then. Most tansu sold here are in need of some restoration; and those restored prior to sale are often refinished poorly and without regard to the original appearance of the

piece. The best buys are unrestored Meiji-era tansu and hibachi. The Oriental Bazaar does not bargain. They will provide a certificate of the furniture's age only in terms of "old," "100 years old," or "over 100 years old." (Closed Thursdays)

Akariya Antiques
4–8–1 Yoyogi, Shibuya-ku, Tokyo
Tel: 465–5578
This shop, with its friendly staff, sells some antique furniture in addition to kimono and other Japanese antiques. Most tansu for sale are unrestored, and usually in need of restoration. The proprietors are willing to bargain, and some of the staff speak English. (Closed Sundays)

Shinjuku Area

Tsuinku Antiques
5–40–15 Chuo, Nakano-ku, Tokyo
Tel: 383–8628
This shop offers a diverse selection of antiques, both Japanese and European, including antique tansu and small furniture. Prices on Japanese antiques are very reasonable. The tansu are unrestored and, thus, moderately priced. Tsuinku has a branch shop at 3–7–2 Minami Ebisu, Shibuya-ku (tel: 792–1026). English is not spoken, but the staff is willing to attempt communication. (Both shops: closed Wednesdays)

APPENDIX 2

Flea Markets and Antique Fairs in Tokyo

Monthly Flea Markets

Flea market locations and dates are subject to change. Such changes (due to holiday or cancellation) are normally posted at the entrance to the market area on the month before the change is to take place; fliers announcing changes are often distributed as well. When new flea markets start up, they are usually mentioned in local tourist newspapers, such as *Tour Companion,* and are announced at other flea markets via fliers or posters.

1st Sunday of every month:

Arai Yakushi Temple (Nakano-ku)
Nearest train station: Araiyakushimae (Seibu Shinjuku Line)
(8 minutes on foot from the station)

2nd Sunday of every month:

Nogi Shrine (Akasaka)
Nearest subway station: Nogizaka (Chiyoda Line)
(Located just next to the station's south exit)

3rd Saturday and Sunday of every month:

Alpa Bl Hirokoji, Sunshine City (Ikebukuro)
Nearest subway station: Ikebukuro (Marunouchi and Yurakucho lines)
Nearest train station: Ikebukuro (Yamanote Line)
(7 minutes on foot from the station)

4th Sunday of every month:

Togo Shrine (Harajuku)
Nearest subway station: Meiji-jingumae (Chiyoda Line)
Nearest train station: Harajuku (Yamanote Line)
(3 minutes on foot from either station)

4th Saturday of every month:

Yushima Shrine (Ueno)
Nearest subway station: Yushima (Chiyoda Line)
Nearest train station: Okachimachi (Yamanote Line)
(7 minutes on foot from Yushima, 10 minutes from Okachimachi)

137

4th Friday of every month:	Roi Building (Roppongi)
	Nearest subway station: Roppongi (Hibiya Line)
	(5 minutes on foot from the station)
28th day of every month:	Kawagoe Naritafudo (Kawagoe City, Saitama Prefecture)
	Nearest train stations: Kawagoe (Tobu Tojo Line) and Hon Kawagoe (Seibu Shinjuku Line) (15 minutes on foot from either station)

Other

Biannual Fair of Folkcrafts and Antiques

A large association of antique and junk dealers from all over Japan holds a huge sale in spring and in fall of each year. Many shop dealers and flea market vendors from the Tokyo area sell here and offer discounts if you bargain. The largest discounts come at the end of the day. Each sale is a two-day affair, and it can take a good eight to ten hours to go through the entire fair with a look at each stall. If you know your antiques, there are bargains and many unusual items to be found. For information about the fair, call the Japan Old Folkcraft and Antique Center at 295–7112, in Japanese. Since the location of the sale changes periodically, it is best to confirm the location before going. Sales are always announced on fliers distributed at monthly flea markets, with directions to the site, and usually announced in local tourist papers. The huge, diverse collection of wares ranges from treasures to junk.

Biannual Fair of the Tokyo Bijutsu Club

This select group of established antique dealers from all over Japan, but primarily Tokyo, holds biannual sales at their club (6–19–15 Shimbashi, Minato-ku, Tokyo; tel. 432–0191). The sales are open to dealers and the public, but non-dealers must pick up tags at the entrance, which are placed on items to be purchased. A large, varied selection of excellent-quality antiques are offered. Sales are announced in English-language newspapers.
Nearest subway station: Onarimon (Mita Line)
(5 minutes on foot from the station)

Salvation Army (*Kyūseigun*) Weekly Flea Market

The Salvation Army (2–21–20 Wada, Suginami-ku, Tokyo; tel. 384–9114) runs a weekly flea market of used items, almost always including some Japanese furniture and tansu. Prices tend to be very reasonable, but beware of unsalvageable pieces. If you have some knowledge of Japanese furniture, you can often spot real bargains. The market is held every Saturday from 8:30 A.M. to 12 noon near the Salvation Army Booth Hospital.
Nearest subway station: Nakano Fujimi-cho (Marunouchi Line)
(15 minutes on foot from the station)

APPENDIX 3

Metric Conversion Table

The metric system is used for most measurements in this book. For the reader unfamiliar with this system, the following table will enable easy conversion to approximate measures in the English system. Abbreviations used in this book are noted in parenthesis.

	When You Know	**Multiply by**	**To Obtain**
1) Length	millimeters (mm)	.04	inches (in)
	centimeters (cm)	.4	inches (in)
	meters (m)	3.3	feet
2) Weight	grams (g)	.035	ounces
	kilograms	2.2	pounds
3) Volume	milliliters (ml)	.034	fluid ounces, U.S.
	liters	1.06	quarts, U.S.

Examples:

$$6 \text{ mm} \times .04 = .24 \text{ in (or approx. } 1/4 \text{ in)}$$
$$120 \text{ cm} \times .4 = 48 \text{ in (or 4 ft)}$$
$$400 \text{ g} \times .035 = 14 \text{ oz}$$
$$260 \text{ ml} \times .034 = 8.8 \text{ fl oz}$$

Bibliography

ENGLISH-LANGUAGE PUBLICATIONS

Hall, Alan, and Heard, James. *Wood Finishing and Refinishing*. New York: Holt, Rinehart and Winston, 1981.

Hauge, Victor and Takako. *Folk Traditions in Japanese Art*. Tokyo: Kodansha International Ltd., 1978.

Heineken, Ty and Kiyoko. *Tansu: Traditional Japanese Cabinetry*. Tokyo: John Weatherhill, Inc., 1981.

Joya, Mock. *Mock Joya's Things Japanese*. Tokyo: Tokyo News Service, Ltd., 1958.

Morse, Edward S. *Japanese Homes and Their Surroundings*. New York: Dover Publications, Inc., 1961.

Munsterberg, Hugo. *The Folk Arts of Japan*. Tokyo: Charles E. Tuttle Co., Inc., 1958.

Nakashima, George. *The Soul of a Tree: A Woodworker's Reflections*. Tokyo: Kodansha International, Ltd., 1981.

Paine, Robert Treat, and Soper, Alexander. *The Art and Architecture of Japan*. 3rd ed., rev. New York: Penguin Books, 1955.

Reischauer, Edwin O. *Japan: The Story of a Nation*. 3rd ed. New York: Alfred A. Knopf, Inc., 1970.

Seike, Kiyosi. *The Art of Japanese Joinery*. Tokyo: John Weatherhill, Inc., 1977.

Taut, Bruno. *Houses and People of Japan*. London: John Gifford, Ltd., 1937.

Wickman, Michael. *Korean Chests: Treasures of the Yi Dynasty*. Seoul: Seoul International Tourist Publishing Co., 1978.

Worswick, Clark, ed. *Japan: Photographs, 1854–1905*. New York: Alfred A. Knopf, Inc., 1979.

141

Yanagi, Sōetsu. *The Unknown Craftsman: A Japanese Insight into Beauty*. Tokyo: Kodansha International Ltd., 1972.

JAPANESE-LANGUAGE PUBLICATIONS

Koizumi, Kazuko. *Nihon no Tansu*. Tokyo: Kagu no Rekishikan, 1973.

————. *Wa Kagu*. Tokyo: Shōgakukan, 1977.

Shionoya, Hiroji. *Ko-dansu Hyaku-sen*. Tokyo: Sōjusha Bijutsu Shuppan, 1980.

Tonami Wa-dansu Kenkyūkai. *Wa-dansu*. Toyama: Bunchodō, 1978.

Glossary

atari: a metal stud attached to the wood of a tansu directly under a handle to prevent it from nicking the drawer's wood surface.

bō-dansu: any tansu that bears a vertical locking bar (*bō*) across a series of drawers; commonly found on Sendai clothing chests.

bura pull: a small teardrop-shaped pull found on the drawers of small furniture.

burled wood: wood cut from a burl on the trunk of a tree where the wood grain is very compact, forming a curly, twisted pattern. Burled wood is prized for its beautiful striations.

Cashew: the brand name of a synthetic lacquer produced in Japan that possesses qualities approximating natural Japanese lacquer.

chō-bako: a style of sea chest designed with drawers and/or sliding door compartments on the chest front.

chōba-dansu: merchant chest. Also called *chō-dansu.*

chō-dansu: merchant chest. Also called *chōba-dansu.*

daiwa hibachi: a rectangular wooden hibachi produced in the Kyoto area.

dōgu-bako: a tall, narrow chest with drawers used for the storage of a tradesman's small tools.

double-action lock: a type of lock operated by a key that turns clockwise to lock the mechanism and counterclockwise to unlock it. Double-action locks were in use during the Meiji and Taishō eras.

finish: a material, such as lacquer, Cashew, varnish, shellac, or urethane, that is applied to wood to seal and protect the surface.

fitted-piece construction: the use of several pieces or boards of wood, adjoined with glue and/or hidden bamboo dowels, to make the side, top, bottom, or back of a piece of furniture.

funa-dansu: sea chest

grit: the degree of coarseness and size of particles in sandpaper.

gumbai: a style of drawer handle designed in the shape of a *gumbai,* a traditional, lacquered fan formerly used to signal the start of a contest or battle. Also called *gumpai.*

hako: literally "box," but often used to denote a type of small chest or other container made of wood. Pronounced *-bako* when used in a compound.

hakudō: a copper and nickel alloy, popularly used to form thin circular rings

143

around lockplates on Yonezawa and Sendai clothing chests. Appears silver in color.

han-bako: a one-drawer box used for the storage of name seals (*hanko*) and ink.

hangai: a style of sea chest having a full-front door on the chest face that lifts off completely from the case.

hari-bako: sewing box or chest

hibachi: a brazier crafted of porcelain, copper, bronze, or wood, which holds burning coals used primarily for heating a room or water.

hinoki: Japanese cypress

hirute: a style of drawer handle designed in the shape of a water leech.

ishō-dansu: clothing chest; a tansu containing drawers and often a small door compartment that opens to two small inner drawers.

kaidan-dansu: staircase chest; a tansu constructed as a freestanding staircase with storage drawers and compartments built into the steps.

kakesuzuri: a style of sea chest that has a single front door hinged at one side and opening to reveal a series of inner drawers.

kakute: a style of drawer handle designed with square edges.

kamon: a Japanese family crest, often used as a motif on tansu metalwork.

kan: a ring pull

kanagu dōgu-bako: tool chest; a small chest with shallow drawers used by ironsmiths to store hand tools.

kannonbiraki: a type of double doors whose hinges are attached flush against the chest face. Chests bearing these doors are often called *kannonbiraki tansu.*

kashi: Japanese evergreen oak

katana-dansu: sword chest; a long, low tansu used for the storage of Japanese swords and associated equipment and cleaning supplies.

keyaki: zelkova

kiri: paulownia

kokyō: a hand mirror made of copper, silver, or nickel, used by women in the Edo period.

kotatsu: a sunken, squared hole in the floor of a traditional Japanese home, where burning *sumi* coals were placed for cooking and heating. Also used to mean *kotatsu yagura.*

kotatsu yagura: kotatsu stand; a wooden stand placed over a *kotatsu* on top of which a futon is spread to hold in the heat.

kuri: chestnut

kuruma-: a prefix meaning "having wheels," as in *kuruma-dansu*, or wheeled chest.

kusuri-dansu: medicine chest; a tansu used by medicine peddlers, pharmacists, or doctors to store medicinal herbs, roots, and powders.

kuwa: Japanese mulberry

kyodai: a vanity or dressing table

lacquer: thick sap extracted from the Japanese *urushi,* or lacquer, tree, which is used to impart a durable, high-gloss finish to tansu. Lacquer is used raw or with natural colors added.

lockplate: the iron plate covering a

drawer or door lock, which is visible on the exterior of a piece of furniture.

masu: the funnel-shaped, wooden aperture on the top of money boxes; literally, "measuring box."

matsu: Japanese pine

mizuya-dansu: kitchen chest; a large tansu used for the storage of food and crockery.

mokkō: a style of drawer handle that is shaped as a three-part scallop. The name is derived from *mokkō,* the curves made by the vines of cucumbers and watermelons.

naga-hibachi: a long, square or rectangular wooden hibachi with a built-in copper receptacle for copper.

nagamochi: trunk; a rectangular, wooden trunk with a hinged lid used traditionally for storing bedding and out-of-season kimono.

Nihonmatsu ishō-dansu: Nihonmatsu clothing chest; a type of tansu from the Nihonmatsu area of Fukushima Prefecture, noted for its expansive drawer fronts of zelkova or chestnut. Also called simply "Nihonmatsu tansu."

nōmen-dansu: Noh-mask chest; a short tansu with small inner drawers used for storing Noh masks.

Ogi ishō-dansu: Ogi clothing chest; a type of tansu originating in Ogi on Sado Island. Also called simply "Ogi tansu."

ryōbiraki: a type of double doors whose hinges are attached at the corner edges of the chest. Clothing chests bearing these doors are called *ryōbiraki ishō-dansu. Ryōbiraki chō-dansu* (double-door merchant chests) are also found.

Sendai ishō-dansu: Sendai clothing chest;

a tansu produced in the Sendai area of Miyagi Prefecture, known for its elaborate ironwork, hardwood drawer faces, and rich burgundy, lacquer-based finishes. Also called simply "Sendai tansu."

single-action lock: a type of lock that locks when a knob on the exterior of the lockplate is pushed upward. A key inserted into a keyhole and turned counterclockwise unlocks the mechanism.

stain: a natural or chemical dye used for coloring wood. In tansu restoration, stain is applied directly to the wood after fine sanding is completed and before the finish is applied.

sugi: cryptomeria

suzuri-bako: a small wooden chest with drawers for the storage of ink, brushes, and an abacus; most typically used in shops during the Edo period and Meiji era.

tabako-bon: tobacco box; a wooden box that contains a small charcoal receptacle resembling a hibachi and a bamboo cylinder that serves as an ashtray. Also popularly called "smoking box."

tansu: Japanese cabinetry constructed of wood and designed for storage. Pronounced *-dansu* when used in a compound.

tatami: flooring for Japanese homes composed of a base of tightly woven straw (measuring approximately 8 cm thick, 90 cm wide, and 150 cm long) covered with a thin mat of woven rush.

Tōkyō ishō-dansu: Tokyo clothing chest; a type of clothing tansu produced in the Kantō area, known for its simple construction of four drawers, sometimes combined with a small door compartment, and its austere ironwork.

warabite: a prominent style of drawer

handle that derives its name from its graceful curve, which resembles that of a Japanese mountain fern (*warabi*).

Yahata ishō-dansu: Yahata clothing chest; a clothing tansu originating in Yahata on Sado Island, noted for its highly ornamental ironwork and large dimensions. Also called simply "Yahata tansu."

Yonezawa ishō-dansu: Yonezawa clothing chest; a style of clothing chest produced in the Yonezawa area of Yamagata Pre-fecture, noted for its butterfly-motif locks and *hakudō* rings around lockplates.

zeni-bako: money box; a wooden box used for the storage of coins during the Edo period and early Meiji era. *Zeni* is a small copper coin circulated during the Edo period.

zeni-dansu: money chest; a small chest with drawers used for the storage of coins during the Edo period and Meiji era.

Index

The "weathermark" identifies this book as a production of John Weatherhill, Inc., publishers of fine books on Asia and the Pacific. Book design and typography: Miriam F. Yamaguchi and Pamela Pasti. Composition of the text: Korea Textbook Company, Seoul. Engraving and printing: Kinmei Printing Company, Tokyo. Binding: Okamoto Binderies, Tokyo. The typeface used is Monotype Baskerville.